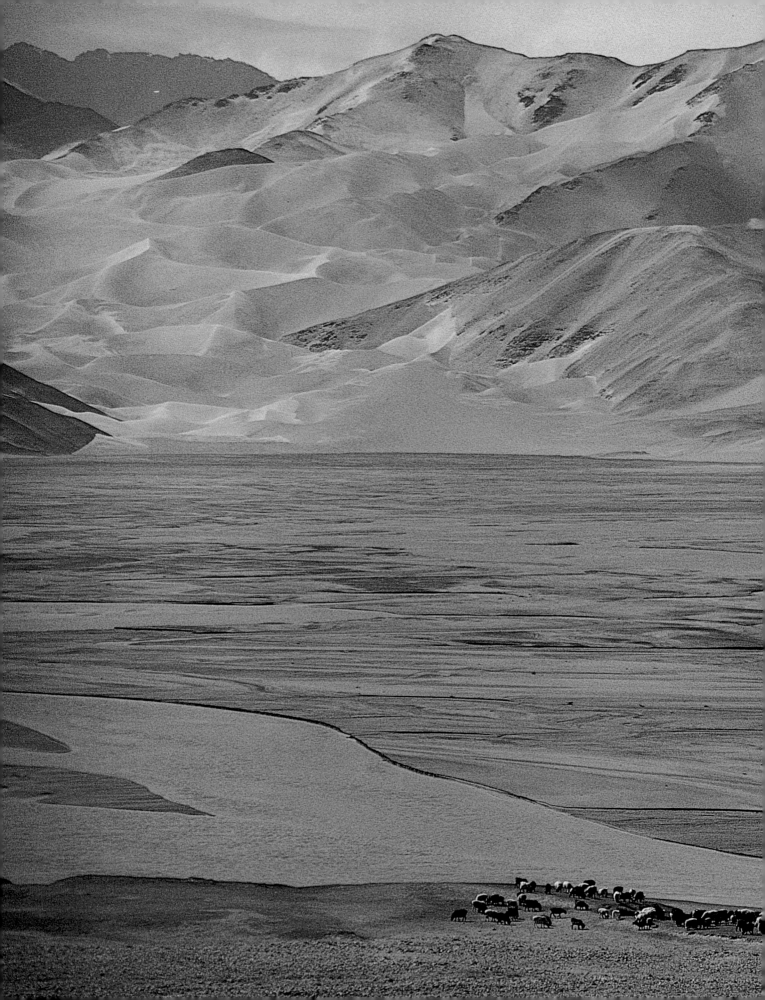

ADVENTURE TRAVEL
PHOTOGRAPHY

NEVADA WIER

WATSON-GUPTILL PUBLICATIONS/NEW YORK

Nevada Wier is a professional photographer who specializes in remote-travel photography, particularly in Asia. Her photographs have been published in such magazines as *Audubon, Discovery, Geo, Natural History, Popular Photography, Sierra*, and *Smithsonian*.

Editorial concept by Robin Simmen
Edited by Liz Harvey
Designed by Areta Buk
Graphic production by Ellen Greene

Copyright © 1992 by Nevada Wier
First published 1992 in New York by AMPHOTO,
an imprint of Watson-Guptill Publications,
a division of BPI Communications, Inc.,
1515 Broadway, New York, NY 10036

Library of Congress Cataloging-in-Publication Data
Wier, Nevada.
 Adventure travel photography: how to shoot great pictures off the
beaten track / by Nevada Wier.
 Includes index.
 ISBN 0-8174-3275-2 ISBN 0-8174-3276-0 (pbk.)
 1. Travel photography. I. Title.
TR790.W54 1992
778.9'991—dc20
 92-13989
 CIP

Manufactured in Singapore

1 2 3 4 5 6 7 8 9 / 99 98 97 96 95 94 93 92

I OWE A BIG THANKS TO EVERYONE WHO SUPPORTED ME DURING THE
COMPLETION OF THIS BOOK, ESPECIALLY LISL AND LANDT DENNIS,
SHELLY O'CONNELL, AND, MOST OF ALL, SALLY BUTLER.
I ALSO OWE THANKS TO ALL THE PEOPLE WHO'VE TRAVELED WITH
ME OVER THE YEARS IN THE WILD CORNERS OF THE EARTH.

CONTENTS

THE DESIRE TO WANDER

Hearing the names Kathmandu, Rangoon, La Paz, Samarkand, and Nairobi evokes hazy images of unabashedly romantic and seemingly unreachable destinations. People sometimes assume that these are places where only missionaries, scientists, mountaineers, wealthy individuals, and *National Geographic* photographers travel. Today, however, distances in time and space have shrunken; it doesn't require months of sailing, riding camels, or trudging across deserts to reach these remote outposts. Within two days you can be sipping tea in the most fabled cities on the globe. But for the truly adventurous, the journey is just beginning. Turning your back on the cities, you can head into the surrounding terrain: mountains, deserts, vast plains, jungles, and seas. In these windswept, sunshine-drenched worlds you visit the land of your dreams and people of the past—places where you truly understand the meaning of the word "remote."

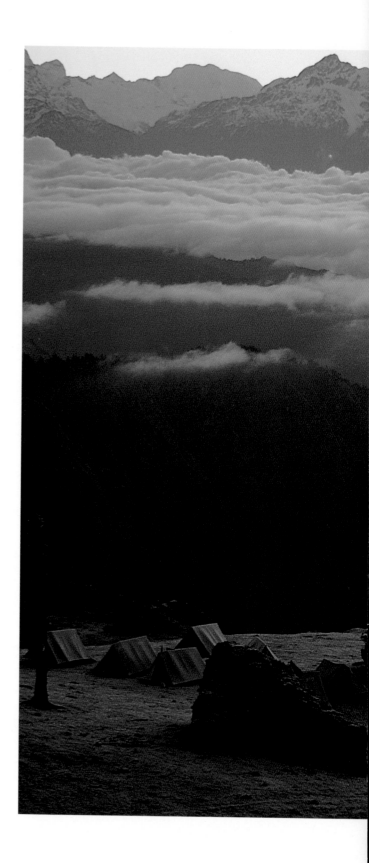

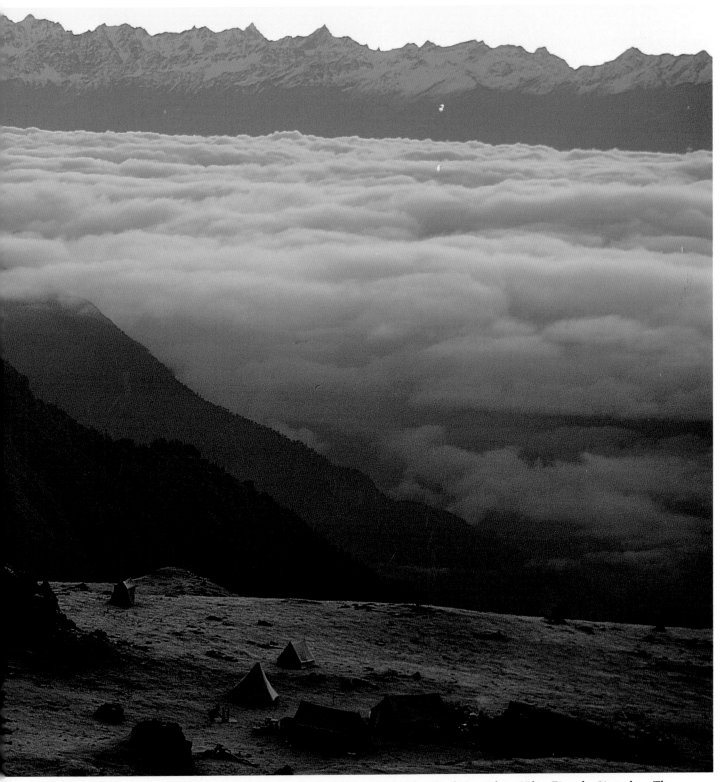

I photographed this tranquil morning scene on the Tiradanda Ridge in Nepal, below Singla La with my Nikon F3 and a 50mm lens. The exposure was 1/60 sec. at f/4 on Kodachrome 64.

HOW I GOT STARTED

Twenty years ago I began exploring the canyons, mountains, deserts, and rivers of the American Southwest. As I learned the skills to feel comfortable and confident in various challenging outdoor situations, I was inspired to venture farther. Sometimes with friends, sometimes alone, I explored deeper canyons, wilder rivers, and more remote mountains.

In 1972 while hiking in Escalante Canyon, Utah, I turned a bend and confronted an immense sandstone wall. It was late afternoon, and the canyon resonated with an intense orange glow that seemed to radiate from within its massive walls. I wanted to keep that image with me forever. I owned a book by Eliot Porter called *Glen Canyon—A Place No One Knew*, and the beauty of his photographs echoed my immediate feeling. However, those were his images. I wanted to record my own viewpoint. I remember thinking, "If Eliot Porter can photograph these walls, so can I!" I was naive to assume that I could be Porter's rival, but that flash of inspiration and intent changed my life forever. From that moment on, I aspired to incorporate photography into my philosophy of travel and life. The camera became a tool for investigation and my photographs expressions of a quest to explore my personal vision and relationship to the world in its largest sense.

My travels began to take me farther afield, from the shores of Lake Titicaca, Bolivia, to Xinjiang Province, China. I'd found my niche and calling in combining my outdoor skills with an intense desire to explore remote destinations and interact with people of other cultures. At that point I didn't realize I was joining the ranks of a long line of photographers who set out on voyages to record foreign places and cultures.

I supported myself by guiding adventure tours in Nepal and China initially, until I began to develop enough professional contacts to absorb the cost of film and travel. Travel photography isn't an easy field in which to make a living, and adventure-travel photography is even more difficult. Amassing assignments requires a prodigious dose of perseverance and what I call the "tenacity quotient." I sometimes feel that amateur photographers are in an enviable position; they don't have to worry about hustling a story, meeting deadlines, or having heart palpitations if their camera breaks down. They can enjoy their travels unencumbered by imposed photographic restraints or time schedules and can dive 100 percent into discovering artistic thresholds.

Whether you're traveling alone or with an organized tour, in the Appalachian Mountains of Tennessee or in the Himalayas of Nepal, the key is to take advantage of a chance to travel beyond familiar places and comfortable facilities. Whenever I venture into "terra incognito," which is anyplace outside my normal frame of reference, and encounter new cultures and traditions, I experience a revitalization of my physical, sensory, and perceptual self.

Adventure and photography are natural partners. If your instincts are sharp and your eyes are open wide, you can translate your experience into an evocative, revealing, informative, or dazzling photograph—however you define your purpose. Unfortunately all too often, photographs are taken with an acquisitive intent and become a substitute for the real experience. As Susan Sontag remarks in *On Photography*, "Most tourists feel compelled to put the camera between themselves and whatever is remarkable that they encounter. Unsure of other responses, they take a picture. This gives shape to experience: stop, take a photograph, and move on."

Photographers have been accused of hiding behind cameras and viewing the world as a small rectangle. But I find that photographing doesn't divorce me from a situation; it motivates me to become more involved. I find myself searching out light, colors, emotions, and patterns more intensely and relating to people I might otherwise feel too shy or reluctant to greet. Photographing forces me to interact with other people, and it demands that I concentrate and be open and genuine. I find that the source of the real joy in photographing is the relationship between my subject and me, which becomes much more important than the actual image I take home.

To raise a photograph above the average, traveling photographers must be willing to develop sufficient intellectual and aesthetic capabilities in order to interpret a situation and translate it into a personal photograph. Just as you search for meaning and value in your travel experiences, you need to look beyond the obvious in your photographic investigations. There is a tendency to romanticize and perpetuate myths about foreign destinations and cultures. People tend to photograph only blue skies, gleaming mountains, and smiling natives—what I call the "waist-level-up-viewpoint." And by continually recording these images, traveling photographers are ignoring their own vision, unfairly glamorizing the world, and losing credibility as responsible communicators.

When I first conceived the idea of this book, I had some reservations. Environments and cultures are fragile, and certain species are becoming extinct. You have to delve into the densest jungles to find a culture untouched by the modern world. Each passing year and each passing traveler bring changes to the farthest reaches of the globe. I was concerned that writing a book encouraging travel to remote areas would

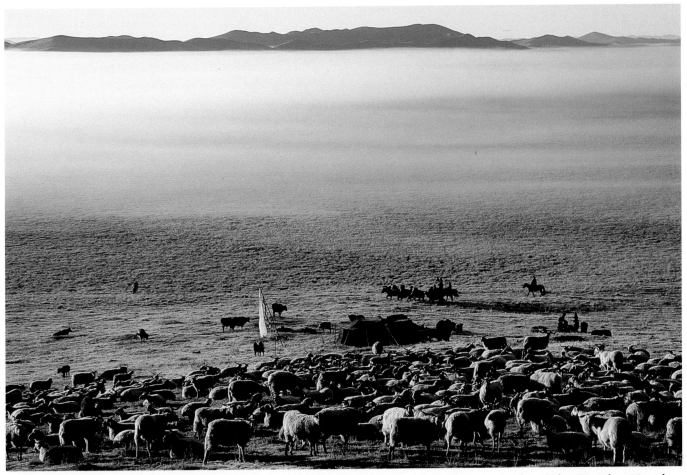

In China's Sichuan Province I photographed these Tibetan sheepherders in the morning mist as the sun rose with my Nikon F3 and an 85mm lens, and exposed Kodachrome 64 for 1/60 sec. at f/5.6.

contribute to cultural annihilation and the spread of America's pop-cultural dogma.

On the other hand, this has never been a static world and never will be. Civilizations have risen and fallen and cultures and languages have mixed and flourished since the beginning of humanity. Ironically some individuals in the Western world, the purveyor of change, lament cultural evolution for developing countries. Change is inevitable, but unfortunately there is a tendency now toward cultural homogeneity instead of diversity. I believe that it is important to venture beyond your own culture in order to cultivate global awareness as well as an appreciation of foreign mores and customs, rather than to smugly stay at home with a false sense of cultural superiority. As you travel you need to be sensitive to your impact, as well as to abandon your self-absorption and become more responsible for relating to the world and yourself as a continuum.

Images are usually your first encounter with the myriad of cultures and environments outside your own. Movies, television, and photography books and magazines bombard you with information. The camera has done more to enlarge your awareness of the world than any other invention of modern society. Ours has become a culture addicted to cameras and their resulting images. A camera is the one item people rarely leave at home, and the one they rarely take full responsibility for.

Travel and photography have become my profession and my lifestyle. This isn't a lifestyle that I encourage you to emulate in its entirety: it is certainly less romantic than it sounds. Hauling around between 25 and 50 pounds of photographic gear isn't fun. Sometimes I yearn for an Instamatic and a daypack. Just as important as your physical stamina is your mental stamina. You have to cultivate a willingness to endure delays, hardships, infuriating bureaucrats, inclement weather,

I shot this late-afternoon storm light on Lake Titicaca in Bolivia with my Pentax Spotmatic, a 40mm lens, and Kodachrome 64.

fouled-up air schedules, and unforeseeable and uncontrollable events that are impossible to resolve quickly. But once I am out in the field becoming acquainted with a new place and people, experiencing new food, and saturating myself with sensory stimuli, I realize that the struggle is worth it.

I can't tell you in this book how or what to photograph in foreign situations. I can only give you a kind of map to start you on your own photographic journey. Curiosity and circumstance are your best personal tour guides. Of course, you don't have to go to China or Africa to make a great photograph. "Remote travel" is really only a term that signifies your allowing the exploration of your interior world to reflect your image of the exterior world. Remote travel often involves using primitive modes of transportation, such as walking, riding animals, and traveling in dugout canoes, thereby offering the ultimate luxury in this fast-paced, frenetic world: time. You have time to think, to observe, to explore all your senses, and to investigate all photographic possibilities. By taking time and being deliberate, you can pursue encounters and experiment with compositions that can lead you to your singular vision.

When you do decide to explore new terrain, I hope that this book encourages you to venture off the beaten track; helps you deal with the nuts and bolts of logistics, equipment, and technical and cultural situations; and propels you toward a greater personal photographic vision.

The source of my desire to wander is still a mystery to me. I didn't grow up in a family of explorers, athletes, or even armchair travelers. I didn't pore over *National Geographic* magazines as a youth and fantasize about riding camels across blowing dunes. I was a city girl, seemingly destined for an urban academic existence. However, through a series of fateful events, I was propelled in a very different direction, and the fire of a latent wanderlust was ignited. My journey to Lake

Titicaca, Bolivia, was my first impromptu foreign adventure, and I was just beginning my photographic career.

On my previous outdoor trips in America, I often set out on one path only to end up on another. In fact without any forethought or predictions of the outcome on my part, many of my travels have taken a 90-degree turn into an unexpected adventure. Such was the case in Bolivia. It was like sliding down a dark chute and not knowing where I was going to land.

SAILING A REED BOAT ON LAKE TITICACA IN SOUTH AMERICA

In 1978 I went to South America originally intending to go climbing with my friend Jeff for two months. I didn't have a photographic assignment when I left home. But I ended up staying in Bolivia for over half a year and went on one of the most remarkable journeys of my life, a seven-week voyage circumnavigating Lake Titicaca in a tortora reed boat (tortora is an indigenous reed that grows prolifically in the lake).

Jeff and I'd hoped to set out immediately to climb in the Cordillera Real of the Bolivian Andes. However, my climbing gear was held up in customs, so we looked in the direction of the altiplano, a high plateau, for a different type of adventure. Jeff had seen Lake Titicaca on his earlier wanderings around Bolivia and mused about the possibility of kayaking or sailing around it. Lake Titicaca, pressed between earth and clouds at 13,000 feet, is the highest navigable lake in the world. Spanning 3,200 square miles in Bolivia and Peru, it has the temperament of a miniature ocean: moody, capricious, and often dangerous. Winds sweep down from the Andes, instantly transforming the placid lake into a raging sea with surfing

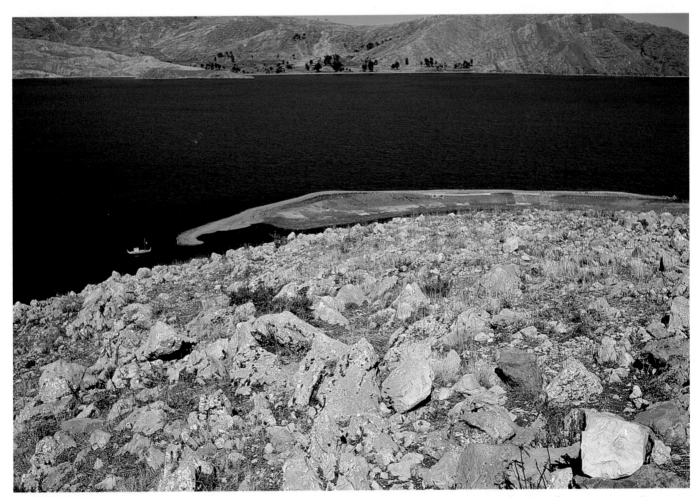

I climbed above the boat to get a high-angle view and was struck by the graphic design of the landscape. I used a 40mm lens on my Pentax Spotmatic to include a wide expanse of foreground, so the composition accentuates the insignificance of the boat in comparison to the spacious landscape.

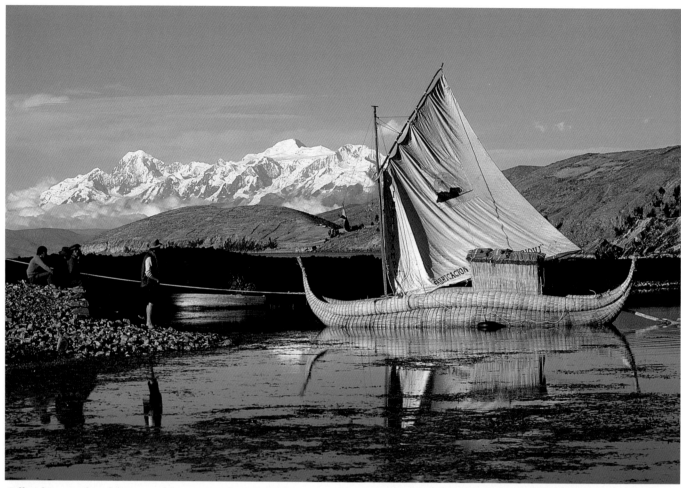

Jeff and I stopped in this protected lagoon to make some repairs to the ropes on our boat. Shooting with my Pentax Spotmatic and a 100mm lens, I stood back to photograph our Bolivian friends and the inti yampu with the Andes Mountains in the background.

waves. Along the shore the population is predominantly Aymara, a people whose ancestry dates back to the mysterious pre-Inca civilization of Tiawanaku.

Intrigued by the lake, Jeff and I abandoned our climbing plans in an impulsive moment of naiveté and commissioned the island men of Suriqui to design and build a 23-foot-long, 6-foot-wide, and 6-foot-high tortora reed boat. Most tortora boats are small and made for riding around placid lagoons, but not ours. The inti yampu, which is the Aymaran term for sun raft, took five weeks to build. It was an elegant bundle of reeds, fitted with a eucalyptus mast, a handsewn sail, an anchor made by the Bolivian Navy, a massive handcarved oar in the back that served as a rudder, and two oars 6 feet apart that required both of us to row simultaneously.

Neither Jeff nor I had ever sailed before. On the first day, we began drifting sideways across the lake, out of control and away from the safety of the shore. We knew there was a terrible flaw in the boat design. There wasn't a keel or sideboard to help keep us on course. We were at the mercy of the wind. We couldn't sail against it because we'd be swept in the middle of the turbulent lake, and we couldn't row into it. Jeff and I realized that we could sail only when the wind was directly behind us, or row during a lull in the wind. We also found out that circumnavigating the lake was a bigger undertaking than we'd originally expected.

As we struggled our way northwest, we proudly told the curious Bolivians that we were heading to Peru and around the lake. "It would be faster in a car," one Aymaran woman remarked. "Yes, I'm sure it would," I replied, "but I would miss out on the adventure." They stared at us and at the reed boat. Shaking their heads matter-of-factly, they said, "If you get to Peru, you're going to die there. Very cold in lake. The waves

As I was returning to the boat after visiting an Aymaran family, I was attracted by the soft light on the daughters' round faces and knelt down to take their portrait. I used my Pentax Spotmatic, a 40mm lens, and Kodachrome 64.

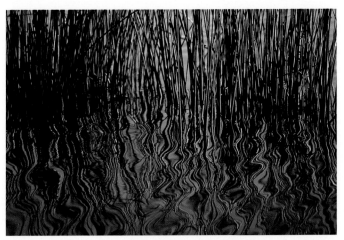

I spent many hours on the boat staring at the reflections of the tortora reeds in the water. Finally recognizing their photographic appeal, I captured them on Kodachrome 64 with my Pentax Spotmatic and a 40mm lens.

hit rocks. Boom. Boom. Boom. You will be smashed." Living daily in a rough, difficult world, it was impossible for them to understand why anyone would intentionally want to inflict hardship on themselves. A couple of months later, I began to have a profound insight into their point of view.

After two months passed and Jeff and I were only halfway around the lake (we originally estimated five weeks for completion), we were discouraged and tired. We'd weathered storms, fierce winds, and incredible waves, as well as a glut of boring days sitting on the boat waiting for the winds to change in our favor. However, we were still determined and kept

plodding onward from the tortora patch to the sheltered harbor praying our boat would hold together. Finally on Thanksgiving Day, 11 weeks after we began, we sailed our battered, soggy, 2-ton boat into our home port of Huatajata to the astonishment and relief of everyone.

I've traveled for longer periods of time, and I've been on numerous outdoor trips from four to six weeks. But this was the longest outdoor trip using one mode of transportation in one region that I'd ever gone on. I'd never choose to repeat this particular voyage, but I expect to go on more extended journeys. Jeff and I had no idea when we started how long the trip was going to take. We had no set agenda on this trip, except to complete it. And if I knew then what I know now, I might not have gone. Still, despite the boredom, hardships, cold, and worry, it was a grand adventure. There is definitely something very special about traveling with no plan or schedule whether you're walking, sailing, or riding horseback. You connect intimately with the country, the people, and yourself.

This was my initiation into photographing outside Western countries and using color-transparency film. Before this, I'd used only black-and-white film, a large-format camera for landscapes and portraits, and a 35mm camera for sports photography. I decided that I didn't want to cart a large-format camera around the world; a 35mm camera seemed better suited to traveling. I took two camera bodies, a Pentax MX and a Pentax Spotmatic, and three lenses, a 40mm, a 100mm macro, and a 135mm. I kept my cameras in individual leather cases in a ratty old daypack. I also brought some lens paper, a few filters, and a small screwdriver. It was a very simple and lightweight arrangement. For this trip I decided to shoot color transparencies. I took with me only about 25 rolls of Plus-X and 25 rolls of Kodachrome 64, which at the time seemed very excessive. I shot the black-and-white film with one camera, the color with the other.

At that time I took only one or two photographs of a scene. Now, looking back over my photographs, I see some gaps and lost opportunities but not as many as I could expect. This reinforces the idea that you don't need a motor drive and a large assortment of lenses to create excellent images. When you're just beginning to shoot, it is important not to overwhelm yourself with too much technical information. Remember, photographs primarily come from within yourself, not the camera. Since I had a minimum of equipment, I learned everything about the limitations and advantages of my lenses.

I also learned many lessons on that trip: watch out for pickpockets, eat only peeled fruits, drink only boiled water, and, second to my life, save and protect my cameras at all

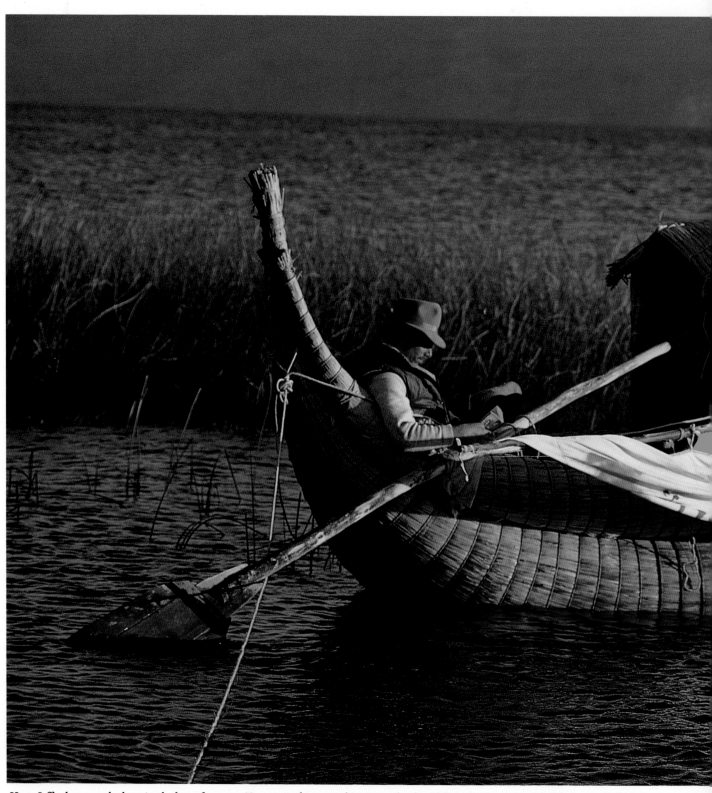

Here, Jeff relaxes on the boat in the late afternoon. Your eye is drawn to this picture by the golden sun, the strong sidelighting, and the deep shadows on the tortora boat. Shooting Kodachrome 64, I used my Pentax Spotmatic and a 135mm lens.

costs. In my journals I wrote more than once, "We almost lost the boat, but I saved my cameras." However, about halfway around the lake, my Pentax Spotmatic camera with the 100mm macro lens on it fell into 5 feet of water. I jumped into the frigid water, fished out the camera, shook out the water, and laid the camera in the sun to dry. Amazingly the camera dried out and worked fine, but the lens never recovered. (For more information on dealing with water, see page 28.)

One of the most difficult tasks on a long journey is maintaining photographic momentum. It is easy to roll over in the morning mumbling, "I'll take a sunrise photograph tomorrow." Inevitably you'll miss the quintessential sunrise, and the next day it'll rain. Only you know the difference between a well-deserved rest and laziness.

Sometimes when I go on longer trips I give myself an assignment. I try to narrow the theme to an object, color, or expression and portray it in as many different ways I can. For example, in Vietnam I photographed conical straw hats. And in Nepal I've focused on the color red and temple details, while in the Chinese Pamir Mountains I photographed the buttons on young girls' coats and in their hair. On Lake Titicaca I shot the tortora reeds. Giving yourself an assignment on a long trip can help keep your photographic momentum alive. Also, don't forget self-portraits on the trip, and be creative.

Keep good notes and records of the photographs you take. Over a long period of time your memory can fade, and you might not remember the Aymaran name of the weaver, the town she was in, or what she was weaving. Write down precise notes of names, dates, events, and photographic exposures in a notebook. Finally, on long trips you have time to be experimental, not just three days to photograph everything. Experiment with night shots, low-light indoor shots, and slow exposures.

Not only was my sailing trip around Lake Titicaca a great journey, but also, in retrospect, a pivotal event: the prelude to a new thrust to the rest of my life. I cultivated flexibility, stamina, and a sense of humor. And I learned not to rush but to take time and listen to people, and to keep my eyes open and genuinely "see" what was around me. I began to understand what it means to see with a camera. Photography and travel became indispensable partners.

PART 2

THE THRILL OF ACTION

Some of my travels have turned into unexpected adventures that require a flexible mindset and time frame. My trip to Lake Titicaca, Bolivia, falls into this category. These are exceptional experiences. However, I also like succinct, well-planned (and usually shorter) kinds of journeys, when I know where I'm going beforehand and basically what I'll be doing once I get there.

Each type of trip has its own travel and photographic appeal. The more time you spend in a region, the greater the possibility of capturing intimate images. However, it is easy to lose your photographic momentum over a long period of time. On a short trip the impetus is strong, but sometimes it feels as if you're just beginning to detect the essence of the place or the people when you have to leave. How much time you spend on a journey is subject to personal needs and limitations. There is something to be gained from every trip, whether you head out for one year or one day.

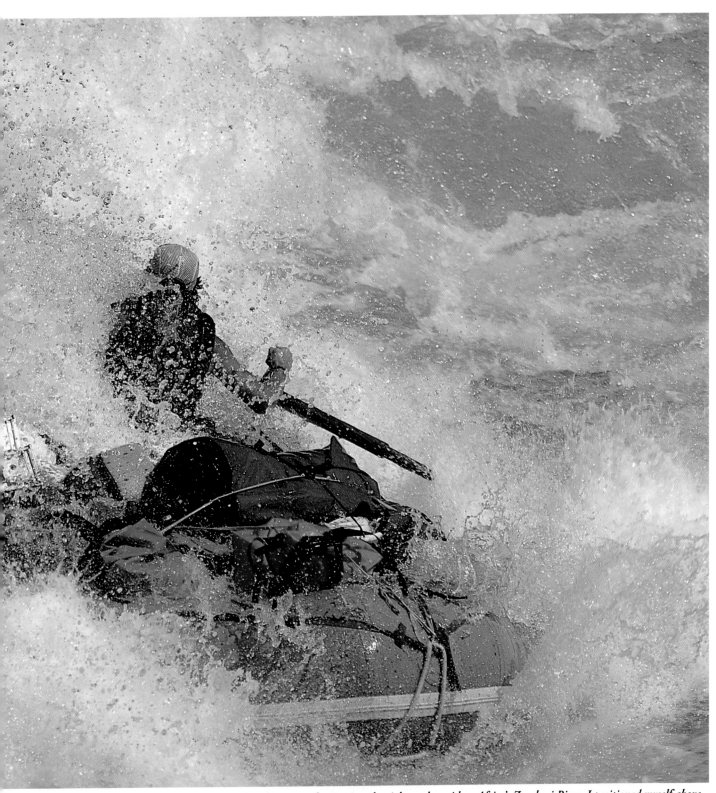

After we stopped on the bank to photograph the other two rafts running the eighteenth rapid on Africa's Zambezi River, I positioned myself above a huge "hole" of recirculating water and photographed the raft as it attempted to punch through the water. Shooting with my Nikon N8008, an 80-200mm lens, and Fuji Velvia, I exposed for 1/500 sec. at f/4.

DOG SLEDDING IN THE BROOKS RANGE IN ALASKA

Since very few people are able to take 11 weeks off in order to go on an international, outdoor photography trip, I say, "Take it while and when you can." On a 5-to-10 day trip you can journey to a remote place and have an unforgettable adventure. Time seems to expand when you aren't at home or at work. I've marveled many times at what I've experienced and seen in only a week.

Recently I went on an eight-day dog-sledding trip in Alaska. It had been 13 years since I'd gone sailing on Lake Titicaca. I have more experience and gray hair, but I still feel the same excitement about being in an unfrequented, pristine environment.

The Gates of the Arctic National Park reaches from Alaska's central Brooks Range into the far-north Arctic region. Southerly foothills sweep into waves of mountains that have limestone and granite peaks over 7,000 feet in elevation. The Brooks Range is wild, immense, and inspiring.

I flew by skiplane with three other people into the Gates of the Arctic near Tinyaguk Cabin, a rustic and very primitive log cabin on the edge of the Koyukuk River. We were 67 degrees north of the Arctic Circle. At the end of March the sun rose around 6 A. M. and set at 9 P. M. Because of the northern latitude, we were gaining eight minutes of sunlight per day. Yet the angle of the sun was low, maintaining a warm glow during midday and languidly setting in the evening for a protracted sunset. Even though it was the beginning of spring and we had 16 hours of sunlight, the temperature rarely rose above 20°F during the day. And after the sun set, the temperature was in the minus range. Luckily, we were blessed with windless, sunny days.

I carried two packs of equipment. One was a fannypack I attached to the top of the dog sled, so that I could open it while I was moving. In it I kept a Nikon F3 with a motor drive, a 20mm lens, a 24mm lens, and an SB-24 flash. I had an 80-200mm autofocus (AF) lens in a separate hard case also clipped and tied to the sled in a handy position. Around my neck I wore a Nikon N8008 with a 35-105mm AF lens tucked inside my jacket. I often use chest straps or a torso harness, but in this instance my jacket kept the camera from bouncing around. I cinched a belt high around my torso for the camera to rest on and to keep its weight from pulling on my neck.

Inside the sled on top of all my gear, I put a Tamrac camera bag with another F3 body, a spare motor drive, and several lenses, a 35mm $f/1.5$, a 50mm macro, an 80mm, and a 180mm. This camera bag wasn't accessible while I was moving on the sled, so I used these lenses while I was in camp, when we stopped for lunch, or if I stopped for a special shot. The next time I go dog sledding, I'll put my cameras in waterproof cases; this way, in case there is a storm or I encounter unexpected overflow, or water melting on top of the ice in a river, they'll be completely protected.

There is nothing like dog sledding. It is breathtaking and exhilarating to be on a sled with your own team of dogs barking and lunging forward enthusiastically at the release of the break. Since I'd never mushed a dog sled before, for the first few hours I traveled without my cameras around my neck to get used to being on a sled and controlling the dogs. Once I hit a bump while I was shooting and found myself practically hanging off the sled on my belly and being dragged along an icy river. I managed to grab onto the sled with one hand, tuck my camera into my jacket, and pull myself back into position. If I hadn't, my dogs would've gleefully raced on without me for miles, glad to be rid of the extra weight.

We headed north toward the Gates of the Arctic on the north fork of the Koyukuk River; Boreal Mountain was on the right, and the Frigid Crags on the left. We broke trail into the Gates of the Arctic along frozen rivers, snowbanks, and pure white valleys. White was the theme. There were snowy hills, white furry dogs, icy rivers, and blinding sun.

There is very little incentive to be up and on your sled early in extremely cold weather. Between warming up, cooking, packing the sleds, and harnessing 50 dogs, we often didn't get moving until early afternoon. There wasn't much stopping once we mounted the sleds. I found that my camera's motor drive and autofocus capabilities were indispensable; I hung onto the sled with one hand and leaned over or out to the side and shot.

When shooting from the sled, I tended to use either the 35-70mm AF lens or the 20mm lens. The greater the angle of a lens, the greater its depth of field. With ultrawide-angle lenses, depth of field extends from a few feet in front of the camera to infinity. When I used either lens, the front part of my sled was in focus and the background was crisp. Because my Nikon cameras don't have a built-in autobracket, I had to be exact in my light readings. If you have an autobracket you might consider using it: snow needs to be exposed precisely in order for you to capture its luminous quality. Although the physical conditions can be difficult to deal with, snow offers a welcome change from the usual tonal arrangement of land and sky. By coating the land, it tends to simplify images.

On this trip I used Kodachrome 64 for its sharpness, saturation, and neutral color cast. However, keep in mind that Fujichrome

is superb in overcast lighting conditions where its inherent contrast brings out the best in subdued tones, particularly in the green areas. I shot about five rolls of film a day.

Because of the cold weather, I had to pay close attention to keeping my batteries warm. At night I took the batteries out and placed them in my sleeping bag. During the day I had AA batteries in practically every inside pocket of my clothing to warm them with my body heat. When I wore my camera on the outside of my chest, thereby exposing it to the cold and wind, I usually had to switch my batteries at least once. I had only one battery pack for my Nikon N8008 so when the temperatures dropped, I took the battery pack out of the motor drive and kept it next to my stomach or under my arm. Then when I needed to use the camera, I slipped the battery pack back into the camera.

When I went inside a heated tent or cabin, I put one set of cameras inside the camera bag (after taking out the batteries) and left them in a moderately cold place, such as under the cots or next to the door; the cameras remained cool and ready to be used outdoors. I put the second set of cameras in heavy-duty plastic bags, squeezed out as much air as possible, and sealed up the bags before entering a warm room. When

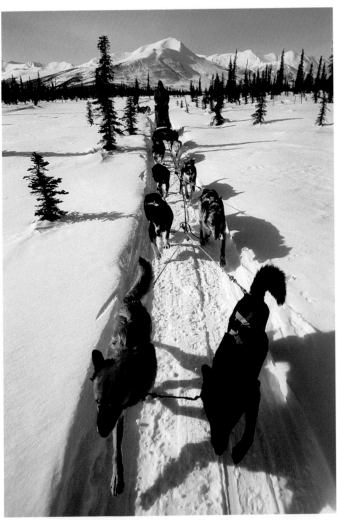

As we were mushing down the trail I twisted around, crouched low, and held onto my moving sled with one hand to photograph the sled behind me with a 20mm lens. Tightly holding onto my Nikon N8008, I exposed for 1/1000 sec. at f/5.6 on Kodachrome 64. The drama of the event is enhanced by the converging lines of the sled, which direct the eye to the top of my friend's head and the mountain in the background.

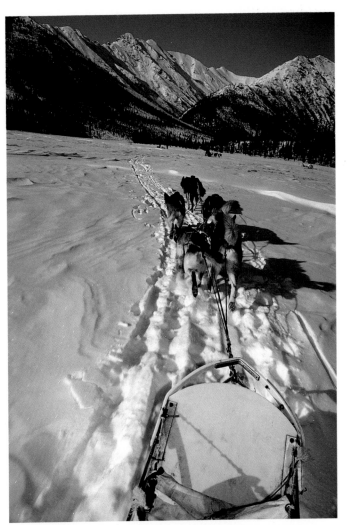

Once we were on our sleds we rarely stopped until we reached our destination. So I did much of my photographing from the moving sled. For this photograph, made with my Nikon F3 and a 20mm wide-angle lens, I leaned forward and low over the sled with in order to photograph the dogs and to include a portion of my sled and the landscape. The exposure was 1/500 sec. at f/5.6 on Kodachrome 64.

the warm inside air hit the cold bag, condensation formed on the bag, not the camera.

I remember the first day I went out to photograph the sunset. It was after 8 P. M., and the sun was very low on the horizon. I panicked and raced around trying to find the perfect shot. Then I remembered that I was in the northern latitudes, the land of the slow sunset. So I calmed down and strolled around for more than an hour, photographing the sun's sweet, pale glow. I was ready to move to the Arctic Circle.

After reaching the actual Gates of the Arctic, we turned back down the Koyukuk River and headed over a series of passes, vast snow meadows, pine forests, and wide ice rivers toward Wiseman, a small town on the Alaskan highway. At this point I reflected on the trip. I'd learned a new outdoor skill, experienced the call of the unbridled landscape, and augmented my repertoire of winter photography in a completely different venue. I could've kept going for weeks, but eight days was all I had. I felt very satisfied and elated. Besides, it is good to leave a place a little hungry for more.

TECHNIQUES FOR SHOOTING IN THE COLD

The hardest winter picture to shoot is a perfectly exposed snow landscape in the middle of a sunny day that holds detail without underexposing its whites. Photographing white as white is a challenge. The margin of error is slim. Because snow is white, the in-camera meter reads that white as 18-percent gray and exposes accordingly. Unless you override the meter reading, the picture is probably doomed; the usual result is a dense image with muddy whites and darker colors often in the hue of blue. So for the best results, use an incident meter or make your own personal adjustments to your in-camera meter reading.

Meter off something that approximates 18-percent gray, such as the sky, your hand, a piece of neutral-colored clothing, or a neutral-gray card. I normally gauge the exposure by metering directly off the back of my hand because I am familiar with its skin tone. When it is tan, I use the exact reading or maybe open up half a stop; if it is pale, I open up 1 to 1½ stops. You can also take a reading off a blue sky, which approximates a gray card, if you point your meter away from the sun. I also carry a gray card in my camera bag that I can use instead of my hand if I'm wearing gloves.

Another option when shooting a snow scene under the midday sun is to increase the in-camera exposure reading by one to two stops depending upon the direction of the light: one stop for light over the shoulder, and two stops for strong light in the face (see page 88). Don't be fooled, though. The whites that you're looking at often aren't really white. As an

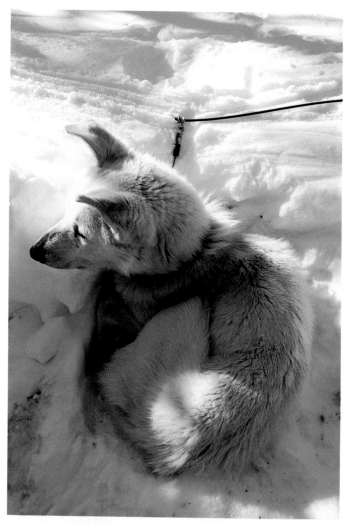

I photographed one of the sled dogs as we hitched them to their sleds. This was a particularly difficult exposure because of the monochromatic scene, although the shadows in the snow helped to separate the whites. Using my Nikon N8008 and a 35-70mm zoom lens, I metered off my hand to get the correct exposure and bracketed my shots. Here, I exposed for 1/60 sec. at f/8 on Kodachrome 64.

efficient reflector snow picks up the color of its surroundings, particularly the blue of a clear sky. Shadows in snow on a bright, sunny day are inevitably blue, so by exposing for the whites you lose the blue. If you want "white whites," open up to override the 18-percent-gray syndrome of reflected-light meters. The creative decision is yours.

When you're looking at a snowfield, examine the light. Check its direction, color, and shadows, and become aware of the shapes and the texture. Texture in snow is a function of the angle, direction, and intensity of light. The stronger and more parallel the light rays are to a surface, the better the light

reveals the texture and shapes of that surface. If you make the exposure only for the white snow and not the shadows, you lose that magic.

I never turn down the opportunity to photograph in a snowstorm. It is easier to predict exposure on an overcast day when the light is constant. I use the camera's reflected meter because it wants to expose everything to make it appear neutral gray, turning the snow darker than normal and blacks lighter than normal. I'll back myself up by bracketing $\frac{1}{3}$ to $\frac{1}{2}$ stops. Err in the direction of a half-stop underexposure to make the storm scene appear dark and dangerous. Blues and purples dominate long exposures in overcast or snowy weather, creating even more dramatic results.

The middle of a cold, sunny day is my least favorite time to photograph. To increase color saturation when the sun provides a uniformly boring light, you should underexpose by $\frac{1}{4}$ to $\frac{1}{3}$ stop. When you photograph right before or after sunset, you can usually be within half a stop of the meter readings. I'll usually bracket for the subtleties of color. Long exposures give an exaggerated color cast to certain parts of the photograph, which actually enhances the scene.

With the exception of a polarizing filter and a Nikon A2 warming filter, I rarely use filters when shooting snow and ice. Occasionally I use the A2 warming filter on overcast days to offset the cool color of the light by warming up skin tones and colors. I use a polarizer to reduce glare and reflections, to sharpen the contrast between the snow and the blue sky, and to enhance the prismatic spectral colors of frost crystals. Be careful when you use a polarizer. Sometimes the sky turns an unnatural navy blue, especially at high altitudes.

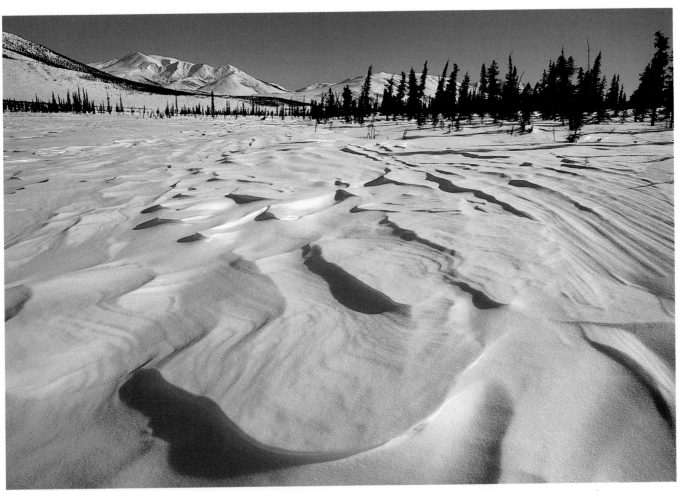

I went snowshoeing one morning to explore the area around our camp and came upon a pristine valley of windswept snow. I used a 20mm zoom lens on my Nikon N8008 to accentuate the textured patterns delineated by thin shadows, and a polarizer to deepen the blue of the sky. With Kodachrome 64, this exposure was 1/60 sec. at f/11.

To photograph glowing tents—your protection from the cold and the elements when you aren't shooting—first you need to add a small amount of ambient light to the scene so you can see the details. Set up the shot with someone inside the tent, and have the individual use a flashlight or lantern to paint the inside with light. Expose for the natural light outdoors if the tents are just one element of your composition. Expose for the light inside the tent if it dominates the frame. Use an exposure time of at least 4 sec. because the longer the exposure, the better the glow.

To get closer shots of people in action in the cold, such as mushing, skiing, dog sledding, or skating, in front or in back of me, I use an 80-200mm zoom lens. By using an autofocus (AF) lens you can shoot a follow-focus series of sledding shots, keeping the focus at the head while capturing a succession of images. To freeze action you need a shutter speed that is fast enough to stop the movement of the subject as well as camera motion. A good rule of thumb is to double the focal length of your lens and use that number as the minimum handheld shutter speed.

While dog sledding in Alaska, I usually shot for 1/1000 sec. since the subject and I were both moving and I was worried about camera shake. I had to hold on to the sled with one hand and shoot with the other, so I had to preset a focal length and shoot or wait for a smooth section of the trail, take my hands off the sled, and shoot with both hands, a potentially hazardous maneuver. I always used my motor drive in order to take a number of shots to ensure that my subject was in optimum focus, and I made at least one shot with a level horizon.

When using a manual-focusing lens you have to concentrate. During this trip I used one basic focusing technique when working with a manual lens. A few times I set up shots where I knew the person would be coming to a prearranged point. I focused on that particular spot and fired the camera at the moment the subject arrived. Since cameras often have a microsecond delay after you fire the shutter, you should press the shutter a microsecond early. You can also use a high-speed motor drive and blast away (although you may miss the decisive shot when the subject leapfrogs away from the point of focus). You can practice this technique while sitting on a road; using a telephoto lens, try to keep the oncoming cars in focus. It takes some time but soon you'll be able to follow the focus from infinity until the car fills the frame.

The longer the focal length of a lens, the less depth of field it provides at any focusing distance except infinity. For example, using a 200mm lens instead of a 400mm lens enables more space around your subject to be in sharp focus. As a result you are less likely to cut off part of it, and it is easier to compose. Longer lenses allow for a larger image on the film, but a larger image isn't an advantage unless it is as sharp as the image taken with one of the shorter lenses. So for me the 80-200mm zoom lens and the 300mm lens are ideal.

A long lens also comes in handy when you want to capture the action in falling snow. It compresses the scene and enhances

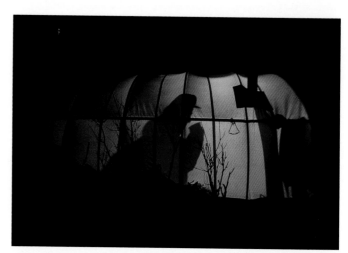

I was outside at 11 P. M. photographing the aurora borealis with my Nikon F3 and a 50mm lens and turned my head to see the exaggerated shadow of one of my friends drinking tea inside the group tent. I abandoned my intended shot, set up my tripod outside the tent, and asked my friend to hold his pose so that I could take a slow exposure. I took a light reading of the tent and bracketed my shots. This exposure was 1/2 sec. at f/2.8 on Kodachrome 64.

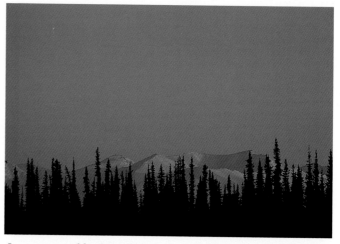

I was entranced by the prolonged sunsets of the northern latitudes. The first evening I strolled down the valley photographing the pink glow of dusk. This silhouette of a line of trees against the luminescent sky was one of my last shots. Shooting Kodachrome 64 with my Nikon N8008 and an 80-200mm zoom lens, I exposed for 1/60 sec. at f/5.6.

the snow in motion. A shutter speed of at least 1/125 sec. stops the flakes, while a slower shutter speed blurs the snow. Make sure that you step back from your subject. You need to put a good amount of snow between you and the action.

Follow-focus shooting is hardest when you're working with a longer lens because you have to be exact about depth of field. A sled running parallel to you is an easy subject to photograph because it's running on approximately the same plane you are. So the focus remains the same, but you need a faster shutter speed. It is more difficult to focus on a sled running at a 45-degree angle to you because the angle masks the speed of the sled. And it is even more difficult to focus on a sled running directly toward you because it's either coming toward or going away from you quickly. Actually, between these two shooting situations, it is easier to focus on a sled heading directly away from you because as it's running, you're approaching the infinity setting on your lens. You can stop the action with a shutter speed as slow as 1/125 sec. if you have a steady hand. If, however, the sled's running directly toward you, focus in front of it and trip the shutter when it appears sharp in the viewfinder.

Be careful if you're using a wide-angle lens: the subject goes in and out of the framing so quickly that you barely have time to shoot, let alone focus. In order to successfully use a wide-angle lens, you must be extremely close to the action. But this shooting position can be dangerous since you may suddenly realize that the dog sled in your lens is also right on top of you.

COLD AND YOUR EQUIPMENT

There are different levels of severity of coldness. From 32°F down to 0°F you need to follow common-sense precautions of keeping your equipment as dry and warm as possible. Below 0°F, however, some of the materials' characteristics are altered. Some lubricants thicken, which causes moving parts to slow down or jam. Film becomes brittle and less sensitive. To avoid tearing or breaking, advance the film lever very slowly. If you use a motor drive or load or wind the film too quickly, you might get small flash marks from static discharge on the film. Of course, the amount of time you spend out in the cold will help to determine how severe the negative effects are. In very cold weather be careful when using ultrafast speeds, such as 1/1000 sec. and 1/5000 sec. The shutter curtain can drag, leaving a dark, unexposed portion at the side of each frame.

Some photographers talk about winterizing cameras, but hardly anyone does this anymore. The process involves replacing normal lubricants that might congeal at very cold temperatures with others based on silicon, molybdenum, or Teflon. This is an extreme and costly process. Furthermore once this is done, you need to "de-winterize" your camera in order to use it again in more temperate climates. With the new lubricants and compatible metals used in modern cameras, winterizing is unnecessary for all but a few makes.

Some people swear by taking only manual cameras in cold climates. I don't have any problems with my automatic cameras and motor drives as long as I keep the batteries warm. Battery failure is the most common technical problem photographers encounter in winter; no batteries like cold weather. As the temperature drops, so does their efficiency. At 32°F, the freezing temperature of water, fresh batteries operate at about a third of their rated capacity. Specifications for most batteries indicate that they can be used to −4°F, but temperatures can fall much lower than that in Alaska and other mountain terrain. Always bring plenty of spare batteries for your camera. The newer rechargeable nicads have a greater capacity in cold conditions. However, it usually isn't possible to recharge batteries on an extended, outdoor winter trip.

Several camera makers have remote battery holders. One end screws into the battery compartment on the bottom of their manual cameras. A long cord connects to the other end, which holds two AA batteries. The battery holder can be slipped into a shirt or coat pocket, so you can protect the batteries from the cold. You can also use a chemical hand warmer to keep your camera or battery pack warm. When shooting with my Nikon F3 with a motor drive, I usually have several battery cartridges readily accessible in my jacket or pants pockets, close to my body. When I start to shoot, I slide one cartridge in and then rotate the cartridges as they cool in the camera.

Expose your equipment to the cold only when shooting. The rest of the time you should keep your equipment insulated in a padded, waterproof bag or under as many layers of clothing as possible. In Alaska I hung my camera around my neck and snuggled it inside my outer jacket, but I had to be careful when I removed it because of the condensation that formed on the lens and body. If you find condensation on your camera, wait a few seconds for it to stabilize and then wipe it off carefully with some lens tissue. Never blow the snow off your lenses. Your breath is warm and wet, and trying to blow moisture or snowflakes off the lens element in freezing weather produces a coating of fog or ice. I use a camel-hair brush for the lens and a soft chamois cloth for a foggy eyepiece.

Finally, don't put your cameras next to a fire to warm them up. Accidents can happen. Furthermore, this is a radical approach. Using body heat and letting your equipment slowly come to room temperature are best.

STAYING WARM

Pay close attention to your field equipment, particularly your clothing. You want to make sure that you're protected adequately from all the elements. The most efficient cold-weather clothing is available through mountaineering shops or catalogs. Some of the equipment is expensive, but it can last a lifetime. Another key to staying warm is maintaining a high caloric intake, up to 5,000 calories a day.

Keeping your hands warm is essential. It isn't a good idea for bare skin to touch metal parts in freezing weather. To protect my fingers, I put three or four layers of black gaffer tape over all the areas of my "winter" cameras, lenses, and tripod that I touch or hold. You can also purchase commercial leg covers for your tripod. These "Tri-Pads" are made from standard foam pipe insulation, covered with a durable cloth material, and secured with Velcro. Wrapping a cushioned bicycle handlebar around the tripod legs also works.

I wear a pair of lightweight, capilene glove liners. I can feel the camera controls through them, and they protect my hands against the numbing cold. Over the liners I wear protective outer mittens. When I want to shoot, I take off the outer shells and stuff them into a pocket. You can also use a safety pin to attach an "idiot cord" from your mittens to your sleeve, so you can drop them at any critical moment without losing them. But be careful not to include the ends of the mittens or the cuffs of your jacket in your shots.

WHITEWATER RAFTING ON THE ZAMBEZI RIVER IN AFRICA

Rafting on the Zambezi River is one of the world's greatest whitewater adventures. From the base of Musi-O-Tunga, the local name for Victoria Falls that means "the smoke that thunders," the Zambezi River careens down a narrow corridor of black volcanic rock between Zambia and Zimbabwe. I joined a commercial trip down the Zambezi. We put into the river in three rafts at the Boiling Pot directly beneath Victoria Falls (the spot where Dr. David Livingstone abandoned his exploration in 1885). We had 60 miles of challenging whitewater before we hit the flat water of Lake Kariba. The Zambezi has 38 named or numbered rapids, and boasts 10 of the world's biggest rapids. I sat in the back of the middle raft because this was the best vantage point for photographing the front of the boat when it hit the rapids and was flung sharply upward. I was also positioned to shoot the raft in front of or behind mine.

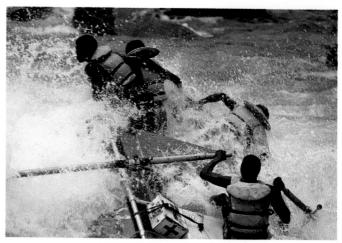

I made this shot of the first boat as it plunged into the Ghost Rider rapid with my Nikon N8008, an 80-200mm zoom lens, and Kodachrome 64. Standing on a platform at the back of the second boat, I exposed at f/4 for 1/500 sec.

For photographing in the whitewater, I had a Nikonos V with a 35mm lens mounted on it around my neck, across my chest, and under my arm with a neoprene strap. The rest of my camera gear was in a Tundra #613 waterproof case, which measures $13\frac{1}{2} \times 9$ inches, and was attached to the raft but accessible. The case held a Nikon N8008 camera, an 80-200mm AF $f/2.8$ zoom lens, a 50mm macro lens, a 24mm $f/2.8$ lens, a 20mm $f/2.8$ lens, and an SB-24 flash. I opted to travel compactly. I was able to untie the case quickly whenever I left the boat. It was light and small enough to clip with a carabiner, a piece of rock-climbing gear that acts like a large safety pin, to a strap on my life jacket. This was awkward, but left my hands free at critical moments. My tripod, extra film, and backup equipment was in a waterproof rubber bag made expressly for river rafting. But this gear was available only when we unloaded the boats at the end of the day.

On the first day we had a nonstop series of huge rapids to run. As we approached the first rapid, I grabbed onto the boat line with my left hand and clutched my Nikonos in my right, eye to the viewfinder. We plunged into the current, and a wall of water blasted the raft. The raft pitched to the left and right as we were battered again by curtains of water. Dazed, swamped, but intact, we slid into the calm water. I'd been able to shoot a few frames during the turbulence, but it was harder than I thought to keep a firm stance and secure grip. Pools of calm water separated the dizzying succession of rapids, but the current was swift and we barely had time to bail out the boats before we were attacked by another set of rapids. I didn't even

have time to open up my camera case and shoot the other rafts with my regular camera and long lens, so I concentrated on capturing the commotion in my raft.

As we entered the seventh rapid I was able to see the lip of a massive wave directly in front of us. I had my camera cocked and was as steady as a two-legged, one-armed tripod could be. Just as I was making the shot, I felt myself submerged in a cascade of water. I was ripped from my handhold and as I lurched for another grip, I knew I was being catapulted out of the boat. I was immediately sucked down into the frothy, turbulent water. I tried to get a shot on one of my brief excursions to the surface, but it was too tumultuous. Finally I was spat out, and a boatman threw me a line and dragged me into his boat. I didn't lose my camera, but from that moment I clipped the strap to my life jacket with a carabiner.

SHIFTING POSITIONS

The next day we continued our adventure through impressive rapids. I changed my position in the raft so that I'd be able to photograph from the bow of the boat and concentrate my attention on the expressions of our boatman, Vinnie. I wedged myself down low, bracing against the tubes and the other rafters, and shot up toward Vinnie. Then we plunged into the rapids, and the river jumped over my head into Vinnie's face.

Shooting from a raft gives you the chance to capture an intimate and dramatic photograph. However, you're shooting under volatile conditions, so you risk being washed overboard if you don't have a firm stance. Inevitably since you're pitched unpredictably and unexpectedly around the raft, you often miss the decisive moment. Shooting a rapid from the banks of the river, on the other hand, means that you can previsualize

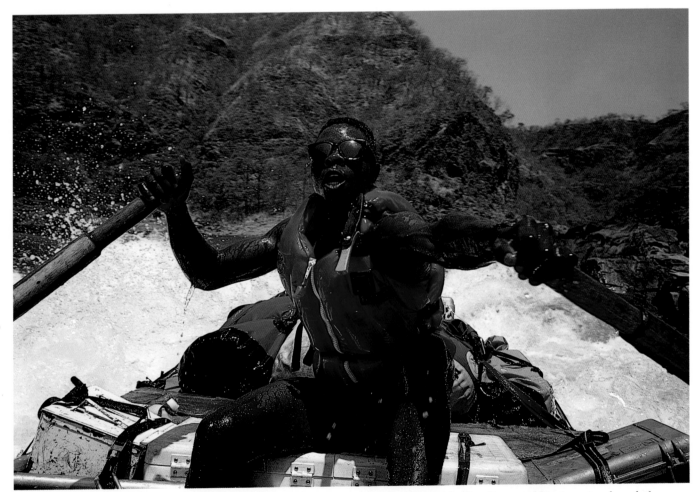

I often knelt in the bow of the raft and shot up toward the oarsman as we negotiated the rapids. Here, I captured him in action through the "Let's Make a Deal" rapid with my Nikonos V and a 35mm lens. The exposure was 1/250 sec. at f/5.6 on Kodachrome 64.

the shot. And by not being limited to a waterproof camera, you also have a bigger selection of lenses to choose from as well as the ability to use a motor drive to catch quick movement. Each perspective has advantages and disadvantages; try both.

Since I was with an amenable crew, I spent some time hanging off the back end of my raft and photographing the raft following very close behind. If the Zambezi River didn't have hippopotamuses and crocodiles, I also would've jumped into the river to photograph for a water-level viewpoint. I experimented with various positions within the boat trying to find intriguing camera angles, such as sitting directly behind the oarsman and shooting with a 20mm or 24mm lens to capture a portion of his movements with the crew and the rapids in the background.

By the last day the river was wide, cutting through the flat, arid countryside, as it does above Victoria Falls. We languidly, and cautiously, floated around the hippos and crocodiles until we reached the exit point at the near-still waters of Lake Kariba.

EXPOSING FOR ACTION

Exposure is the Achilles heel of sport photography. The subject moves fast and is usually in the frame for only a microsecond. You may have time for only one shot and no time to bracket. And you can never be absolutely sure if the meter's electronic circuitry will be fast enough to see the subject. In addition if the subject is wearing white or black, your meter reading will be way off.

The feeling and rendition of whitewater movement vary greatly with the exposure interval. For example, a shutter speed of 1/500 sec. freezes a breaking wave so that you can clearly see what's happening but you are more likely to sense the dynamics of water against rock when you shoot the same wave with a shutter speed of 1/2 sec. And there are times when a 6-sec. exposure may best express the movement of water.

Sometimes the exposure is simple and straightforward, and other times it can be extremely complex. Your eyes and brain have the uncanny ability to adjust to almost all lighting variations. You don't look at the world as if it's underexposed or overexposed; you can handle a 15-to-20-stop range perfectly, from snow white to coal black, while your camera can handle only a 5-stop range.

Like snow, the highly reflective quality of water or bright sand can cause your in-camera meter to give you an underexposed reading. To correct this, use an incident-light meter or take a reading off a middle-tone subject, such as your hand or gray camera case. If you're metering off the water, open up one to two stops. You can also apply the "sunny 16 rule" to the film you're using (see page 105).

CHOOSING WATERPROOF EQUIPMENT

Nikonos cameras have been the choice of professionals specializing in underwater photography for years. One of the most recent incarnations, the rugged Nikonos V, is especially practical. It has through-the-lens (TTL) metering for both ambient light and high-power strobes. You can select from six lenses, ranging from 15mm to 80mm. Each lens requires a matched optical or open-framed sportsfinder. The extension tube offers magnification up to life-size, thereby allowing photographers to focus on even the smallest marine life or micro images. The Nikonos V also has aperture-priority automation, which comes in handy when there is no time for fully manual exposure control. You might also want to take a look at Nikon's newest model, the Nikonos RS camera. It offers reflex viewing without the need for bulky housings, as well as autofocus capabilities, TTL flash, and matrix metering. The Nikonos RS can be used to depths of 300 feet and is the first camera to have a 20-35mm $f/2.8$ zoom lens. Another choice is the Sea and Sea Motor Marine II. This camera provides TTL flash control, automatic film advance, power rewind, and a wide variety of accessories, and has the added advantage of enabling photographers to change lenses underwater.

A less-expensive option is to buy a flexible housing from Ewa Marine. These high-strength bags are available for virtually any lens-and-camera combination, from 35mm compact and SLR cameras to medium-format cameras and camcorders. The housings are tested to 100 feet, feature optical glass ports for lenses, and allow for unrestricted autofocus operation. Some are designed with built-in gloves, making it easy to manipulate camera controls. An adapter is available to accommodate most lens types and sizes.

These are only a few of the numerous options available. Many manufacturers are beginning to produce smaller waterproof and water-resistant cameras. (For up-to-date information, contact your local camera store.)

Don't panic if a few unexpected drops of spray or flying sand hit your non-waterproof camera; the chance of this causing serious damage is practically nonexistent. But be sure to dry off your camera as soon as possible. If you don't immediately attend to your camera equipment, it could get ruined. And if there is any chance that water has entered the interior of the camera body, remove the batteries at once, dry them, and clean them with a pencil eraser. Rubbing the contacts lightly with an eraser or cotton removes corrosion. Once you are in a sheltered area, remove the lens and the film and thoroughly check for water. Dab away any you find, and pack the camera in a plastic bag with a few packets of fresh desiccant

overnight. If salt water has entered the camera or strobe, flush it with fresh water to remove any salt or battery acid.

Trying to air-dry or blow-dry a camera is controversial because it can help internal rust and corrosion begin. However, in situations where keeping a camera sealed or frozen isn't practical or possible or getting to a repair shop isn't an option (such as on Lake Titicaca), this technique can be quite effective. If you need to use a blow-dryer, select a medium or low setting and thoroughly dry the camera or strobe. A high-heat setting can damage rubber or plastic parts. Then open the equipment and allow the warm, dry air from the dryer to get inside. You can make a simple drying oven by placing the camera or strobe inside a plastic bag. Tape the nozzle of the blow-dryer to the inside of the bag, and make a small hole at the other end of the bag so that the air can escape. By following these steps after a camera or

strobe is flooded, you'll probably be able to use it until you can take it to a repair shop.

When a non-waterproof camera gets a good soaking, it usually stops working immediately. But even in this dire situation there is still hope. Take out the battery and film, seal the camera in a plastic bag to prevent evaporation, and take or send the sealed camera to a competent repairperson immediately. If you can't get to a camera repair shop soon, freeze the camera to retard rust formation. Sometimes the cost of repairing the camera is more than the cost of the camera itself, but if it is a valuable camera it is usually worth fixing.

Sand can do nearly as much damage as water; it just takes a little longer. Use a soft brush to gently remove sand from the camera and lens exteriors, and a blower brush to carefully clean the camera interior. Take great care when cleaning lens surfaces. Begin by removing any dust or grit with a few puffs

A colossal wave blasted the raft as it entered the fifth rapid on the Zambezi River. Sitting behind the oarsman to capture the impact of the mammoth hydraulic, I used my Nikonos V, a 35mm lens, and Kodachrome 64; I exposed for 1/30 sec. at f/11.

At Moemba Falls we carried all our gear and the rafts around a large waterfall, and then lowered them from a rock cliff into calm water. I climbed around the cliffs to a pinnacle across from the cliff and photographed the scene with my Nikon N8008 and a 35-70mm zoom lens. The exposure was 1/125 sec. at f/5.6 on Kodachrome 64.

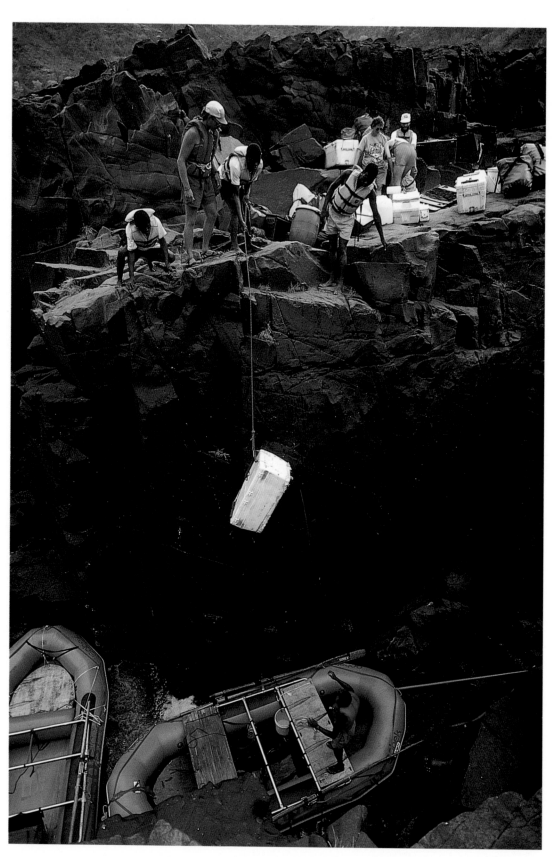

from a second blower brush, then brush the lens surface gently to remove any remaining material. If necessary clean any smudges with a lens tissue lightly wetted with a commercial lens-cleaning solution or blow gently on your lens to create a moisture film, then delicately wipe it with lens tissue.

Two of the best waterproof camera cases for whitewater rafting are made by Pelican and Tundra SeaKing, and are available in a number of sizes. Both cases are made of a lightweight, noncorrosive material; high-impact ABS polycarbonate resin; and injection-molded construction; both have an O-ring seal. They are waterproof, airtight, dustproof, dentproof, and shockproof. Some models are even equipped with a pressure purge valve that compensates for changes in temperature and altitude.

The Tundra SeaKing offers the option of replacing the top foam padding with the SeaKing Palette. This lid insert is actually a nylon-mesh storage device with loops and see-through pockets that hold film, lens-cleaning supplies, filters, batteries, lens hoods, and other sundry items.

Because the difference in interior temperature between a dark and a light case is significant, always purchase a reflective gray color instead of black. Despite this precaution, when the temperature soars on a river trip, I stow all my cases beneath a white towel that I've drenched in water. I bring along several towels specifically for this purpose.

An alternative means of transporting photography equipment is a large ice chest. An 80-quart cooler holds a lot of camera equipment, but be aware that it doesn't offer the same watertight security commercial waterproof cases do. This is only an alternative for a mild float trip with no possibility of the boat flipping over. Another option is to buy an Army-surplus metal ammo can and customize it with foam inserts. These were the standard before the Tundra and Pelican cases were available. In fact boatmen still use these cans for carrying various necessary items during the day. They can be rigged to the raft so that you have only to flip a latch to open them; however, they are heavier and have sharper edges than the newer cases.

You can also carry your cameras on a river trip in a padded camera bag or a convertible bag that doubles as a backpack. Wrap the backpack in a plastic bag, and clip it with a carabiner to the tied-down gear on board. On a mild river I cover my camera with zip-lock bags and keep it around my neck. Then when I see a potential photograph, I take off the bags, stuff them in my pocket, and shoot.

When you are on a river trip, make sure that you secure your camera at night. Dew can collect on a camera if it's left unprotected overnight. Use your camera bag or

water-resistant case; either can combat most moisture problems. You can also wrap your camera bag in a plastic bag. Use a desiccant to absorb potentially dangerous moisture in all your equipment bags.

In addition I always bring a tripod with me. Shooting doesn't end after the whitewater run of the day is over. You'll make some of your best shots—of camp, the river, sandstone walls, or campfire scenes—during the magic hours of twilight and dusk. But sometimes you'll find that it is tough to keep your tripod steady in the sand. Even when you've cranked it down into the sand until it seems steady, it often isn't. To help solve this problem, you can either weigh the tripod down with a bag of sand hanging from the middle of it or make "tripod sandshoes" from pieces of cardboard, plastic lids, or books. These keep the tripod afloat and steady.

It is important to guard your film, as well as your cameras, against heat. Keep your film in a small waterproof case inside a cooler to protect it from dampness. If this isn't possible, do what I often do: I stuff my film into a stuff sack and place it inside the center of my sleeping bag. Every evening I remove exposed film from my daytime camera case and replace it with fresh film for the next day.

In addition to the regular tool kit you should carry the following on a river trip: a dry towel, plastic bags, an O-ring removal tool (a bobbypin works well), silicone grease (to lubricate O-rings), and spare O-rings.

SEA KAYAKING ON THE BAY OF ISLANDS IN NEW ZEALAND

A friend, Shelly, and I unloaded our kayaks at Whangaroa Harbor, north of the Bay of Islands, New Zealand, during a downpour and gale-force winds. We couldn't help glancing at each other and wondering, "What are we doing?!" The waves were smashing furiously on the basalt cliffs of the sheltered bay, and I dreaded to think about what was happening on the open seas. Nevertheless we stuffed our kayaks with sausage-shaped bags of clothes, food, sleeping gear, tents, diving gear, stoves, fuel, and other essential items. Next I tied my waterproof camera boxes tightly on top of the front and rear decks of the kayak. A Nikonos V hung around my neck, tucked into the pocket of the kayak's spray skirt.

We shrugged and shoved our boats into the mayhem, committing ourselves to a 10-day excursion south along the coast. As my muscles struggled with the paddle against the wind and waves, I noticed that I never remember to work out

enough before a trip. After a grueling two-hour paddle Shelly and I arrived at a Park Service hut. Malcolm, a calm, competent fellow and our local guide for the trip, underscored that July brings the worst weather to the Bay of Islands. For most of the year the seas are tranquil, with clear waters and good diving possibilities. The Bay of Islands is reputed to have some of the most superb sea kayaking in the world, from its mangrove swamps to rocky islands, calm bays, and river estuaries, to open water and coastal surf beaches. However, it was difficult to picture halcyon days as the waves crashed and frothed at the rock cliffs outside our door. Unfortunately, I happened to arrive right in the middle of an uncommon series of severe storms. But that didn't matter. I was committed and willing to confront whatever came my way.

The rain abated in the morning, and Shelly and I set out for a day foray in the kayaks. The wind was having the party of its life, blowing up to 50 knots and creating 10-foot-high swells. It was impossible to kayak and shoot at the same time. I didn't want to take my hands off the paddle, fearing it would immediately blow away or flail out and knock me off balance. I also had to keep a forward momentum against the wind, so that I wouldn't be blown backward. We inched our way around the cove, straining against the wind. I was very concerned that the wind was going to torment us for the next eight days. Despondent, I visualized returning to America having shot just one roll of film. Fortunately the next couple of days were a bit calmer: the swells were only 3 to 8 feet high. I was becoming stronger and more confident; nevertheless, it was still a challenge to photograph while maintaining my equilibrium in the surges and swells.

On the front of the boat, tied to the deck, was a small Tundra case rigged so that I could open the box easily. Inside I kept a Nikon N8008 with several lenses, a 20mm, a 24mm, a 35-70mm, and a 180mm. I had a Nikonos V with a 35mm lens around my neck. Tied to the back of the kayak was a larger Pelican case with a Nikon F3 and motor drive, an SB-24 flash, a 50mm macro lens, an 85mm $f/1.4$ lens, a 300mm $f/4$ lens, and assorted filters. Inside a waterproof bag stuffed in the boat I had a tripod, a repair kit, more filters, spare items, and the bulk of my film. I also had a small waterproof diving box with film that I kept available during the day. Coupled with all the camping gear, this equipment made my kayak weighty but fairly stable.

The breaking waves made it difficult to undo the front box, and I was afraid of water flooding it. So I often had to ask Shelly or Malcolm to stabilize my boat in order to change film

I had two waterproof camera cases tied to the top of the kayak. The front one was accessible while I paddled, so I kept gear that I used while on land in the back one. I made this shot with my Nikon N8008, a 20mm lens, and Kodachrome 64, and exposed for 1/60 sec. at f/8.

or shoot with both hands. Primarily I used my Nikonos V. I felt as if I were shooting from a bucking bronco, hanging on to the paddle with one hand and the camera with the other. Still I had better balance and more nerve than I did on my first day of kayaking, and I was desperate to get some photographs. I prayed that a wave wouldn't knock me over; a rescue in that water would've been a nightmare. I draped a towel from my visor so that I could easily wipe the spray off the lens.

The hardest part wasn't taking pictures, but advancing the film. I had to press the camera against my chest, maneuver my fingers to rewind the film, check my distance dial, and then prepare to shoot. The weather was partly cloudy, which made it impossible to have a consistent light reading. Since I didn't always have time to take a light reading with every shot, occasionally I changed the setting to automatic (something I rarely do) to give me an aperture-priority setting. Because I had to preset the focusing distance on my Nikonos, I used Kodachrome 200 film to obtain as much depth of field as possible with a shutter speed of 1/500 sec. Later when I edited the film, I was amazed to see that most of my horizons were straight and my exposures acceptable.

The Nikonos is really best for conditions when you can use both hands to manipulate the controls. One-handed photography was quite difficult. It was virtually impossible to change film and lenses in the conditions I faced. I wish that I'd brought two Nikonos cameras with me, so I could've had one with a wide-angle lens and the other with an 80mm lens.

On our last day Shelly, Malcolm, and I kayaked back from Deep Water Cove to Waipiro Bay. The waves were savagely flogging the rock walls as we paddled our way across the open, unprotected waters. The troughs were irregular and ugly, often breaking on top of the kayak and spitting into my face. My camera cases made the boat top-heavy and a better target for the battering waves. Sometimes I'd look over and see my companions 5 feet or more above or below me on a large gray swell. I had to concentrate on keeping my balance and staying relaxed. We had to keep moving; the wind was against us, and the current was coaxing us out to sea. It was a grueling, tense paddle, and yet an exhilarating experience in terms of all the great personal challenges we faced. The three of us paddled into the harbor exhausted and relieved. This trip was splendid—and worth every aching muscle.

ACTING LIKE A HUMAN GYROSCOPE

Working from a kayak, or any other boat, requires that you, the photographer–kayaker, act like a gyroscope in order to absorb the movements inherent to kayaking. The trick is to isolate the camera and lens from the boat. One technique is to use a "tele-stock" to hold the telephoto lens and maintain the position as the boat shifts around you. Most of the time you'll find yourself trying to keep your upper body steady while your hips and legs absorb the motion of the kayak. When shooting from the kayak in shallow areas, I run the boat up onto the sand and rest my elbows on the stabilized edge of the boat. Using an Ewa Marina bag while kayaking is difficult. It is hard to move your hands in and out of the waterproof bag to operate the camera. However, this is more manageable when you use a motor drive and an AF lens.

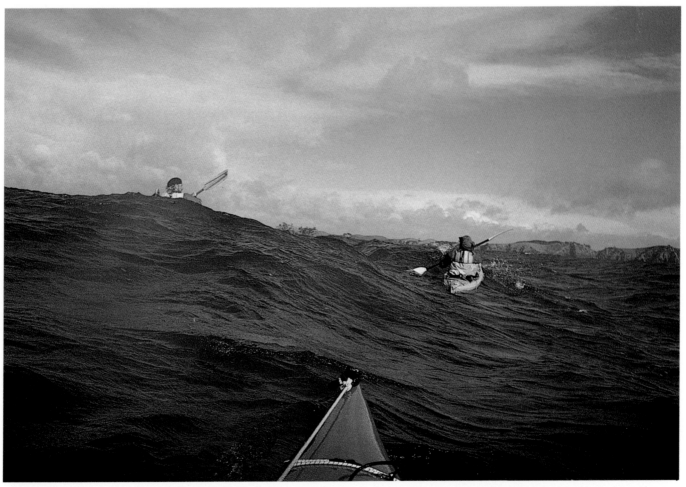

It wasn't easy to shoot from the kayak and negotiate the large ocean swells at the same time. However, I managed to shoot a number of images as we crossed a particularly turbulent stretch. Working with my Nikonos V and a 35mm lens, I exposed at f/5.6 for 1/250 sec. on Kodachrome 200.

SHOOTING FROM THE HIP

Perspectives change quickly when you're continually moving. In some situations you have very little time to previsualize images, and you have to shoot literally from the hip. This is when I switch the camera to autofocus and shoot. I also take a lot of "insurance shots" when working this way. For an unusual perspective, try taking a swim with your camera among the kayakers. Be careful not to get speared by the bow of a kayak if you're using a wide-angle lens. And make sure that you wear a diving mask and a snorkel so you can breathe.

There was only one evening during the sea-kayaking trip that the winds and seas abated. I was able to stop during a magnificent sunset and choreograph my kayakers. Sea kayaks don't turn as fast as river kayaks, so it takes more time to get into a good shooting position. Carefully observe what you want to include in the shot and get into position. Direct the kayakers clearly. Look through the viewfinder with both eyes, so you can track them as they come into the frame. You don't, of course, want to miss the perfect moment.

Don't forget to focus on the activities outside of kayaking. Take advantage of photographing from different vantage points, such as hills, promontories, and ledges. One benefit of bad weather is the quality of light. I had fabulous sunsets, sunrises, and rainbows to shoot on every day of this trip.

PROTECTING YOUR EQUIPMENT AT SEA

Always use a skylight filter, a lens hood, and an eyecup when shooting out on open water. The lens hood cuts the flare, and the filter slightly warms the cold light of stormy scenes. The eyecup reduces ambient light in the viewfinder, thereby giving you a better view and ensuring an exposure that isn't confused by stray light. Eyecups also help protect your camera by blocking drips, spray, and blowing sand. I have neoprene straps on all my cameras. They are durable, absorb the camera weight, and are perfect for humid and wet environments.

A common problem I face regularly when photographing on salt water is spray on my camera and lenses, which can be almost as bad as dropping the camera into the ocean. Salt, moisture, and salty air can create rust or oxidation, which in turn causes photo equipment to age rapidly. You can prevent this after your shooting is completed by taking a soft cloth with a small amount of WD-40 oil sprayed on it and gently wiping the camera and lens barrel. Make sure, however, not to get any of the WD-40 on the glass lens or eyepiece. This process leaves a protective film on the camera. Then wipe the camera with a soft, dry cloth to remove any excess WD-40 and any salt loosened during the process.

If I'm going out for an extended period of time, I always take extra O-rings for the waterproof cases with me. I take special care to keep the case closures clean. When I get home I wash out all the cases in clean water, dry them well, check them in the bathtub to see if there are any leaks, and dry them again. When a case isn't in use, I remove its O-rings and let them swell back to their original size.

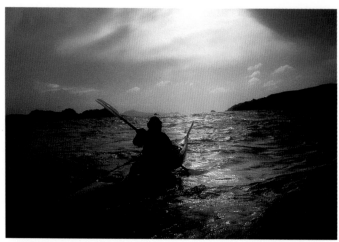

The weather was very stormy during our kayaking expedition. Not only was I contending with maneuvering the kayak, but also with shooting in unsettled conditions. While I made this photograph, we were in a bay sheltered from the waves, but the winds were gusting up to 50 knots. In between the powerful gusts, I managed to photograph Shelly with my Nikonos V and a 35mm lens, exposing Kodachrome 200 for 1/250 sec. at f/5.6.

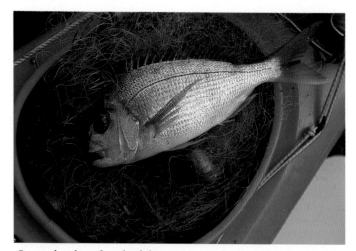

On one beach we found a fishing net snagged on a group of rocks and pulled it loose. Then we stuffed the net into a hatch of a kayak, and I arranged this red snapper on top for this closeup. Shooting with my Nikon N8008 and a 50mm macro lens, I exposed Kodachrome 64 for 1/125 sec. at f/8.

In New Zealand I had the good fortune to travel with an interesting and knowledgeable native. He had a wonderful face, but was very shy and reluctant to have his photograph taken. It was only after we'd spent a number of days together and established a rapport that he felt comfortable enough to look directly into the camera. I exposed for 1/60 sec. at f/11 and used my Nikon N8008, a 35-105mm zoom lens, and Kodachrome 64.

WHILE YOU TRAVEL

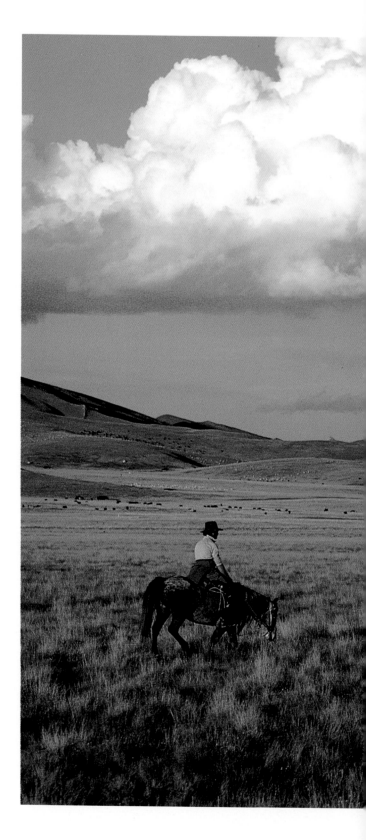

Today you can travel in many ways. Part of the adventure in remote travel is using a mode of transportation that the locals themselves use or is appropriate to the terrain, such as trekking in Nepal, horseback riding in Mongolia, and bicycling in China.

In order to find out about local methods of transportation, you need to thoroughly research the area you're thinking about going to. Read historic and recent travel accounts, look at guidebooks, talk to people who've been in that region—anything that will give you a feel for the area, its people, and its ways. If you've never been to the country before, don't expect to be able to waltz in and make local arrangements in a day or two without backup from a government liaison office or travel company unless, like Nepal, Kenya, or Thailand, the country is accustomed to tourists. Even then, if you want to travel in unfrequented regions, it takes time and experience to navigate the local bureaucracies and regulations. If this kind of travel is new to you, go with a reputable adventure-travel outfitter.

This isn't a definitive guide to all of the different modes of adventure-travel transportation, which might mean skiing or riding pony carts or motorcycles. However, with a little imagination you can apply my traveling suggestions to almost any method of travel.

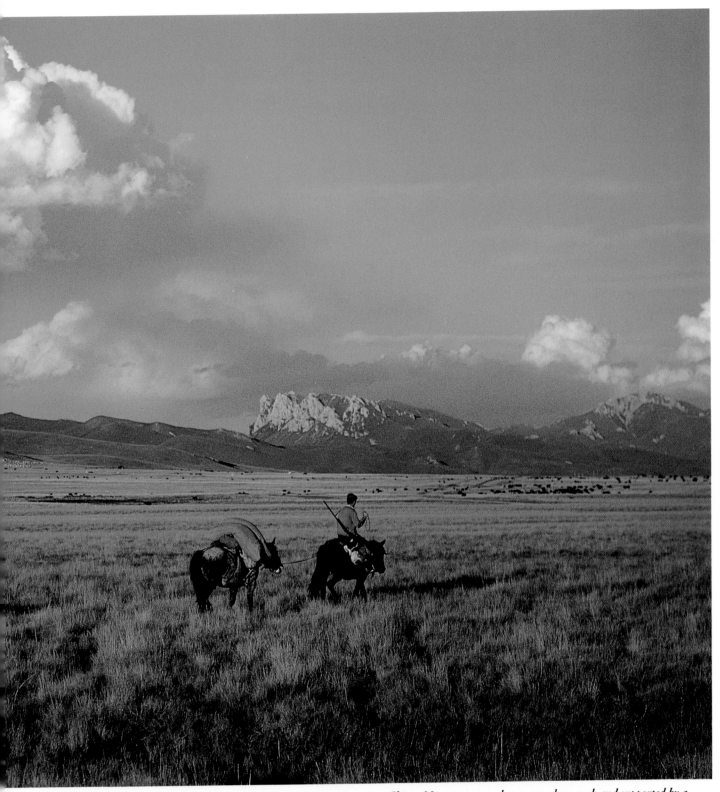

I made this photograph while riding in the grasslands of Sichuan Province, China. My camera was slung around my neck and supported by a Velcro strap around my waist. I prefocused my Nikon F3 and waited until my companions were ahead of me and under the white cloud. Then I quickly took this shot using an 85mm lens and Kodachrome 64, and exposing for 1/250 sec. at f/5.6.

USING PACK ANIMALS

When you're planning an extended journey, it is difficult if not impossible to carry all your gear and food on your back. If you're bringing a large quantity of camera equipment, it certainly helps to have the assistance of an animal or two. I've been on legions of trips with pack animals in China, Tajikistan, and Nepal. Animals add a different dimension and flavor to your trip. They can also restrict where you can travel. For example, horses, mules, yaks, and camels are impressively sure-footed, but they can't go over ice falls or rocky cliffs. And you have to worry about not only your own welfare and meals, but also those of your animals and handlers.

On one trip to the Pamir Mountain range of western China, four companions and I used a medley of horses, mules, and camels to carry our packs and duffels. The Kirghiz look scornfully upon you if you travel on foot and carry your gear on your back. We journeyed from one Kirghiz village to another, negotiating for animals for the next day's journey in each settlement.

The Kirghiz who live in the Pamirs may be far removed from cities, but they are extremely savvy bargainers and traders. My friends and I were continually renegotiating the rental cost of our pack animals. The locals had the advantage—they had the animals and we were strangers—and they knew it. We bargained fiercely, sometimes for hours. We'd come to a friendly agreement, pay for seven mules and two men for two days, or whatever, and then the next day they'd show up with only five mules. "Well, you may have paid for seven mules, but if five can carry the load, so what?" they'd shrug. Their logic was hard to

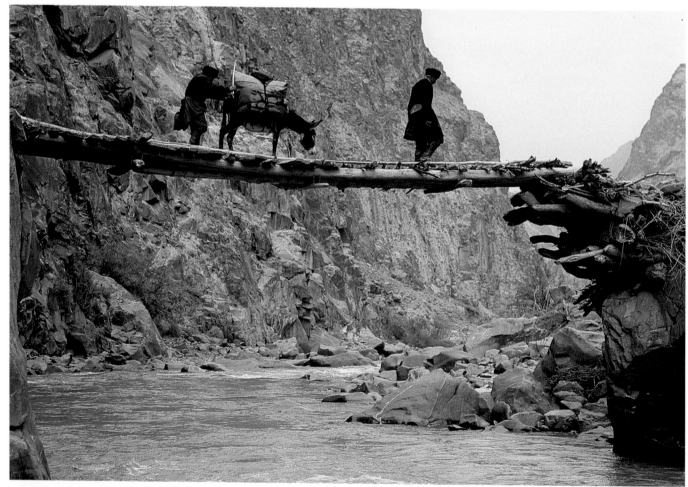

While traveling through one of the canyons, we had several bridges to cross. The mules were far from enthusiastic and had to be prodded and cajoled across the shaky wooden trestles. I positioned myself upstream and below the bridge in order to combine the mules with a sense of place. With my Nikon F3 and a 35mm lens, I exposed at f/5.6 for 1/250 sec. on Kodachrome 64.

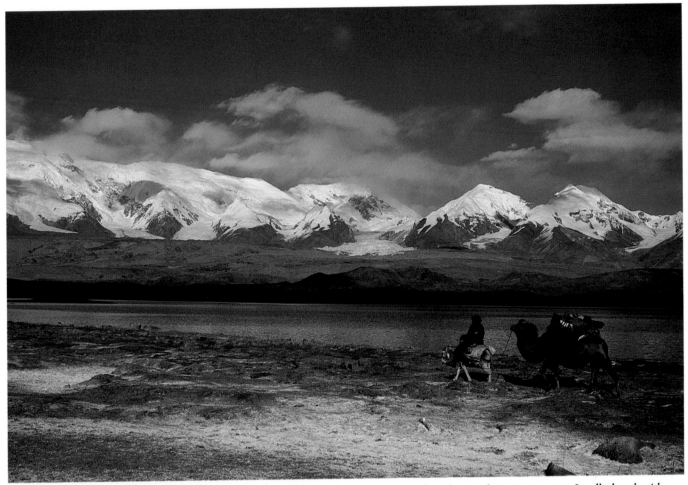

On the first leg of our journey in the Pamir Mountains in China, we hired a Kirghiz guide and a camel to carry our gear. I walked to the side so I could photograph our entourage with the mountains as a backdrop. I used my Nikon F3, a 35mm lens, a polarizer, and Kodachrome 64, and exposed for 1/125 sec. at f/5.6.

disagree with, especially when you don't know the language and you're using gestures, drawings in the sand, and a smattering of badly accented Kirghiz and Chinese words to communicate.

Loading the animals was a time-consuming morning ritual, taking at least one hour. We had put all our gear in soft backpacks and duffels. All of the bags had shoulder straps in case there was a rock fall or a river crossing where we'd have to haul the gear ourselves. We brought webbing and straps with us to tie up the loads and purchased extra cord in the Kashgar market.

I wore a camera vest laden with lenses and accessories and carried extra equipment in my daypack. I securely tied my tripod and my camera bag that held my spare camera bodies and miscellaneous items onto the most sure-footed pack animal in a place where they wouldn't be banged or get wet. Still I was taking a risk because an animal can decide instantly to sit down or roll over and flatten your camera bag.

This was a memorable month in the Pamirs. My friends and I negotiated narrow trails in steep canyons, river crossings, and mountain passes while traveling from village to village. Then winter began to set in, and we prodded our irascible mules back toward Kashgar.

TRAVELING ON HORSEBACK

Horseback riding across the vast Mongolian plains and with the Tibetan cowboys on the Songpan Grasslands are five-star memories. In Inner Mongolia I rode across the vast, pastoral plains past mud villages and yurts, which are Mongolian tents made of heavy felt wrapped around a collapsible wooden frame, with windmills powering the radios and television sets. Mongolians ride as if they were born on horses, standing

At a rest stop in Inner Mongolia, I noticed a young girl peering shyly at me from a doorway. I backed up, composed so the doorway was underneath a wooden frame, and made this shot. I especially like the saddle and the bucket on either side of the image. Here, I used my Nikon F3, a 35mm lens, and Kodachrome 64; I exposed for 1/60 sec. at f/8.

straight up in the stirrups, proud and laughing, with the wind battering their faces as they gallop ahead. Tibetans are more restrained, but are equally brilliant horsemen. There are very few vehicles on the eastern edge of the Tibetan plateau; horses, however, are everywhere. People gather around pool tables set outside on the dusty streets, and swarthy Tibetans in thick yak coats trimmed with fake leopard fur send pool balls slamming wildly across the old, warped tables. Their horses stand placidly beside them, reins tucked securely into the players' leather belts.

Photographing from a horse is a completely different experience than photographing on the ground. Not only do you have the obvious technical problems, such as camera motion and dealing with your camera's controls, but you also have to manage the spirit and will of your horse. An autofocus camera with a motor drive is indispensable for shooting from a horse. Unless you are an expert rider on a docile horse, it isn't wise to take your hands from the reins to focus and to advance the film. And since it is even more difficult to be continually changing lenses, zoom lenses are your best bet.

How to wear your camera so that it is accessible, protected, and comfortable is a dilemma. Having a camera hanging around your neck while riding is a miserable experience; for the duration of your ride, one hand has to grip the camera while the other holds the reins. For more comfort and security use either a Quick Shot, a nylon pouch with a quick release, or a CamJacket, a chest bag for one camera and mounted lens

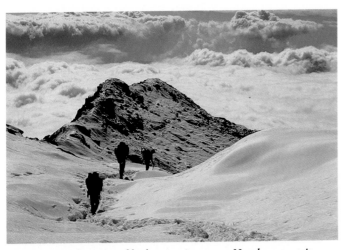

We experienced a series of bad storms in eastern Nepal on one trip to Makalu Peak. The snow was very deep on the trail. While crossing a high pass, I photographed three porters as they reached the crest of the ridge ahead of me. The three figures in the middle of a triangular hill and the monochromatic nature of the scene are what make this composition so strong. Shooting Kodachrome 64 with my Nikon F3 and a 180mm lens, I exposed for 1/250 sec. at f/4.

that is secured with a chest strap. You can also wrap your camera around the horn of your saddle when your horse is at a walk. I wear a photography vest for keeping film and filters available and strap my camera bag tightly onto the back of my horse, making sure any lenses inside are wrapped in chamois cloth or well padded and secure in the bag. Some photographers who frequently ride customize their saddlebags with padded pockets and pouches.

TREKKING WITH PORTERS

I've been going to Nepal every fall since 1978. The Himalayas have some of the most spectacular scenery found on earth, as well as some of the oldest living cultures. I've worked as a guide for various adventure-travel companies, and now I guide my own custom treks in the more remote regions of this remarkable kingdom.

Most of the trails in Nepal are too steep, narrow, and rugged for pack animals. For a great many people, trekking with porters who carry gear and cook is the best way to walk in the Himalayas. On nearly every trek, whether I am with a group or alone, I hire porters to carry the loads. These usually weigh around 65 pounds and are transported by means of a tumpline; this is a band that goes around the load and around the forehead. You only need to put the load in a duffel bag or a doko, which is a conical basket.

Much like having pack animals, having a porter to help you shoulder your load frees you to enjoy the Himalayas, which is the reason you came. You can take your time along the trail, photographing, talking, or pursuing whatever interests you. Traveling with local people also means that you have companions to photograph as you travel along the trail, and they introduce you to much that might otherwise pass by unnoticed.

Being a porter is a well-respected job in Nepal. Every time you hire a local, you're supplying him with much-needed income. If you have a guide, he'll take care of all the porter arrangements. If you're traveling with only porters, you are responsible for arranging everything yourself. Be sure to treat your porters well: check to see that they have the proper equipment and sufficient food for the undertaking.

When traveling in the Himalayas, I wear a photo vest on the trail, keep bulky lenses in my daypack, and put my extra gear in my duffel. I make sure that my gear is well protected with padding. By using a vest I make my lenses immediately available; I don't have to stop, take off a daypack, and dig inside for my lens of choice. I try to travel as light as possible since

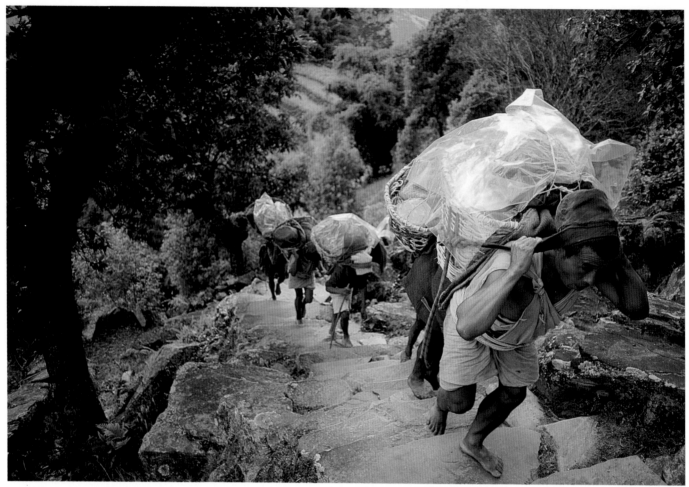

On a trail in the Annapurna region of Nepal, I stepped to the side, knelt down, and photographed the porters as they walked past me with their loads. For this shot, I used my Nikon F3 and a 24mm lens and exposed for 1/125 sec. at f/5.6 on Kodachrome 64.

I'm also carrying a heavy daypack. I bring zoom and wide-angle lenses with me; the longest lens I carry in my vest is an 80-200mm zoom lens. Usually I carry a small tripod with me in my daypack and a larger one in my duffel bag. If you're going to be seriously photographing, you can hire a porter to carry your photographic gear and stay close to you as you trek.

TRAVELING IN CANOES

Canoes come in different forms, including African mokoras and Malaysian dug-out canoes, and are found all over the world. Canoeing is fun and relatively easy to learn, and you can carry more gear in a canoe than in a kayak. I had my first experience on the lower section of the Zambezi River, a wide and easygoing river with an impressive parade of wildlife and birdlife.

Canoes are great to photograph from, especially if you have an amenable partner. My canoeing partner gingerly paddled me astride the carmine bee-eater nests and grazing buffaloes and elephants while I endlessly photographed. Needless to say, as you maneuver through the pockets of hippopotamuses and crocodiles, you need an experienced guide with you.

Because my waterproof case hadn't made it to Africa, I had to bring my regular camera bag on the trip. Inside I had two Nikon F3s, a Nikon N8008, and various lenses: a 300mm, an 80-200mm zoom, a 35-105mm zoom, a 24mm, and a 20mm. I selected the most experienced canoeist as my partner and prayed that we wouldn't capsize. I kept the camera bag in front of me on the canoe floor, on top of an upside-down cooking pot. A strong wind was lapping waves and tossing spray into the canoe and, unfortunately, my camera bag. So I put it into two garbage bags with the opening toward me in

order to protect it. I was still able to reach in and remove my camera easily. I had my tripod, extra filters, accessories, and film in a waterproof bag tied into the canoe. After the wind subsided the next day, I dispensed with the garbage bags but kept the camera bag on top of the pot in order to keep it out of any stray water on the canoe floor.

I took a tremendous risk with my gear, one that I hope never to repeat. But the point is that you often don't have the perfect gear for each trip. Be creative, make do with what is available, and try to minimize the hazards you expose your equipment to.

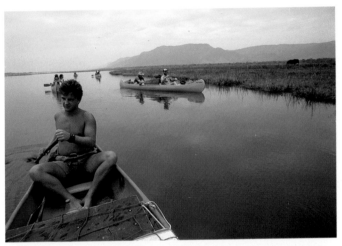

On the lower Zambezi River in Zimbabwe, I made this shot from the front of the canoe with a 20mm wide-angle lens on my Nikon F3. I wanted to include my boat, the other boats, and the elephant on the shore. The exposure was 1/125 sec. at f/8 on Kodachrome 64.

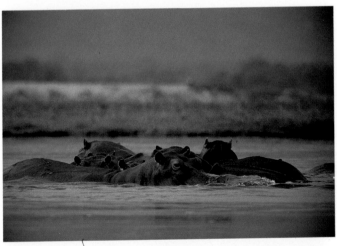

I always had my cameras ready while we were canoeing. At one point a group of hippopotamuses emerged next to us. I grabbed my Nikon N8008 already fitted with a 300mm telephoto lens and quickly made this shot. Here, I exposed for 1/500 sec. at f/2.8 on Fuji Velvia.

CARRYING YOUR OWN GEAR

Being completely independent by carrying your gear yourself in a backpack has positive and negative points. On the positive side you aren't restricted by the limitations of an animal, other people, or a vehicle. You can traverse difficult terrain, climb high-altitude peaks, and rappel down canyons. On the negative side you have to carry the backpack.

During one trip in the Pamirs the camel driver belatedly informed the group that the upcoming pass was too treacherous for the camels. So we unloaded them; gave away our extra flour and sugar; and pushed the tents, stoves, food, and too many other things into our packs. I strapped my 20-pound camera bag on top of my 50-pound pack and trudged up the trail, leaning like the Tower of Pisa. It wasn't any fun crossing an 18,000-foot glaciated pass with that load of gear. I cursed my heavy cameras and my stupidity for not anticipating such a situation. Luckily, on the other side of the pass we descended into a village and were able to continue on with mules.

Whenever you travel it is important to carry the minimal amount of equipment possible. Pare down to the essential items. Leave your heavy cameras at home, and bring the simplest and lightest one you own. I always wear my photo vest and keep any extra gear in a small fannypack that I put on top of my expedition backpack. I usually carry one camera body, a few essential lenses, film, flash, and a small tripod. You'll also probably want to get a chest strap; it prevents your camera from swinging when you climb trails and from bouncing against your chest on descents. I also recommend the Quick Shot, CamJacket, or Galen Rowell's new system from Photoflex. Another option is to place your camera inside your camera vest and cinch up the belt to your backpack, so it holds your camera firmly in place.

RIDING BICYCLES

Bicycles are the primary vehicles in China, and riding them is a grand way to tour the villages. On my first trip I brought my mountain bike over from the United States and joined a tour into the back roads of Sichuan Province. It isn't easy to bring a bicycle into China, but if you are persistent you can wind your way through the bureaucracy. On my second trip to the area, I led a guided tour and used the company's bikes.

I felt very cavalier and free, peddling down the roads, stopping when the mood struck me or when I saw potential photographs. The local people found my mountain bike

Paddling through Mana Pools National Park in Zimbabwe, we came upon spectacular wildlife. As we drifted past this elephant, I quickly framed its body and reflection and made this shot before we moved out of range. Shooting with my Nikon F3 and an 80-200mm zoom lens, I exposed for 1/500 sec. at f/4 on Fuji Velvia.

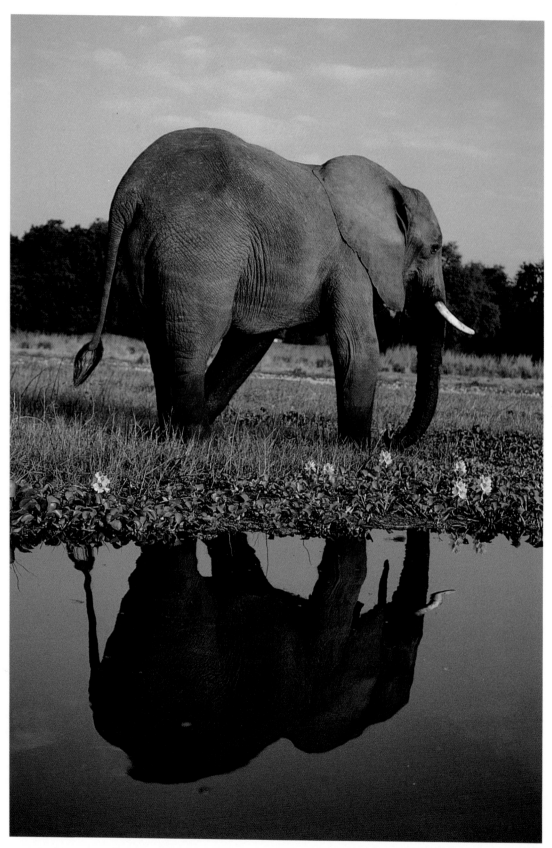

fascinating. It was much lighter, had more gears, and was brighter than their basic black models. Support vehicles accompanied me on the trip, which meant that I was able to bring extra equipment and plenty of film. If, however, you have to carry all your gear on your bike, you have to travel light.

I wore my indispensable photo vest and slung my camera over my head and around my shoulder. Some days I brought a fannypack and tied it into the basket on the front of my bicycle. You might want to consider custom-made paniers; these are small, rigid packs made of padded foam and nylon that attach to the front handlebars of your bicycle. Some bicycle companies make paniers that are designed specifically for photographers. But you have to be careful not to overload them or you'll have a difficult time steering your bicycle.

SHOOTING FROM THE AIR

If you want to photograph from the air in third-world countries, you must plan ahead. Getting the necessary government permission to do aerial photography can be a nightmare. It can sometimes take six months or longer to receive clearance to shoot aerials in a small country. And once you've got the papers there isn't any guarantee that you still won't be arrested on a technicality. Always expect the worst.

Around takeoff and landing you can shoot satisfactory aerial landscapes from a commercial passenger aircraft, provided that you avoid the vibration of the fuselage and reflections from the window. A rubber lens hood near or pressed up against the glass helps to eliminate both problems. You can also avoid vibration by not resting your arm or the camera on the aircraft body as well as by using a high shutter speed, 1/250 sec. or faster. Small planes are a better option, especially if the door is off or open. Don't—under any circumstances—lean out of the aircraft without a harness on. And be sure to attach the camera well to your body because the airflow may tear the camera from your hands.

If you shoot from a helicopter, you can usually open the windows to shoot. But pay attention when you compose so that you don't get the helicopter rotary blades in your wide-angle shots. One advantage to shooting from a helicopter is its ability to fly lower than an airplane and to land places where planes can't.

Because exposure meters often give misleading readings in aerial photography, you need to take a reading on the ground before takeoff and a second one in-flight. Split the difference to find the ideal setting. Depth of field isn't a problem because the whole scene is distant; just be sure to set the fastest shutter speed you can. And since the principal enemy of aerial photography is haze, shooting on a clear day is best. Take pictures as soon after dawn as possible; when you shoot later in the day, heat blurs the view. Photographs taken in the early morning have the additional advantage of long shadows that help delineate indistinct landscape features. Finally, be careful when you photograph animals that you don't fly so low that they become upset.

On one trip we rode down 5,000 feet from the top of Balan San Pass, which is 15,000 feet high. I waited at the top of the pass and photographed my companions peddling around the curves before I jumped on my bike to catch up. I exposed at f/5.6 for 1/250 sec. on Kodachrome 64 and used my Nikon F3 and an 85mm lens.

While riding in a helicopter over the Central Pamir Mountains in Tajikistan, I opened a window and shot with a 24mm wide-angle lens on my Nikon F4. I like this image because of the repeating curves of the glacier and the ominous weather. The exposure was 1/500 sec. at f/2.8 on Kodachrome 64.

PART 4

VISUAL INTUITION

During my travels I've observed photographers who arrive somewhere and expect "the-picture-taking-place" to be right in front of them. They have one preset image in their minds and believe that there is one and only one right spot to stand. It is better to search instead for whatever is meaningful to you and the image that expresses it. When your mind becomes set on one thing or one way of doing things and is relentlessly determined to pursue this course, you inhibit your intuition and miss much of the wonder of the world around you. Traveling fosters my intuitive response to the world. When I place myself outside of my normal context, I'm forced to become more aware of my surroundings and pay more attention to the sensory and visceral undercurrents.

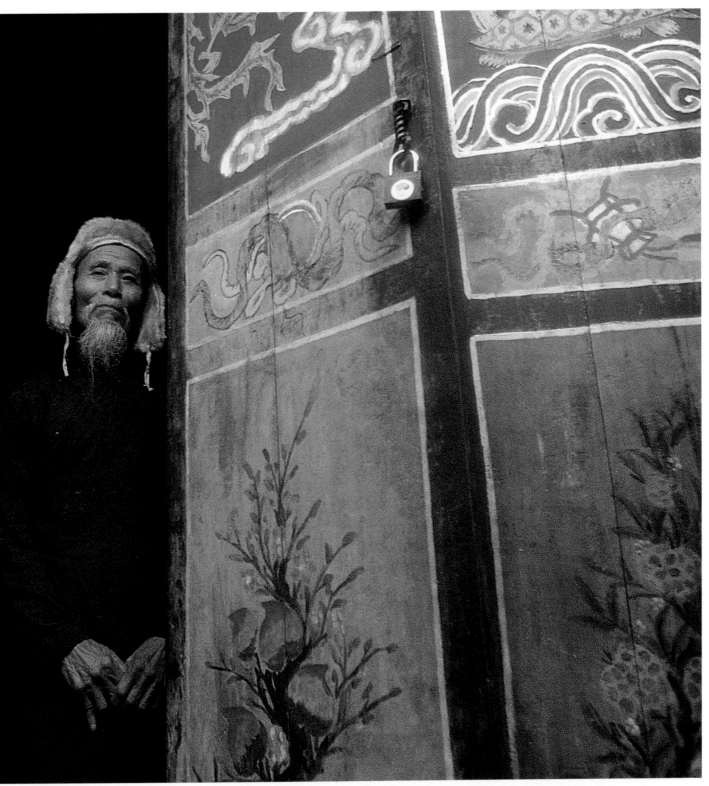

Along the Yen River outside Hanoi, Vietnam, I visited a small pagoda. After photographing one of the icons, I saw the pagoda keeper leaning against the door. I immediately knew that this was the image I was looking for. So I pulled out my Nikon F3 and a 20mm lens, knelt down, and gestured for him to lean farther into the doorway and to clasp his hands. I exposed for 1/30 sec. at f/5.6 on Kodachrome 64.

The word "intuition" means various things to different philosophers, psychologists, and artists, but the basic sense of the word is captured in the dictionary definition: "the act or faculty of knowing directly without the use of rational processes." You know something but don't know how you know it. You can no more force intuition than you can force

While standing on a bridge over the Bagmati River in Kathmandu, Nepal, during the Magh Purnima festival, I noticed that the river was crowded with people taking a ritual bath. Because there was quite a tangle of activity, I waited until I sensed a perfect combination of light, composition, and action before shooting this scene with my Nikon F3, an 85mm lens, and Kodachrome 64.

I made this photograph while visiting a Nepalese family I'd become very close with over the years. While sitting at the family hearth waiting for dinner, I was struck by the glowing firelight illuminating the young son's face. I replaced the Kodachrome 64 in my camera with Fuji P1600 and pushed it to ISO 800. The grainy aspect of the film precisely reflects the moodiness of the atmosphere. With my Nikon F3 and a 24mm lens, I exposed for 1/15 sec. at f/5.6.

someone to fall in love with you. You can prepare yourself for your intuition to manifest itself, invite it, and create attractive conditions to coax it, but you can't say, "Now I'll have intuition." Intuition can defy your expectations by suddenly veering off in a new direction, rearranging the material you've been working with, or bringing in something that seems entirely out of place.

If you work too hard at seeing, you never will. If you over-intellectualize a photograph and try to make images filled with information instead of emotion, you aren't getting to the soul of your vision. Intuition can't be ordered, commanded, implored, or contrived. You simply have to be ready for it.

Taking real photographs—photographs that mean something to you—doesn't come easily. This takes a tremendous amount of effort and even suffering when you feel that your effort hasn't given you what you wanted. You can't will yourself to be intuitive, but you can will yourself to be open to what comes your way.

INTEGRATING INTUITION AND TECHNIQUE

Photographing is a fine-tuned combination of thinking and feeling, and of intellect and intuition. The more technical information you have to integrate into your picture-taking, the more complex your decisions about photography become. At the same time the more technically competent you become, the easier it is to photograph with greater awareness. Of course, you need to know the technical aspects of photography in order to operate your camera and lens. But when it comes down making the actual photograph, that comes from your gut.

Sometimes expertise can actually work against intuition because it can make you overly dependent on a particular frame of reference or on a stylized, orthodox approach. You can try to "wow" yourself and others with tricks, filters, and unusual effects, relying completely on your knowledge of technique and equipment. But by doing this you lose your heart and soul, as well as inhibit the free working of your heart. Follow your inner voice; it is far more central to your photographs than technique is.

You can't leave yourself open only to luck and chance and the hope that you'll miraculously find a photograph. Shooting in a wild, crazy way without any discipline doesn't mean that you're being intuitive. If you don't have inner discipline and technical discipline, you might not be able to decipher what pleases you. Choice encourages you to define your own vision.

I spent a week living with the monks at the Gonga Shan monastery in Sichuan Province, China. While I was there a visiting Tibetan lama, Tu Den Shi Long Lama, beckoned me to come into the room where he was praying with the other monks. Although I didn't want to intrude, I sat down to listen to the chanting. Toward the end of the ceremony, he paused and looked at me; I knew then that taking his portrait was fine. For this shot, I used my Nikon F3, a 24mm lens, and Kodachrome 64, and exposed for 1/15 sec. at f/5.6.

If someone tells you what you should be photographing, you might make a photograph that looks pretty but it won't reflect you. However, if you go into a shooting situation where you have a choice, and no one dictates or inhibits your expression, you may find a new inspiration and a startling image.

LETTING YOUR INTUITION EMERGE

The most important thing anyone can do to develop intuition is to cultivate a higher state of awareness. Some photographers meditate or practice yoga to keep the mind fresh and open. I like long solo walks in the outdoors. Inner silence and heightened clarity are the hallmarks of a consciousness conducive to quality intuition and vision. Most artists and athletes spend a few moments preparing themselves before they perform. The orchestra tunes up, the tennis pro hits a few balls, and the painter fiddles with the paints. I usually take a few insignificant photographs. This ritual puts me in a clear and fresh frame of mind and disperses erratic and undisciplined energy.

People often work against intuition by taking themselves, their work, their dilemmas, and their problems too seriously. A certain playfulness and an appreciation of whimsy and

absurdity seem to favor intuition. The most creative and innovative people are those who revel in unsolved problems and play with their imaginations the way children play with toys. Curiosity is a lightening rod for intuition.

All photographers have experienced a run of mediocre photographs, and then, suddenly, "the one" appears. It is possible that you might not even recognize that you'd seen something profoundly moving until you edit your photographs and say, "Of course! How could I have not seen it?!" But eventually, you come to recognize "the one" when it emerges. It may not even be anything you can intellectualize; you just "know."

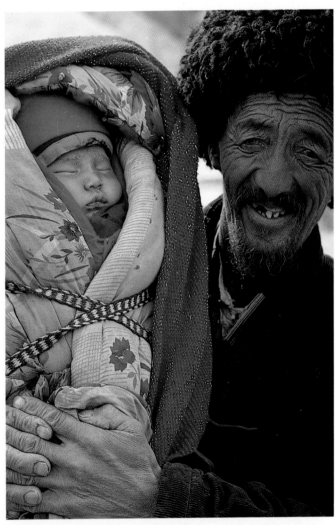

As I was walking through a Kirghiz village in the Pamir Mountains of northwestern China, I passed an old man holding his newborn grandchild. He stopped me and raised the baby, hoping that I'd take a picture. I knew this was a wonderfully poignant expression of young and old, so I quickly captured it on Kodachrome 64 using my Nikon F3 with a 50mm lens.

It is fine to have some preconceived ideas about what you're going to photograph, but don't let your plans blind you to other photographic possibilities. Never be afraid to reformulate or drop your original intentions. Keep your eyes and your mind open. Those who can free themselves of old mindsets, open themselves up to new information and surprise, play with perspective and context, and focus on process rather than outcome are likely to become the most creative and expressive photographers.

THE ESSENTIALS OF COMPOSITION

Most photographers are better at making sweeping statements in their photographs than paring down to the essentials of an image. This is usually because even when they focus on one particular object, design, or color, their eyes also see the environment surrounding it. For example, if you focus on an orange cup on a table, your mind concentrates on the cup while your eyes also see the desk it's sitting on, the room, and any objects surrounding the cup. So often when you take a picture, you include all that your eyes see even though your intent is to show only a detail of the whole; this clutters the photograph with unnecessary information and objects. Simplicity in design is critical to a strong photograph. What you omit from an image is as important as what you include in it.

Photographing a detail of an object or place can provide a sense of the bigger picture and can elicit subliminal responses to the subject's shape, form, or pattern. Colors also evoke latent emotional responses. While you travel it is important to key into essential details and color, to enhance not only the quality of your journey but also that of your photographs. You need to carefully observe and be aware of the wondrous designs, details, and colors found in the larger perspective of people and the landscape.

USING COLOR AND DETAIL EFFECTIVELY

Some photographers have a penchant for light, others for action, and a rare few for the quality of color. I try to have a balance of all three. However, color often becomes the motive and justification for a photograph. Everyone varies considerably when it comes to perceiving color. People filter out a scene and truly "see" only certain portions of it unless

they concentrate. The ability to see the quality of color and its different relationships is an art, as well as a skill that must honed through continual exercise.

Color relationships can make or break a great photograph. Placing warm colors next to cool colors or vice versa can make a dull subject come alive. Warm colors usually prevail over cold colors that are next to them in the same picture. Shades from yellow to red are associated with fire, the sun, and tanned skin, and brilliant scarlet subjects sometimes seem to leap from a picture. On the other hand, blue shades communicate cold, isolation, and silence; they are the colors of ice, cloudy skies, and night. Cold tones—blues and greens—also intensify the

At the Gorkanath temple in the Kathmandu Valley, Nepal, I admired the intricacy and craftsmanship of this ancient wood carving. I came in close with my Nikon F3 and a 180mm lens to isolate one piece as well as to emphasize the repetitive curves. The exposure was 1/250 sec. at f/5.6 on Kodachrome 64.

As we were heading back to camp in Botswana, Africa, I spied a zebra set aglow by the last remnant of light from the setting sun. I yelled to the driver to stop, quickly steadied my camera on a sandbag on top of the roof, and shot a number of frames, aware that the red would be enhanced by a slow shutter speed and Kodachrome 200. With my Nikon F3 and a 300mm lens, I exposed for 1/15 sec. at f/2.8. One of my companions was surprised that I was able to photograph in the late twilight and was doubtful that the images would be sharp, but I knew that because the sandbag was as sturdy as a tripod, the images would be fine.

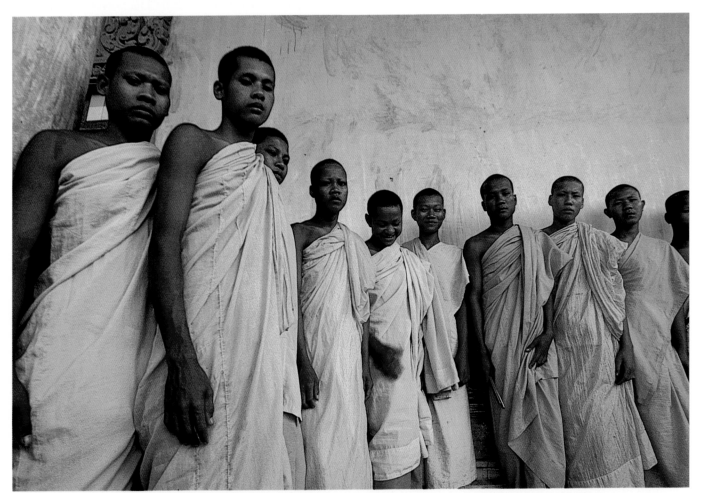

At the Soc Soai pagoda in Vietnam's Kien Giang Province, I was struck by the bold robes the young Buddhist monks wore. To emphasize the yellow robes, I placed the monks against a cool-blue wall, came in close with a 20mm wide-angle lens, and shot with my Nikon F4 from a low position. The exposure was 1/60 sec. at f/8 on Kodachrome 64.

On the only day I was at Hailong Bay in Vietnam the weather was miserable and rainy, and the light was even worse. I knew that all the photographs I was taking were terrible, as shown on the right. So as a last resort I decided to use Cokin colored filters to alter the light. I combined a sepia and an orange filter to mimic late-afternoon light for the shot below. Working with my Nikon F4 and a 35-70mm zoom lens, I exposed for 1/125 sec. at f/4.

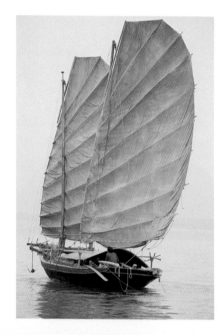

mystery and suspense of a scene, and cool-colored subjects appear to recede. When you want to suggest depth, you can use this effect to your advantage by composing pictures with warm hues in the foreground and cooler colors behind them. Including black in your images intensifies and isolates a color.

A hue is the tint of a color. Color saturation is a fairly relative, subjective quality that refers to how vivid a color is. Some films, such as Ektachrome, favor hues over saturation, but no film delivers color exactly as you see it. I achieve intense color largely either by underexposing transparency film to saturate the colors in the scene or by using a polarizing filter, also called a polarizer, that cuts glare in a landscape shot, thereby making colors richer and darker. I routinely rate Kodachrome 64 film at ISO 80 and process it normally; this automatically underexposes the film a bit. With Fujichrome and Fuji Velvia I don't change the film-speed rating, but I always bracket with a bias toward underexposure to saturate the colors in my photographs.

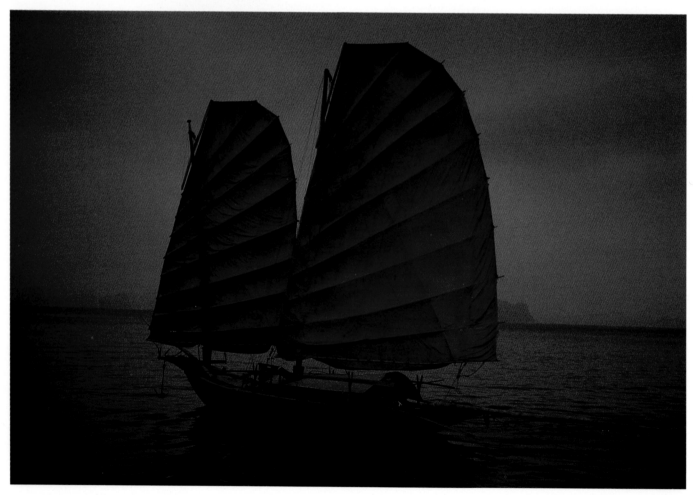

During an afternoon walk through the rice fields in Pejeng, Bali, a light rain was falling, diffusing the light and saturating the green of the surrounding fields. I found the deep color and the sinuous double curve of the hill enchanting. I photographed this scene with my Nikon F3 with a 35mm lens; the exposure was 1/60 sec. at f/8 on Kodachrome 64.

Manipulating exposure to produce saturated or pastel colors can bring a spirited mood to your images. You can also create a mood via the use of monochromatic color or even the absence of color. Capturing the colorful mood of landscapes means observing and understanding the cycles of nature, as well as the direction and color of the light. There is a great temptation to go looking only for images that incorporate nature's brightest colors yet subtle colors can weave as powerful a spell. Overcast weather provides subtle, more delicate colors than sunlight does, and some of the most beautiful hues appear just after the sun slips down below the horizon. By restricting the field of view, a telephoto lens makes it easier to crop out brightly colored details.

Scenes of a single color are also pleasing to the eye. Remote third-world villages tend to be monochromatic. Here, light combines with mud adobe buildings and the desert sand to make everything seem one color. I frequently photograph in countries where mud and stone are the predominant materials for houses, walls, and streets. The real challenge is to separate objects and enhance their color. I look for long shadows to create definitions and to put contrast into monochromatic situations. Like black-and-white images, monochromatic-color photographs express more about tone and texture than color ones do. Haze and mist restrict color and act like a pale-blue filter over a scene.

Some countries are meccas for photographers who prefer shooting color. The people of India, Nepal, Burma, and Africa, to name just a few, have a color style uncommon to that of Western countries. They boast color, parading every shade in the spectrum. Male birds may flaunt the colors in the aviary, but in the human realm rural women are inevitably the most brilliant. In regions where men now wear drab Western

When shooting at the Purple Palace in Hue, Vietnam, I noticed the reflection of the setting sun in one of the large bronze urns. Working with my Nikon F3 and a 50mm macro lens, I came in close to concentrate on the light and design and exposed for 1/125 sec. at f/8 on Kodachrome 64.

This is one of the hundreds of prayer flags surrounding a Buddhist shrine in Tibet. With a 50mm macro lens on my Nikon F3, I tightly framed to accentuate the patterns formed by the thin gauze and hand-stamped prayers. The exposure was 1/125 sec. at f/8 on Kodachrome 64.

While photographing a monk at a Buddhist temple in Damiao, Inner Mongolia, China, I became fascinated by this door. Using my Nikon F3 and a 35mm lens, I zeroed in on its ornate handles and symmetrical design. The exposure was 1/125 sec. at f/5.6 on Kodachrome 64.

trousers, women still don their traditional colorful attire. And each minority group has its own personal dress, colors, and design sense. Red seems to be the color of choice, but all the primary colors are on display. They're embroidered in skirts and jackets, stitched into hats and boots, and printed on cottons and silks.

Although I rarely use colored filters, they've saved me on a couple of occasions. For example, I've found that a sepia-colored filter or a blue filter improves dull-gray rainstorms. I've also used a weak-orange warming filter to enhance sunsets and a yellow filter for early-morning scenes.

While it is important and natural to photograph both large vistas and human events, it is just as important to look beyond the big scene at the details that are an integral part of it. Vast expanses, such as the Tibetan Plateau, are as interesting in detailed closeups as they are in wide-angle shots. By shooting details you can make your own personal statement.

Some of my favorite travel photographs are graphic-detail shots in which I drench the frame with as much color as possible. If I am in a market and see a woman wearing a red scarf next to a group of bright yellow flowers, I move in close and fill the frame from edge to edge with an explosion of color.

I was walking down a street in Hanoi, Vietnam, when my eyes were filled by the brilliant yellow and red of a display of funeral wreaths. I decided to come in close with my Nikon N8008 and a 50mm macro lens to fill the frame with only color and form. Here, I exposed Kodachrome 64 at f/8 for 1/125 sec.

The subjects of travel photographs shouldn't be limited to people and landscapes. I like to shoot interesting vignettes, such as elements of my hotel rooms. In Datong, China, I composed a photograph of the objects common to most of the hotel rooms in the area: a teacup, elaborate wallpaper, covered chairs, and fresh flowers. Here, I used my Nikon F3 with a 35mm lens and exposed for 1/15 sec. at f/8 on Kodachrome 64.

At Wat Phra Maha That in Ayuthaya, Thailand, I found this ancient stone carving of Buddha embedded in the roots of a Banyan tree. With my Nikon F4 and a 50mm macro lens, I focused tightly on the head and the tangled roots. The exposure was f/8 for 1/60 sec. on Kodachrome 64.

I've found that most people are reluctant to come in close with their cameras. However, sometimes the closer you move in, the easier it is to reduce an object to its intrinsic essence or form. You can even make it appear abstract. For example, if you're photographing a sunset and you include the shore and the sun, the resulting image is a beautiful rendition of a recognizable sunset. But if you use a telephoto lens and capture only the reflective colors on the water, you can transform the scene into a symbolic image of color and light. Mystery can be created by showing only a small fragment of a familiar subject. Less can often mean more.

When you begin creating abstract or symbolic images when you photograph other people or objects, you'll find that the act of seeing becomes more complex and interesting. Being able to see detail or abstract patterns in the subjects you're considering shooting broadens your approach to photography and expands your vision, and at the same time narrows your focus. Once you begin to recognize what holds your interest in a potential image, whether it is the necklace a woman is wearing, a rhythmic repetition in nature, or someone else's hands, then you'll begin to photograph not only what you see but also what you sense.

I was fascinated by the hair braids of the young Kirghiz girls in the Pamir Mountains in China. The braids were adorned with buttons, ribbon, silver, and beads. I asked one of the girls to turn around so I could photograph the braids up close. I particularly like how the hair seems to be moving in this photograph. I used my Nikon F3 and a 50mm macro lens, and exposed for 1/125 sec. at f/8 on Kodachrome 64.

While shooting a statue of Garuda in Kathmandu, Nepal, I moved in close on the meditative pose of the hands. I felt that an intimate photograph would be more compelling than one of the entire body. I especially liked the three repetitive curves around the neck, under the hands, and around the belly. Working with my Nikon F3 and a 50mm macro lens, I exposed at f/8 for 1/125 sec. on Kodachrome 64.

PHOTOGRAPHING PEOPLE IN THEIR ENVIRONMENT

Whenever you point your camera at someone, you have a precise reason for doing so whether it is conscious or unconscious. The crux is to understand this reason and translate it into your photograph. In order to do this, you must have a clear idea about what you want to say and to whom. You also need to decide on the appropriate technique and logical approach to produce the image.

There are many important elements in composing a good photograph of a person, such as the light source, composition, color details, and expressions. (Take a look at some of the excellent books that are dedicated entirely to photographing people.) But when photographing people in a travel situation, I find it critical to express the essence of an individual in his or her own natural and home environment.

I'm interested not only in unspoiled nature but also how humans can find intimacy within it. Most of my travel photography focuses on people, what I call "ethnographic photography." I am curious about how people relate to each other and their environment. Population density isn't as great in rural areas as it is in urban areas. And rural people are more aware of their natural surroundings and spend more time outdoors working and playing.

People add interest and intrigue to a photograph. The human figure is the most potent of all introduced objects. It draws the eye and can easily dominate the scene, so that even

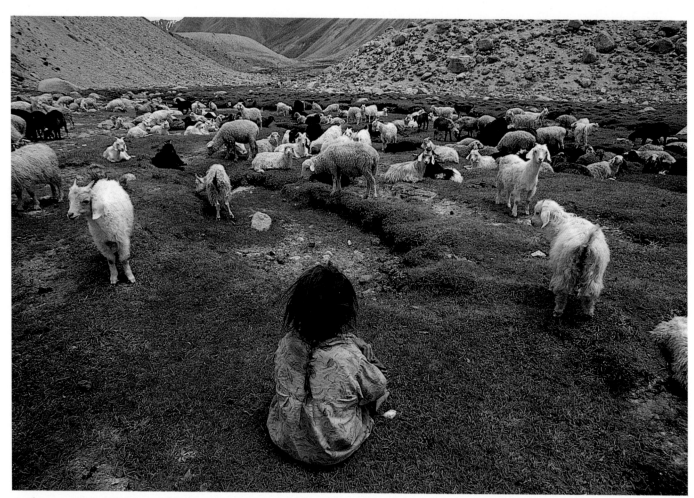

In the mountains of Tajikistan I happened on a little girl tending a flock of sheep and goats. Overwhelmed by a feeling of aloneness and contentment, I stood behind her and shot from above with a 20mm wide-angle lens on my Nikon F3 in order to position her prominently in the image with the animals in the background. Because I kept her back to the camera, I was able to maintain the sense of isolation. The exposure was 1/60 sec. at f/8 on Kodachrome 64.

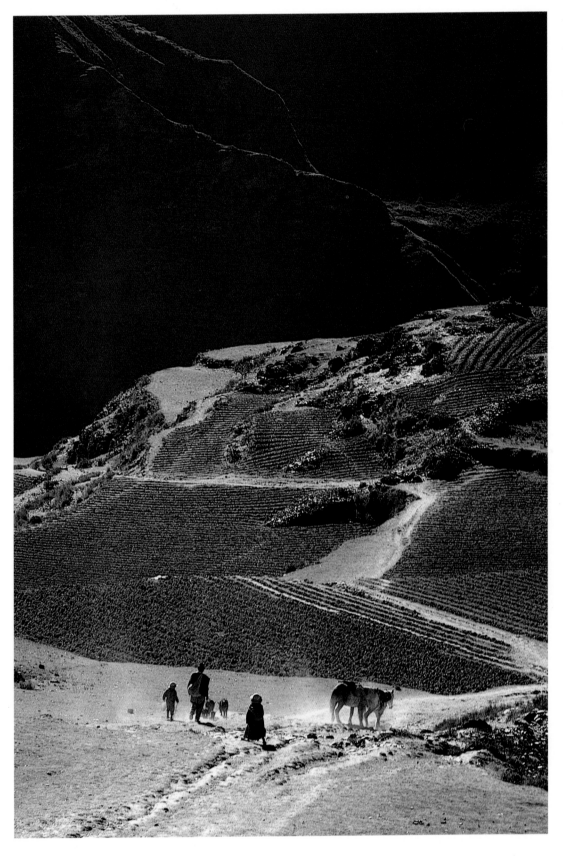

As I was exploring the terrain around Caata at the foothills of the Cordillera Apollobama in Bolivia, I spied this family ahead of me on the trail. The frontlit fields and the shadows on the hills were wonderful, but without the people to add a human touch and perspective the image wouldn't work. Here, I used my Pentax Spotmatic, a 135mm lens, and Kodachrome 64.

a tiny figure on the horizon is a counterpoint to a towering landscape. A human form in a large landscape provides scale and perspective. In an unfamiliar environment, the eye seeks out familiar objects as points of reference. Because the human figure is instantly recognizable and relatively constant in size, it is a valuable yardstick for measuring distance in landscape pictures. Trees, animals, and familiar structures can also form a focal point and suggest depth, but they don't catch the eye quite so readily.

When put in perspective against the landscape, the human figure also defines the situation. Often the environment is the key to a portrait. It sets the atmosphere and the tone. If the sun is about to break through the clouds and you see someone heading toward the rays of light, don't be afraid to quickly get into position in order to capture the special moment. Although the people may be the essential element, the background answers unspoken questions about the subjects, their life, and their work. You can make many landscape photographs more interesting—and more publishable—by adding people. Some photography magazines demand that you get the whole picture. They're interested in photographs that set the stage for the action and give readers more information.

Wide-angle lenses can create a sense of closeness and involvement between subjects and their environment. You can position a figure in a photograph in relation to a vast landscape in two ways. The figure can dominate the landscape, or the landscape can be the main subject and a small figure can be included to add perspective and the human element. This is a personal choice and

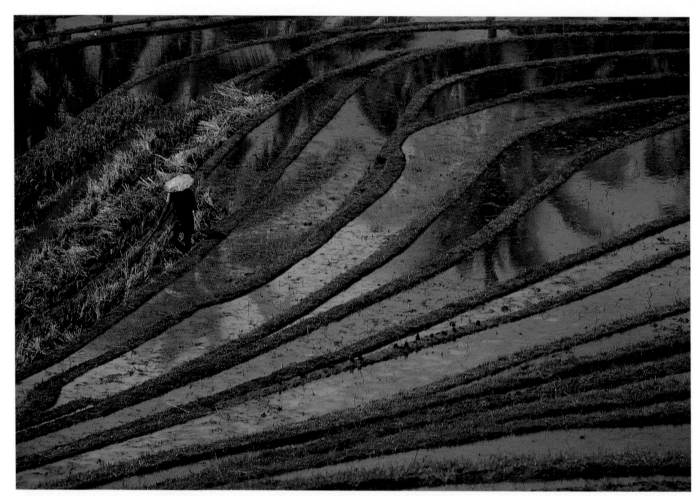

While riding a motorcycle around Bali, I noticed a worker harvesting the rice field below me. I leapt off the bike and grabbed my camera out of the camera bag, which I'd secured between my knees. I framed the figure off to the left to balance the weight of the field and to keep the water reflections in the frame. Working with my Nikon F3 and a 180mm lens, I exposed for 1/250 sec. at f/4 on Kodachrome 64.

En route to the Makalu Basecamp in Nepal, my traveling companions and I crossed three high passes. From the top of the second pass I photographed the porters walking toward the third pass. The small figures add perspective and dimension to the landscape. Here, I used my Nikon F3 and a 35mm lens; the exposure was 1/125 sec. at f/8 on Kodachrome 64.

Lying on my stomach on a beach in New Zealand with my Nikon N8008 and a 20mm lens, I shot at eye-level to the shell so it would dominate. The exposure was 1/60 sec. at f/11 on Kodachrome 64.

depends on what you decide you want the predominant focus of the image to be.

Take advantage of using the people you're traveling with as subjects for your photographs. They may not seem as interesting or colorful as the local people, but they may be more accessible and willing to be in your photographs. In addition they are the obvious choice of subjects when it comes to showing your activities and undertakings against a landscape backdrop. You can also capture any spontaneous interaction between your traveling companions and the locals.

So whether you're just traveling through a region or spending time in one place, you should be aware of the human relationship to the natural world. It is something photographers in the Western Hemisphere often ignore, and it's quickly slipping away in all parts of the globe.

THE CHALLENGE OF PHOTOGRAPHING PEOPLE

My raisons d'être for photography are interaction, exploration, and knowledge. Although I take many different types of photographs, such as shots of landscapes, details, and sports, it is people photography that I connect with most deeply. It isn't the image I'm searching for; it is an expression of interaction. Taking a photograph is the pathway to learning about someone else and ultimately about myself. I often see people and details better with a camera in my hand, and I pay more attention to peoples' gestures, expressions, and movements. My camera becomes my tool for exploration and helps pave the way for a personal exploration of life and people.

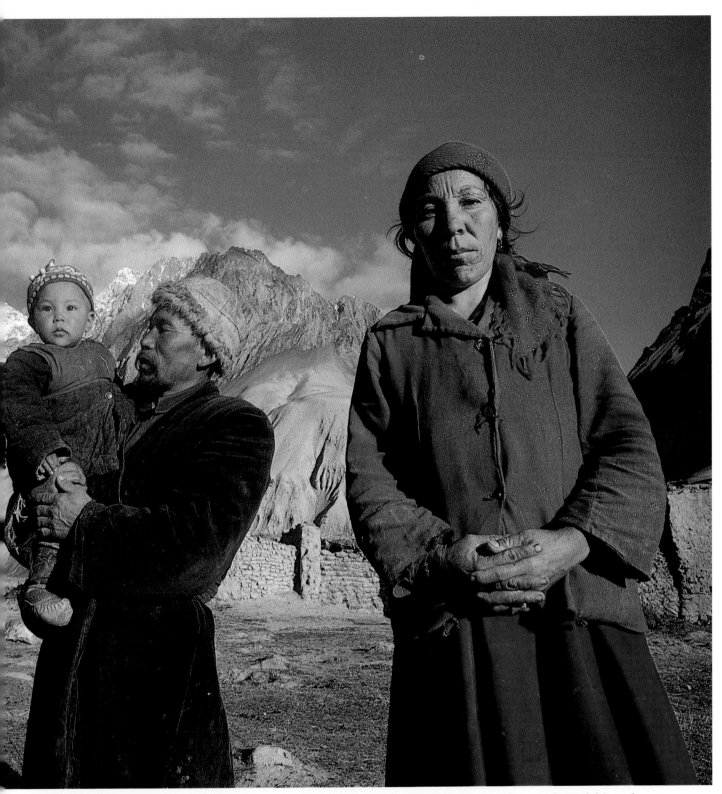

This Kirghiz family accepted me into their one-room dwelling in China's Pamir Mountains for more than a week. We didn't speak a common language, but we communicated fairly well with gestures, expressions, and even drawings. I photographed the family outside their house; I like the asymmetrical quality and different eye contacts. With my Nikon F3 and a 24mm lens, I exposed for 1/125 sec. at f/8 on Kodachrome 64.

Photography has opened the doors to many memorable experiences for me. I've been asked to shoot weddings, ceremonies, and sacred rituals. The photographs were good; the experiences were even better. This is important to remember: you are there first for the traveling experience, and second for the photograph. Of course, if I am on an assignment or have a time limitation, the pressures are greater. However, if I don't have a genuine interest in my subject, even if I express it with only a smile and a thank-you, then I shouldn't be there. As a photojournalist once said, "My job is to parachute into people's lives and establish intimacy in two days."

For most people communication isn't one of their greatest abilities. When they travel outside their comfortable sphere of customs and habits, they're confronted with situations and attitudes that can be confusing, frustrating, and often irritating. The keys to transcending these moments are patience, open-mindedness, and curiosity.

In Hanoi, Vietnam, I usually rose before dawn and wandered through the narrow, old streets. One morning as I was photographing people doing their morning exercises around Hoan Kiem Lake, I came across this gentleman on a pile of rocks, meditatively basking in the faint sunlight. I approached him and nodded a greeting. When he acknowledged me with his eyes, I raised my camera and he kept his pose. I shot nearly a roll of Kodachrome 64. Using my Nikon N8008 with a 35-105mm zoom lens, I exposed for 1/60 sec. at f/5.6.

I am attracted to weathered faces; they can tell a story on their own. In Inner Mongolia, China, a woman saw me photographing, came out of her house, and called to me. When I looked over, I saw her calm face and profound eyes. The serenity of this woman is expressed in her solemn, simple pose. The two buttons complete the image. For this shot, I used my Nikon F3 and a 35mm lens, and exposed Kodachrome 64 for 1/125 sec. at f/5.6.

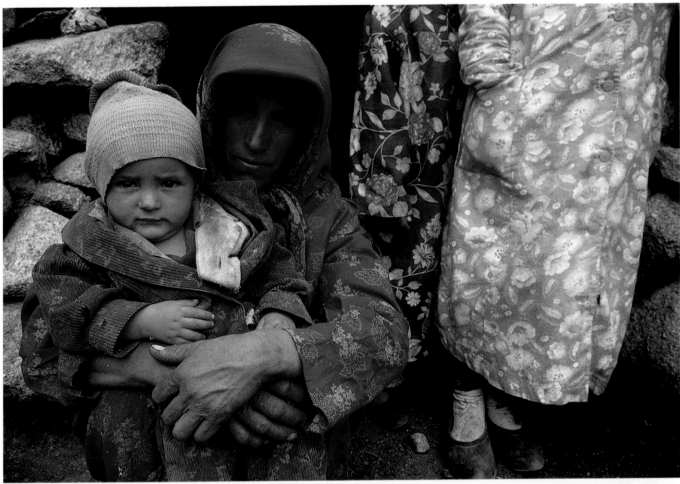

While on a trek through the Central Pamir Mountains of Tajikistan, I passed by numerous stone sheepherder huts. Hospitality is an unwritten law in this part of the world. The women in this home invited me in for a simple meal of yogurt and bread. As I left the hut I was struck by the color combinations in their dress fabrics. I leaned down and with my Nikon F3 and a 20mm lens, I photographed a mother with her son, making sure to include the skirts of her two daughters. The exposure was 1/60 sec. at f/8 on Kodachrome 64.

TAKING TIME

The longer you stay in one place and establish an intimacy with the locals, the better chance you have of experiencing special and unexpected moments. Ideally it would be wonderful to have unlimited time with no government restrictions or family obligations—and an endless bank account. I am in awe of Alexandra David-Neel, a Frenchwoman who traveled intrepidly through Tibet to Lhasa in 1924 disguised as a beggar and wrote about this remarkable journey. Fortunately her husband continually sent her funds for her travel and scholarly work, even though she was gone for periods of time as long as 14 years. Sadly I usually don't have that luxury of time or that kind of financial support. Often the

accelerated pace of modern publishing, not to mention individual time and money constraints, dictate the limitations of a photographer's schedule.

If, however, you're going to be in an area for an extended period of time, it is helpful to have personal introductions and letters of reference. Then once you arrive take the time to build relationships and break down shyness or suspicion. Share in the locals' work, and play with their children. Don't isolate yourself; become part of the daily world. I know one photographer who spends months in a village or community before he even takes out his camera.

That isn't my style. But when I arrive in a village, I don't take my camera out immediately and start shooting. I spend the first day walking around, becoming familiar with the area,

noticing people and their habits, and checking out places I may want to photograph eventually. (I may take a few unobtrusive shots. I usually get some good ones during this time, when my mind is fresh and open and I don't take anything for granted.) I try not to become obsessed with the time limitation on my shooting. I make time to socialize without my cameras.

APPROACHING POTENTIAL SUBJECTS

Sometimes I wonder if cameras shouldn't be licensed. I can always tell where hordes of cameras have come before me. I'll put my camera to my eye and people immediately cringe,

duck, or flee. This is a completely opposite reaction to the friendly curiosity I notice in places where few foreign cameras travel. Of course, having one person in six months come along and photograph you is very different from 16 people approaching you in one day.

Newcomers to travel photography are led to believe that only a combination of stealth and long lenses can guarantee the travel trophies they want. My guess is that most people feel guilty taking photographs of other people; they feel that they're being obtrusive and invasive, so they use a long lens to shield themselves. Still, even with a 200mm lens you need to be as close as 15 feet to your subject for a portrait from the waist up.

All photographers develop their own distinctive manner and style with other people. Some are pushy, some are silent, and some are flamboyant and loud. All kinds of approaches work.

On my first day in Asilah, Morocco, I walked around town with a single camera and lens, my Nikon F3 and a 55mm lens, and Kodachrome 64. I was getting to know the area and scouting places for future shots. As I rounded a corner I was struck by this large, colorful mural and photographed this young boy as he turned the corner.

While staying in Sichuan Province, China, I accompanied two old Tibetan women on their early-morning walks to the sacred shrines around the Gonga Shan monastery. As we walked I photographed them, as well as participated in the different prayers and prostrations to Buddha. Since I was an active participant, they were comfortable with my presence; this enabled me to capture spontaneous moments. For this photograph, I used my Nikon F3, a 24mm lens, and exposed Kodachrome 64 for 1/125 sec. at f/4.

At times you have to distance yourself from an emotional situation while remaining empathetic, which isn't always easy. In Vietnam I waited at the Hanoi National Cemetery for a funeral; I wanted to photograph the mosquito-net clothing worn by the family. Even though I knew I was there specifically to photograph a funeral, I was unprepared for how intensely their grief affected me. When a group of mourners arrived at a burial site, at first I stayed back. But I soon realized that I wasn't capturing the impact of the occasion, so I asked my interpreter if I could go closer. When he said yes, I moved to the front of the grave and photographed until I felt that my presence was becoming intrusive. With my Nikon N8008 and a 35-70mm zoom lens, I exposed for 1/125 sec. at f/8 on Kodachrome 200.

I've seen some wonderful shots made by photographers who fit in every one of these categories. I have a simple approach. I rarely use a telephoto lens; I prefer direct photographic contact with people. Since I enjoy a personal exchange, I go right up to someone and engage in a conversation or make some kind of contact.

Success in photographing people is the result of the manner of your approach. Suppose you are in a village market, and you see an intriguing woman selling beautiful red tomatoes. The light is perfect. You know the best shot is a candid shot, so you quickly hold up your camera and you snap the picture. Suddenly, she senses you and looks up. If you meet her gaze with a guilty look and scurry around the corner, you're sending a message that you've done something wrong or you've violated something. I've seen this happen far too many times.

Don't slink furtively away. Instead, put down your camera, smile, and wave. Go over and shake the person's hand in gratitude. You might even buy a tomato from her. After you establish good, friendly terms, take out your camera, put on a wide-angle or macro lens, and continue shooting. I find that people love this approach, and that the person in the next market stall may also be willing to pose for you. By then you have the market on your side and have shown that being photographed can be fun. Be open and flexible. What you first envisioned might evolve into something better. For example, the woman's twin sisters might come out in pink checkered dresses and stand on either side of the tomatoes.

Sometimes, though, you'll find that a person notices you, becomes annoyed, and waves you away. With experience you learn to tell the difference between people who are sincere in their wish to be left alone and people who say, "No, no, no!" but mean "Yes, yes, yes!" Often these individuals wave you away, saying, "Oh, I'm not dressed in my best clothes" or "I'm not pretty enough." I laugh and dismiss that assertion, which is usually exactly what they want me to do. Most often they agree to have their picture taken. I never patronize people or talk down to them, but I do reassure them and try to put them at ease. However, if people give me an obvious abrupt "No!" in response to my request or ignore my pleasantries, I smile, thank them, and walk away. I never sneak a photograph. It is their choice whether they want their picture taken or not. There is always another photographic opportunity. No picture is worth irritating someone over.

Don't spend too much time photographing one person in front of their family or friends; it begins to embarrass them. Often I'll intensely photograph one person, then leave

or turn to his or her neighbor. Later I'll return and continue photographing the person who initially interested me.

Photographing people isn't for the shy at heart. You need a certain amount of impudence to overcome natural reserve. You have to be friendly and forthright and have a lot of panache in order to approach people. Confidence and friendliness open the gates to communication. People are as curious about you as you are about them, and often all that is necessary to unlock this curiosity is a friendly word or two. And it doesn't matter if you don't speak the same language. I have the longest conversations with individuals who don't speak English. I talk in my language and they talk in theirs. None of us, of course, can understand anything that's being said, but we have a wonderful time.

Sometimes it helps to have a local with you, whether the person is a paid guide or someone who befriends you on the street. I've worked with guides from the Foreign Press Center in Vietnam and local agencies in China, as well as with guides assigned to me in Africa and even little boys who tugged on my shirt in the temples of Nepal. Frequently you find people who are happy to walk with you because they want to practice their English. In Vietnam a teenager who wanted to speak English approached me so we walked together around the streets. As we visited his friends in local cafés, he set up photographs for me, pointed out shots, and dragged me over to likely subjects. I had a wonderful time, and the locals saw me with a neighborhood kid who was also having fun. He broke the ice and paved the way for others to relax with me. The teenager certainly wasn't shy, and he felt very proud that he was showing a foreigner around his town. But you should be wary. Sometimes people want more than friendship.

I always wear jewelry that I think might interest the local women. For example, if I'm around Tibetans, I wear some turquoise rings or necklaces. The women and I inevitably end up admiring and comparing each other's jewelry. Then when the time feels right, I ask if I can photograph them. When dealing with a shy woman, I might ask to take a photograph of her earrings or necklace; this minimizes the emphasis on her face. You may have to do some conventional overall shots and tactfully see if you can work your way in closer. It is rude to immediately zoom in on a subject's chest. And be sensitive when using a flash. Remember how blinding it is to have a flash go off directly in your eyes.

Make your camera a bridge rather than a barricade. If your subjects are unfamiliar with a camera, you might let them look through the viewfinder. Sometimes I even have them take a photograph of me (make sure you put the motor

drive on single-frame exposure). You might get an interesting portrait of yourself.

Many photographers prefer not to use a motor drive when photographing people. I can certainly understand the sentiment. Motor drives can be noisy, obtrusive, and confusing. However, they are invaluable for catching fleeting expressions and a sequence of action. After I've reeled off a series of motor-driven shots, I usually drop the camera from my face, laugh at its antics, and then begin photographing again if necessary. It helps to have a quiet camera. The Nikon F3 with a motor drive is one of the worst in terms of noise: it sounds like a submachine gun. A Leica is a great stealth camera because it is one of the quietest on the market.

I was photographing a market festival in Charazani, Bolivia, when I noticed a young girl sitting under a flower bush with her mother. I approached and asked the mother if I could take her daughter's photograph. Because the young girl was pleased but embarrassed, I photographed her as quickly as possible, thanked the two of them, and moved on. Here, I used my Pentax Spotmatic, a 40mm lens, and Kodachrome 64.

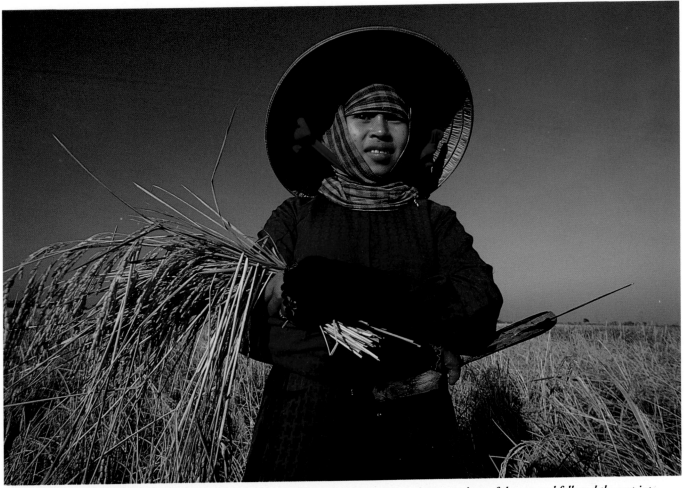

Driving down Highway 1 in Vietnam, I saw an ox cart heading down a narrow dirt road. I jumped out of the van and followed the cart into a field where a few women and girls were harvesting rice. Smiling, I walked right up to them and clasped their hands in mine. Since I was being friendly and effusive, they gleefully posed for me; this girl willingly moved into direct light for me, and I adjusted her position. I used my Nikon N8008 and a 20mm lens, and exposed for 1/125 sec. at f/11 on Fuji 100.

If you're shooting with other photographers, whether they are your friends or people on a photo tour, you need to remember an important rule of etiquette. If you see a person talking with someone and establishing a rapport, don't sashay over and shoot over his or her shoulder. Not only is this action annoying for the person who has set up the shot—as well as rude—but it is surprising for the person who's being photographed.

The key word is sincerity. If people feel that you're trying to use them, they won't communicate with you. If potential subjects find you amusing, go ahead and laugh with them. Laugh at yourself, your clumsiness, and your inept language skills. If you be yourself and are open and honest, in one afternoon you can find yourself taking photographs that

sometimes can only be made after you are in one place for a long period of time.

Even though you want to be sensitive to other country's mores, don't be shy. And don't be afraid to explore the back alleys and tracks not mentioned in the guidebooks. Stretch yourself beyond your own cultural boundaries and inclinations. I find the people of most cultures to be very tolerant; they expect foreigners to make mistakes. As I walk through small towns in foreign countries, I'm not afraid to peer into doorways or go into stores and talk with people. These acts are usually construed as friendly gestures, not intrusions. You'll get the message if you've overstepped boundaries. Seek out the unexpected; if you expect the predictable, that is what your photographs will be.

I gravitate to old women; they have an ease and an acceptance of life that I admire. This Yi woman in China was sitting on her step having a morning smoke as I passed by. From the moment I saw this woman, I felt a rapport with her. I sat down next to her for awhile, silently taking in the scenery. As I got up to leave, she nodded at me and gave me a pat on the hand; then I took this photograph using my Nikon F3 with a 35mm lens. The exposure was 1/60 sec. at f/8 on Kodachrome 64.

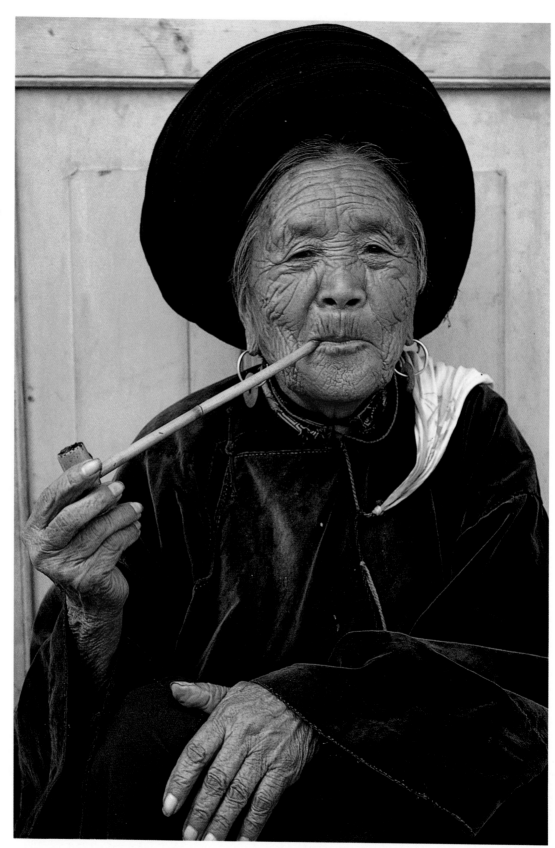

COMMUNICATING ACROSS CULTURES

Try to learn a little of the language. You can easily learn important words and simple phrases, such as "hello," "goodbye," "thank you," and "please," as well as numbers. Your goal isn't to be able to discuss quantum physics, but to extend a thread of contact. Some languages are easier to pick up than others. I find tonal languages nearly impossible. Even if you mangle a language, most people are pleased and honored that you've taken the time to try to learn to speak some of their language.

Lonely Planet Press publishes excellent compact phrase books for some of the more obscure languages. For non-Roman script languages it is helpful to have a phrase book that provides phonetic pronunciation and writes out the phrase in the local script. So if you can't pronounce the words, you can at least point to them in order to have someone read them for you.

I've passed phrase books back and forth in restaurants, trains, and buses, carrying on lively and humorous "conversations."

Phrase books have their limitations, as well as an abundance of useless comments, such as "Excuse me, where can I find a pencil box?" And questions and requests that photographers might need certainly aren't included. I have a list of frequently used expressions that I take with me on each trip; these include "Please, may I photograph your child?" and "Please move over here so I can take your photograph." I usually can find an accommodating hotel-staff member or a friendly person willing to translate them for me. When you liberally mix such remarks with gestures, imagination, good humor, and an outgoing nature, it is impressive how quickly and effectively you can communicate in a short period of time.

Nonverbal communication is an easy art to learn. All it takes is practice and confidence. It involves using your whole body:

I saw an old woman peering out of an elaborately carved window in a Tamang village in central Nepal. When she ducked inside, I called out to her in Nepali, asking her to come back and talk to me. She returned, laughed that I could speak her language, and readily agreed to be photographed. For this shot, I used my Nikon N8008 with an 80-200mm zoom lens and exposed at f/4 for 1/250 sec. on Kodachrome 64.

your face, hands, and head and torso movements. If your first attempt fails, try a different approach or another set of gestures. While photographing people I've found nonverbal communication to be as successful as verbal communication. Be aware, however, that cultural gestures vary from country to country. For example, in India when a man moves his head languidly from side to side, it looks as if he is indifferent and bored. But he's actually saying, "Yes!"

Asking permission to take a photograph isn't always the best choice. In some cultures women are very reluctant to verbally agree to be photographed, and certainly not in the presence of men. Instead, I might ask with my eyes and body language, and expect a similar response, such as a nod, a smile, or simply continued eye contact as I raise my camera. However, if I'm not sure about how the person feels, I always ask.

One of the most exhausting parts of travel is perpetually maintaining a good mood. If you aren't in a good mood your body language expresses this, and people are instinctively repelled from you and your camera. It takes more energy to relate nonverbally than verbally. The best travel photographers are open and indefatigably friendly. Of course, everyone inevitably has down days. That is the time to put down your camera and go do something else.

BEING SENSITIVE, DIPLOMATIC, AND UNOBTRUSIVE

When you travel you may feel as if you're representing only yourself, but to the eyes of the world you're also representing your country. You are a foreign ambassador, for better or for worse. I can't count the number of times that I've been referred to as the "American woman." I've learned not to bristle at this attack on my individuality but to accept it gracefully.

The richest opportunities to photograph people arise when the tourist bus stops and the road ends. You may be the one making the rules for the photographers to come. Learn the local customs and traditions before you go, or ask about them along the way. Being familiar with them will make it easier to interact with the people. For example, before I leave on a trip, I do some research into what the local dress is. This is usually a more important issue for women than men, but not always. I don't believe in wearing only native clothes when I travel. I wear simple, neat, unostentatious clothes to blend into the crowd as much as possible. If I see the local women wearing long skirts and long-sleeve blouses, I mimic their level of modesty in my Western style. Men also need to pay attention

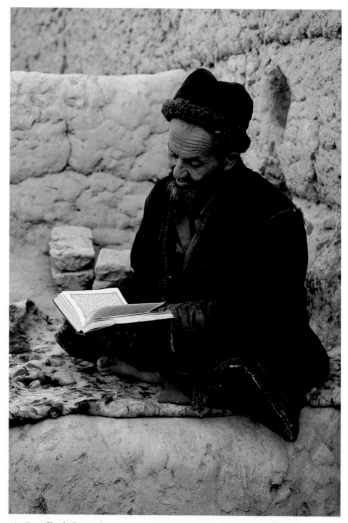

As I walked through a town in Xinjiang Province, China, I saw this Kirghiz man reading the Koran. I didn't want to disturb him, so I slowly walked into his courtyard and stood respectfully to the side with my camera lowered. He looked up, saw me, and went back to his studies. Since he didn't object to my presence and was aware of my camera, I felt comfortable photographing from a discreet distance. Shooting with my Nikon F3 and an 85mm lens, I exposed for 1/125 sec. at f/5.6 on Kodachrome 64.

to whether or not it is appropriate to wear shorts. In some cultures they're viewed with disdain or worn only by men of the lowest social rank.

It is always a good idea to meet the leader of the community when you arrive at your destination. Make sure that you take the individual's photograph, explain why you are there, and present any letters of introduction you might have. Your reputation will be judged by the company you keep. Tactfully inquire as to the standing of the family you're being housed with.

Talk to the people about what you're doing, so that they understand. Keep your communication open and honest. The more people know, the more they'll help you. Explain how your photographs will be used, such as for personal use, in a magazine, in a slide show, or in schools. One Moroccan woman refused to have her picture taken saying, "You will take my picture. It will be in a magazine and someone will use it as toilet paper." I tried to explain, but to no avail. If you're going to be in one city or village for a few days or more, begin making "shop friends." Eat at the same local restaurant, and buy from the same shopkeeper. Soon you'll become familiar to the local people, and they'll relax in your presence. Then you'll have the opportunity to shoot unobtrusively. I usually carry photographs of my family, friends, and house with me in a small book. They are big hits.

As you travel, keep in mind that food is the confluence of a people and their environment. If you have special dietary needs, you might experience trouble when you travel. I rarely refuse hospitality even though I might want to. People usually go to a huge effort to honor me with a meal, so I don't ask what I'm eating; as long as the food is well cooked, I accept it graciously. Since I often travel alone, I'm faced with being the sole ambassador and thus lone imbiber of food and spirits. I've spent many a hazy evening drinking toasts to friendship and goodwill. If you are lucky enough to be traveling with a partner or a group, you can usually share the ambassadorial duties.

Be aware that your hosts might want to find out what you're made of. They might ask you to do menial chores, such as fetching water or making noodles. It helps if you can laugh at yourself and whatever situation arises.

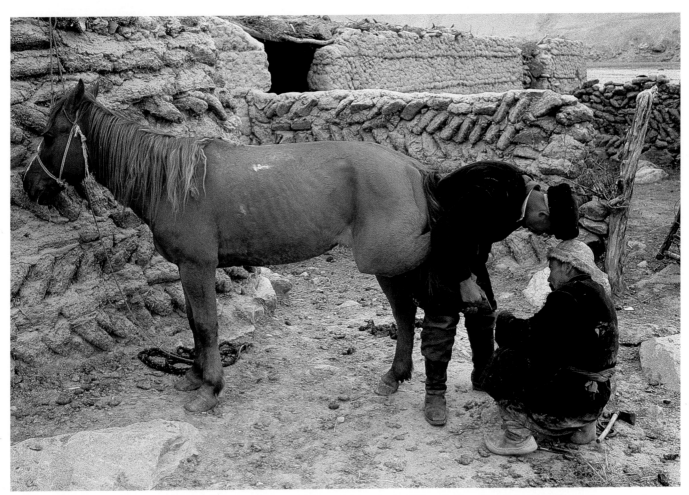

On one trek I spent more than a week in a Kirghiz village in the Pamir Mountains in China. At first the people were self-conscious around my camera, but after a few days they forgot about me and went about their daily tasks as if I weren't there. I used my Nikon F3, a 24mm lens, and Kodachrome 200 to photograph these two men shoeing a horse.

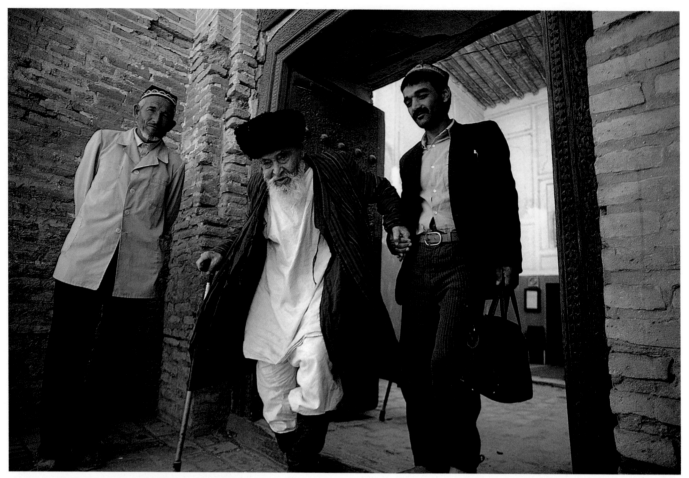

I was wandering the streets of Bukhara, Uzbekistan, when I chanced upon a small mosque; I asked what time the evening service was held. Later on I returned at the end of service, crouched outside the door, and photographed the men as they left. Working with my Nikon F3 and a 20mm lens, I exposed Kodachrome 64 for 1/125 sec. at f/5.6.

WORKING QUICKLY

Photographing people requires you to think and act fast. Before I lift the camera, I get my light reading, think about my composition, and decide which lens to use. Then I swiftly raise my camera, focus, and shoot as many pictures as I want or as many as my subject is comfortable with. Because expressions change quickly, a motor drive helps you catch all the ephemeral reactions. Don't be afraid to change your position or your angle.

It is essential to know your equipment so well that the camera is simply an extension of your hand and eye. Dexterity with your equipment comes from long hours of shooting and familiarity with your gear. Without quick reflexes and an automatic knowledge of your equipment, those instantaneous, decisive moments will pass unrecorded on your film.

Sometimes it is possible to compose your picture without raising the camera to your eyes; doing that reveals your intentions immediately. If you can frame a scene this way, you are more likely to go unnoticed, even from pretty close range. This technique of instinctive shooting is quite easy with wide-angle lenses. You must, however, allow for a margin of safety and leave space around the subject because you can't be sure of the results. Finally, avoid noisy cameras. The classic "click" is a giveaway every time. Take advantage of a sudden sound to cover the noise the shutter makes.

As with wildlife photography, it is helpful to know the habits and customs of the people you're photographing. If you want to photograph people streaming out of the door of a particular temple, you have to find out what time the services are, return before they begin, and find the right photographic angle. It takes practice and effort to time your shooting to coincide with an event so you can catch that spontaneous moment.

Spending time in one area certainly helps you capture spontaneous moments. I once stayed in a Tibetan monastery in the mountains of Sichuan Province, China, for a couple of weeks. When the people became accustomed to me and my camera, I wasn't a novelty any longer and I was able to catch spontaneous and remarkable moments of their everyday lives.

Most third-world cultures have a different orientation to the camera than Americans do. Having a portrait taken isn't a time to be spontaneous and open for these people; it is a serious, special event. They're expected to pose straight-backed and stare somberly into the camera. In Vietnam I once photographed an older Black Thai woman. I really wanted her to smile and show her black enameled teeth (until recently in Vietnam, Black Thai women traditionally enameled their teeth black as a sign of beauty), but her natural reaction was to assume the usual rigid pose. After I shot a few photographs so that I wouldn't seem rude, I tried to change the mood. I talked to her and the crowd, hoping to dispel the somber atmosphere. I mimicked a smile and made everyone laugh, including the woman. Fortunately I succeeded. But this was only because when she laughed, I was ready and shot fast. My camera's motor drive proved indispensable in capturing the fleeting moment.

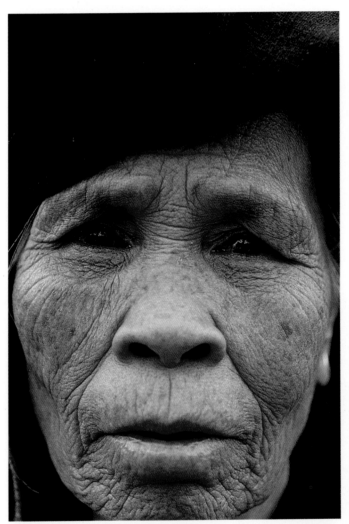 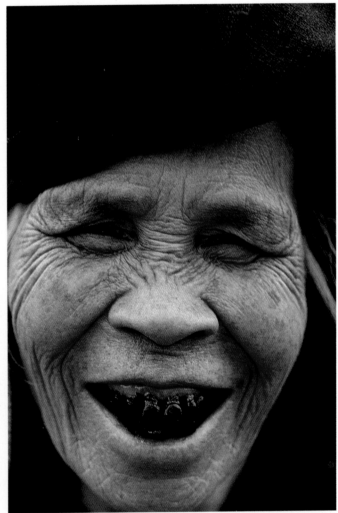

During one of my trips to Vietnam, I photographed an older Black Thai woman in at the Chieng Pac village market in Son La Province. Although the woman's natural reaction was to assume the usual rigid pose shown on the left, I made her smile and show her black-enameled teeth. I made these two portraits with a Nikon N8008, a 55mm lens, and exposed for 1/125 sec. at f/5.6 on Kodachrome 64.

DIRECTING THE PHOTOGRAPH

After you've made a connection with people who are amenable to being photographed, don't be shy about repositioning them if, for example, you don't like where they're standing or if the light is bad. Ask them to move a few inches, sit down, or even follow you to a better place. They'll get the message that you're trying to portray them in a flattering fashion.

When I want subjects to rearrange themselves but we don't speak a common language, I mimic the posture or action I'd like to see and imply that they follow my lead. I put my hands together and give them an "Okay, how about you?" look. Usually they immediately understand. If not, I go over and politely move them to where I'd like them to sit or reposition their hands myself.

POLAROIDS AND TIPPING

The subject of deciding whether or not to bring a Polaroid camera on a trip elicits a variety of disparate opinions. Some people swear by their usefulness, claiming that they unlock doors. Others say that they may briefly unlock a door, but that they close doors for the next person who might not have a Polaroid. I tend to agree with the "anti-Polaroid" faction. I don't believe in fostering a type of instant gratification. Polaroids breed more Polaroids, and eventually people will refuse to have their photograph taken unless they can immediately have an image. Then the sole purpose of a camera becomes an instrument for a quick snapshot of the person and the entire village.

You also have to be aware of the "Polaroid syndrome." You pull out a Polaroid camera, and suddenly the entire town is at your tent door demanding a print. If someone traveling with me has a Polaroid camera, I ask the person to keep it inside a suitcase. Of course, there are times when these cameras are definitely useful, such as when you want to photograph government officials or to give pictures to families you've spent a long time with. But to casually meet someone on the trail and hand out a Polaroid is inappropriate and very expensive.

Sometimes people come up to me and ask to have their picture taken, expecting that it'll come out instantaneously. I have a stock gesture in such situations. I hold up my camera and make my right palm flat as if it is a photograph coming from the camera and say, "No instant," in whatever is the closest approximation of their language. Usually they understand and leave. I prefer sending photographs to people later. I have the subjects write down their addresses, in their native language and script, in a book I keep for this specific purpose. Then when I'm ready to send the photograph, I photocopy the address and tape it to an envelope.

I try to avoid paying for a photograph. As I mentioned before, my main reason for shooting is primarily for the interaction and the experience. I don't pay someone to say hello to me, so I don't pay to photograph. It is my responsibility to convey that in my approach and manner. If you act frenzied and pushy, you can expect the person to feel like an object and to want to be paid.

In a small town in Mongolia I noticed a woman with a beautiful yellow turban standing in the warm afternoon sunlight. I motioned that I'd like to take her photograph. She agreed, but as she turned toward me, she moved out of the sunlight into the shade, as shown on the left. Although I photographed her with my Nikon F3, exposing Kodachrome 64 for 1/60 sec. at f/4, I knew that I'd lost the drama. So I asked her to move back into the red light of the setting sun where the shadows flatteringly framed her face, as shown on the right. After changing the aperture to f/5.6, I quickly took a series of shots because the sun was hurting her eyes, and then thanked her for cooperating.

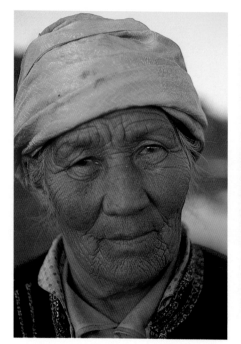
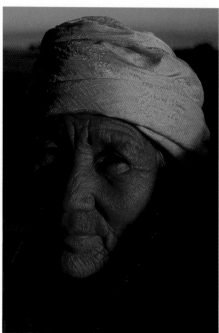

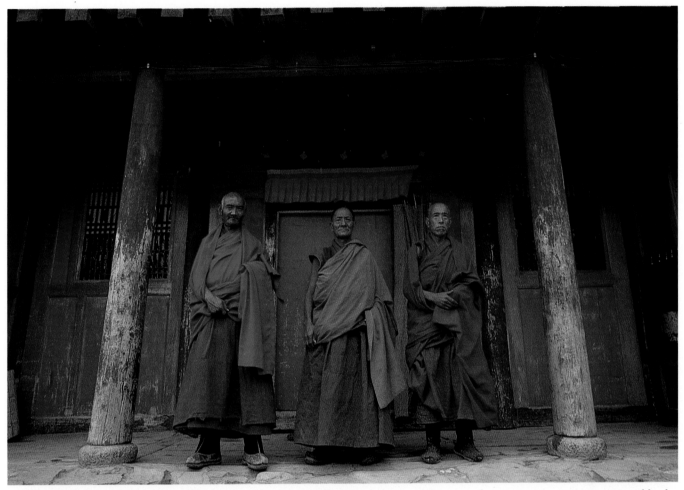

I coaxed these three lamas out of their monastery in China's Sichuan Province and onto the front steps for a group portrait. I was intrigued by the redness of the scene. To emphasize the grandeur and magnitude, I shot from below with a 24mm wide-angle lens on my Nikon F3. The exposure was 1/60 sec. at f/8 on Kodachrome 200. When I finished shooting, I placed a donation on the altar.

If you're shooting in a country or region where a million cameras have come before you, such as the Everest trail in Nepal or the villages in Kenya, you can expect to be greeted by outstretched palms. I never cavalierly saunter into an area and distribute money for photographs. I won't demean people by viewing them as only a photograph and a business deal.

Be aware that there are opportunistic people who'll try to squeeze whatever pennies you have in your pockets into theirs. Trust your intuition about someone, be direct, and don't let yourself be intimidated. I've encountered one scam numerous times. Lively young boys approach me and say or gesture, "Take my picture!" If I agree, their palms come out and they ask for 1 ruppee, 100 bhat, or 10 dollars. I never hand out money on these occasions. I simply smile, wave graciously, and continue on my way.

However, there are a few situations in which I'll pay money or present a small gift in exchange for photographs. For example, I give subjects a token gift when I ask them to take time out from their work or from their home duties to pose for me. And when I photograph a religious beggar or an educational, religious, or art institution, I'll make an appropriate contribution. Keep your gifts modest and personal in nature, such as food or something else that the subject will find useful. Extravagant gifts and excessive amounts of money increase the schism between people and immediately set you apart from the local people. You may even become an object of disdain, since people will think that you don't know the value of money. Before you throw your money around freely and foolishly, think carefully about how the power of money and greed can transform a culture.

DEALING WITH OFFICIALS

If you spend your time traveling in remote third-world countries, inevitably you'll be spending more time than you like dealing with officials and a lumbering bureaucracy. Waiting is an essential part of traveling in remote areas. Always carry a book or magazine in your camera bag.

Even if you judicially do your homework before you go and know what is permissible legally and culturally, there always comes a time when you are a captive of red tape. It is best to be flexible and maintain a sense of humor because everything that can go wrong probably will. If you do get stopped in mid-shutter on the street by an official, don't become rattled or angry. It is probably only a minor hassle. Diplomacy always works best. Smile or feign innocence if necessary. If it becomes clear that there truly is a problem, put away your cameras and move on. If you happen into one of those unfortunate situations when you're asked to speak to the official's superior, relax. The request is rarely serious and is usually just a case of flexing muscles.

I've never had any serious trouble with authorities during my travels. I take special care not to bend too many rules if possible, but sometimes that is unavoidable. I've spent a few occasions nervously waiting in stuffy offices, but usually after I apologized and professed ignorance I was sent on my way with a brief reprimand. I don't like bribery or extortion, and I always feign confusion if that seems to be the official's intent. Occasionally I've been forced to pay small "fines." Ask for a receipt.

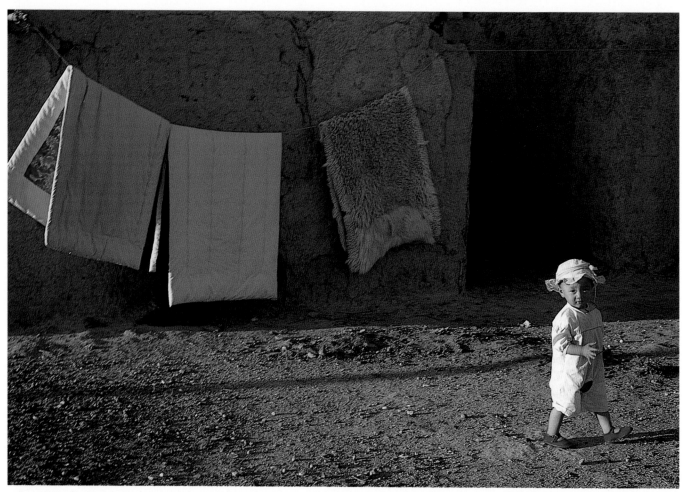

After a long day horseback riding in Inner Mongolia, China, I went out to photograph the village where I was spending the night. I had one camera in my hand and my camera bag slung over my shoulder. As this little girl sauntered by, I quickly photographed her as she passed the mattresses on the clothesline. I like the way the red in the mattress mirrors the red in her shoes. Here, I used my Nikon F3, a 35mm lens, and Kodachrome 64, exposing for 1/125 sec. at f/5.6.

RECORDING SPONTANEOUS MOMENTS

Photographing a spontaneous action requires a combination of intellect, intuition, anticipation, and luck that brings you to the right place at the right time and enables you to "pre-sense" what's about to happen. At times I come into a new situation ready and watching, and grab the decisive moments as they occur. Other times I pick a spot where something unusual or interesting might happen, such as a market street corner or a charming wall or doorway, study the composition, decide what I need, and wait for someone to come along and complete the photograph.

I don't like to have a multitude of cameras around my neck, so I keep my cameras in my bag until I'm ready to use them. When you have cameras and lenses dripping all over you, everyone notices you. Suddenly you are the object of stares and curiosity. And you're inviting thieves. I try to use my equipment as discreetly as possible. Often I see what I want to photograph, go over to a quiet corner, and arrange my cameras. Then I return and pull out the cameras as quickly and inconspicuously as possible.

However, sometimes I find that it is a good idea to have one camera in my hand ready at all times, with either a 24-50mm AF lens or a 35-70mm AF lens with a motor drive or automatic advance. Then if I see something interesting happening or about to happen, I can begin shooting immediately.

Don't look directly at your subjects; follow them out of the corner of your eye. It is easy to become conscious of someone staring at you. Furthermore, eye contact both reveals your intentions and prejudices your chances of success. You should combine this ability to look as if nothing is on your mind with a capacity for acting out roles suitable for the place and time you are in.

MANIPULATING YOUR SUBJECT

Some photographers never move a leaf or a twig for a photograph. Eliot Porter's images, for example, are expressions of found objects. Other photographers, especially commercial photographers, always create photographs from scratch. Both require control and paying attention to the intent of the photograph. I fall into the middle. I like the process of both taking and making a photograph. I'm willing to move an object in order to form a more pleasing composition or color arrangement. For example, I move objects on a table or a

While shooting in Vietnam's Nghia Binh Province, I was struck by a beautiful bush in front of some people planting rice. Still, something seemed to be lacking to complete the picture. Then I noticed two baskets of small rice plants off to the side. So I placed them in front of the bush and made this shot using my Nikon N8008 and a 20mm lens. The exposure was 1/60 sec. at f/11 on Kodachrome 64.

windowsill a fraction of an inch for a more harmonious design. I rearrange objects in a person's house into an interesting pattern or put them in a better light source, such as under a window. I also rearrange the folds in a skirt or the position of a hat, and I brush back stray wisps of hair. I direct poses and hand placements. And if someone's tie is crooked or shirt is unbuttoned, I ask the person to fix the problem.

I don't believe that I'm being dishonest. Everyone is guilty at one time or another of composing a roadside scene with signs, buildings, and power lines until it looks like a pristine wilderness. Changing a hand position or moving a vase isn't much different from changing your shooting angle or the focal length of your lens. Yet to be successful the images mustn't look conspicuously artificial or labored.

Since I rarely travel with more than one flash, I'm forced to be very creative with available light. I often move subjects in direct sunlight into open shade outdoors, near a wall or under a portal, to get a soft, even light.

I'm obviously not shy, but I don't march into a situation and brazenly begin moving objects and people around. I always ask permission when necessary and involve the subjects in the process as much as is appropriate. I find that people aren't put off then; in fact they appreciate the effort and time I spend on the image or their appearance.

Still you don't always have the time or the fortune to wait for serendipity to lead you to a good shot. Sometimes you have to rely on your wits and ingenuity, experience, and

I arrived at this floating market in Hau Giang Province, Vietnam, at dawn. I mounted my Nikon N8008 and an 80-200mm zoom lens on a tripod and photographed from a bridge in order to look down on the activities. I was attracted to the composition formed by the hats and the vegetables, and exposed at f/5.6 for 1/125 sec. on Kodachrome 64.

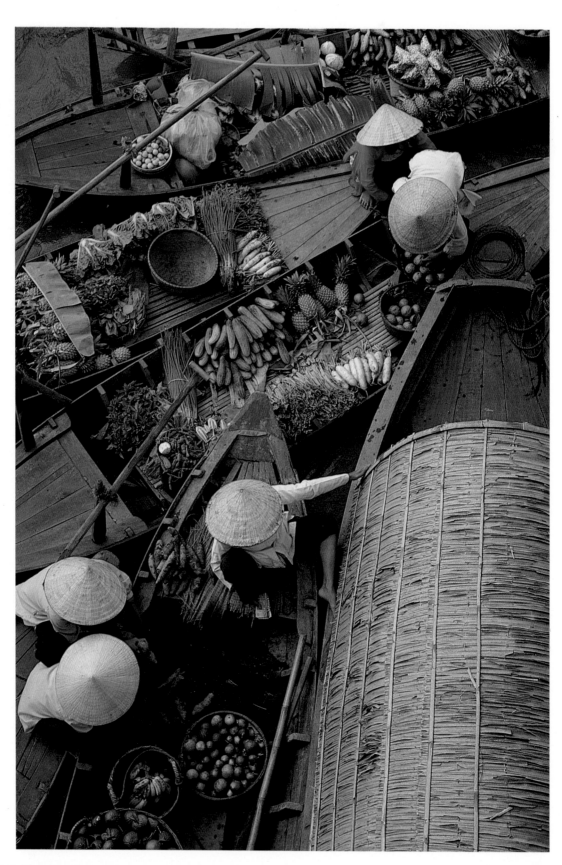

imagination to turn a good opportunity into a great photograph. You don't take great pictures; you make them.

FESTIVALS AND MARKETS

One of the most stimulating moments of any journey comes when you discover a weekly bazaar or market. Rural villagers don't have the convenience of buying food at a local supermarket. They plan their shopping around a weekly market that lasts for only a day or two. Festivals are usually annual events, but can also occur on a 12-year cycle. They can go on for days, even weeks. If you happen onto or get the chance to go to a local festival, do it; it could be the

experience of a lifetime. Markets and festivals are grand events. People are animated and active, and the colors, smells, and sounds are sublime.

Exploring a market and photographing one are two entirely different experiences. I find shooting these festive occasions to be extremely challenging. They are usually crowded, chaotic, and overwhelming. You can easily return home with great stories and disappointing photographs. When a place is teeming with activity, it is difficult to separate out details and situations. You have to pay strict attention to your framing and edges. You have to be aware of people walking in front of the camera, your subject moving, and elbows and legs sticking in from the side of the frame. Photographing festivals and markets is exciting but exhausting work.

Driving along Highway 1 in Vietnam, my companions and I had to stop for a short time at a road-construction block. I jumped out of the van and walked around a small market while we waited. I saw two women with blue shirts sitting behind a basket of fish. One woman had her hands on the basket, so I knelt down and moved the other woman's hands next to her friend's hands. I made this shot with my Nikon N8008 and a 20mm lens; I exposed for 1/30 sec. at f/8 on Kodachrome 64.

At a small local market in Hau Giang Province in southern Vietnam, I was drawn to the design and color of a plate of watermelon and some baskets of rice. Using my Nikon N8008 with a 20mm lens, I shot from above at a slight angle. The exposure was 1/60 sec. at f/8 on Kodachrome 64.

WHEN AND WHERE TO SHOOT

If you're heading to a big market or festival, get up at first light and venture out as the stalls are just beginning to be set up. Use fill flash or fast film in order to capture the early-morning commotion. Then stay late or at least return at the end of the day. Usually there are fewer people in the early morning and late afternoon, so it is easier to move around and get uncluttered photographs. In addition the light is softer, and the shadows are less harsh at these two times of day. Also, I find that people are more relaxed at the end of a successful business day, as well as more willing to pose in front of a camera.

When the activity starts to pick up, a few hints will help you combat the bedlam. Don't try to include too much in a shot unless you specifically want to shoot an overall scene. Narrow in on one person, area, or activity while looking for details, colors, light, and interesting moments. In a crowd of people it is difficult to see or get a perspective on anything. For an overall shot, get above the masses by standing on a roof or climbing up a pole. Frame your shot tightly or expansively depending on the effect you want.

Back on the ground, either shoot with a telephoto lens to frame situations tightly or come in close with a wide-angle lens. I usually carry three camera bodies, one with a 20mm lens, an 80-200mm lens on the second, and a 35-70mm or a 55mm macro on the third. If a lot's happening and I need to shoot quickly in a short period of time, I wear all three cameras. If I have more time for shooting, then I wear just one and keep the rest accessible in my camera bag.

What is so great about festivals and markets is that with so much going on, people tend not to notice you or be bothered by you. And, of course, it is easier to get candid shots in a crowd. You can stand in one place, waiting for the perfect shot without disturbing anyone or making people feel uncomfortable. Zero in on important details and activities that capture the essence of a situation. For example, you might want to concentrate on the exchange of money and goods in a market, the lighting of candles and the beating of gongs in a monastery, or the reactions of the crowd to the festival or dance. Often a very simple image says more than a jammed overall shot. Try shooting a series of shots, isolating the important moments of an event or activity, in order to tell a story.

Don't stand timidly in the back of the crowd. Get in close, especially if you're shooting with a wide-angle lens; otherwise you'll end up with distracting elements at the edges of the frame. When shooting closeups in a market, you have to wait for a lull in shopping activity or work fast so that you don't disturb the commercial transactions. Have your exposures and framing in mind before you step in for an intimate photograph.

I continually move around the area, visiting the same place dozens of times because light changes and there is always something new to see. It is boring when all of your shots of someone show the person only directly facing the camera. Shoot low, high, and from the sides; explore creative angles. Wide-angle lenses are my favorite choices for photographing markets. I can stand above people and shoot down onto their wares, or shoot directly into the vegetables to create a spray of color with a portrait in the back.

If, on the other hand, you want or need to photograph from a conspicuous position or one where your presence might annoy participants or onlookers, you have to honestly judge the appropriateness of your intentions and actions. If you decide that your shooting position won't be an intrusion, go in and out discreetly and quickly. However, I often have to let go of great shots when I think my presence would be rude or disturbing. This is a hard call to make because there is a very fine line between being shy and being restrained.

I try to arrange my travel plans to coincide with as many local markets and festivals as possible. Sometimes it is very difficult to find out where and when they take place, particularly in the more obscure regions. Such remote areas don't have tourist boards, and information can be quite localized. The dates of some festivals are commonly based on a lunar cycle, which makes it difficult to calculate the date from one year to another.

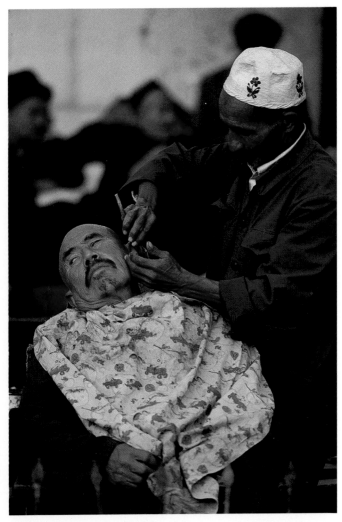

The Sunday market in Kashgar, China, is one of the world's greatest bazaars. There are hundreds of stalls, with thousands of buyers and sellers from the region. As I was walking around the lumberyard at the end of a very long day, I noticed this Uighur man leaning against a cart filled with logs. The light was soft and muted. After I approached him, he held his stance while I took his portrait using my Nikon F3 and a 24mm lens. I exposed for 1/60 sec. at f/8 on Kodachrome 64.

At the central market in Kashgar, China, I came upon this man getting a shave. So I moved back and waited until I got a clear view of him through the crowd. When that happened, I shot a number of photographs quickly and unobtrusively using my Nikon F3, a 180mm lens, and Kodachrome 64. The exposure was 1/250 sec. at f/4.

They're also often planned according to auspicious signs, the deliberations of a shaman, or the impulsive decision of the village headman, making it even harder to pin down a date.

For the best information, consult travelers who've visited the regions before, guidebooks, and government bureaus. Keep your ears open, and continually ask about local festivals as you travel. Make sure that you get a few similar answers before you trust this information, or you might find yourself traveling for days in a crowded bus to a remote town only to find an empty field littered with festival debris. Sometimes you are lucky, but often you aren't. On a trip in Vietnam, every place I visited I heard the refrain, "If only you had come yesterday (or last week, or last month)." Of course, there are also the fortunate times when you arrive at a fabulous festival you had no idea about.

Some festivals are carefully guarded and restricted to foreigners. Be sure that you have the proper permits to be there. Also, be very careful of your camera gear. Markets and festivals invite pickpockets and thieves. Carry your camera bag diagonally over your shoulder to prevent it from being grabbed off your body. Although this has never happened to me, I've heard of camera straps being cut. So if you have a bag with a waist belt, use it. If you're carrying a thin-canvas camera bag, line it with a towel. This way if the bag is slit, the contents won't fall out. Never leave your bag open or unzipped. In a crowd you'll never feel slippery fingers creeping inside your camera bag and stealing your favorite lens. Don't put your camera bag down unattended. It is helpful to go with a friend who can watch your bag. If you do have to put it down, keep your foot or knee on it with your strap around your leg.

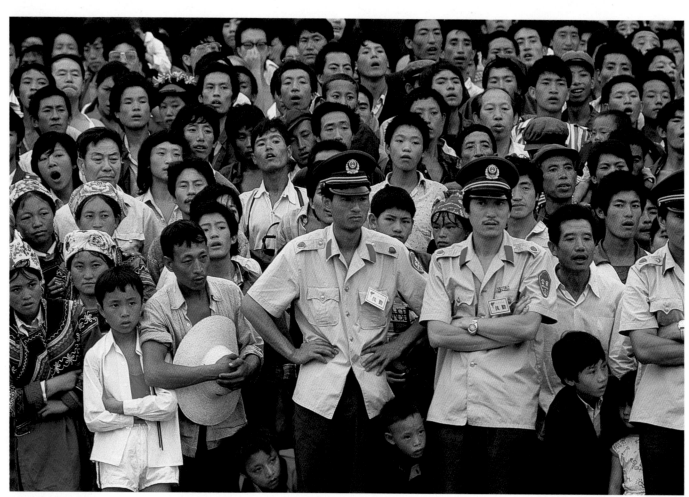

Shooting the Yi Torch Festival in Xichang City in China's Sichuan Province, I decided to focus on the crowd. I was particularly struck by the boy peering out from in between some onlookers' legs. For this shot I used my Nikon F3 with a 180mm lens, and exposed for 1/250 sec. at f/4 on Kodachrome 64.

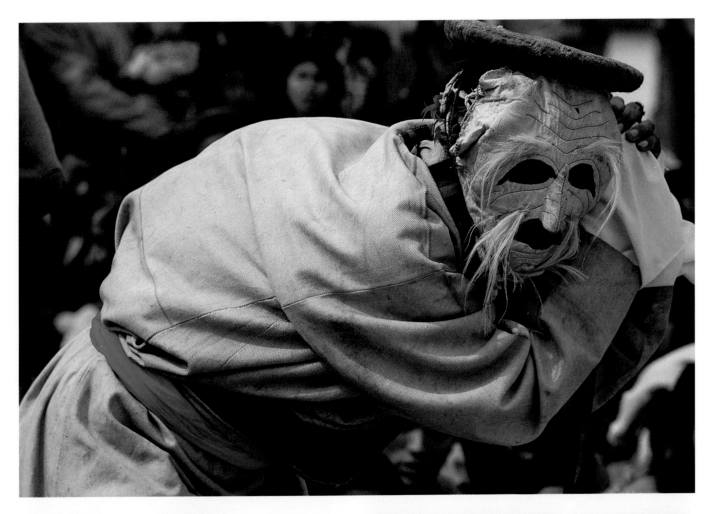

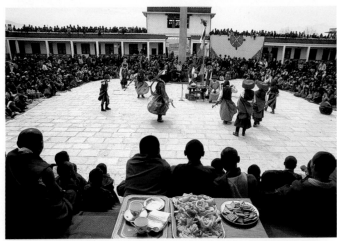

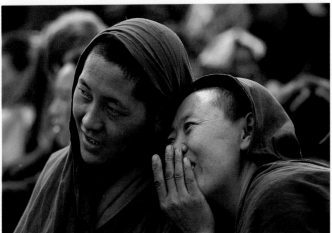

*During the Tibetan New Year celebration in Kathmandu, Nepal, I
concentrated on the details of the dance and the crowd. I was careful
to be unobtrusive, but I still managed to wedge into spaces to get an
unusual angle, such as the area filled with food behind the monks,
shown above. Shooting the scene with my Nikon F3 and a 24mm lens,*

*I exposed Kodachrome 64 for 1/125 sec. at f/8. Then when I sat in
the crowd, I focused on individuals, such as these two Buddhist nuns
enjoying the dance. The masked dancer particularly interested me.
I used my Nikon F3, a 180mm lens, and Kodachrome 64 to photograph
these two scenes; the exposure was 1/250 sec. at f/5.6.*

THE LIGHT IN THE WILD

The aim of photography is to parent shape, tone, texture, and color into a personal expression. Light is the substance that makes this miracle possible. It can transform and exalt the most commonplace subjects. I can't emphasize strongly enough that light is the most important element in photography. Use it inappropriately, and all of your technical skill is wasted; use it successfully, and many of your technical flaws will go unnoticed.

Every photograph is a manifestation of light. I am a rapt admirer of its forms and epiphanies. I marvel at rainbows, thin rays of light streaming through a window in a dark room, shadows, and reflections. For me, light is the ultimate wonder of the world. While I travel through remote landscapes and wilderness, whether I'm photographing people or elephants, I am aware that their very existence is a kind of magic performed by light.

You can't create a perfect sunset, but you can be ready when one occurs. My traveling companions and I were eating dinner in Mongolia when I happened to look out the window and saw a symphony of crimson in the sky. I grabbed my camera and tripod, ran outside, found a good vantage point, and shot until the light disappeared. Working with my Nikon F3 and a 35mm lens, I exposed for 1/30 sec. at f/8 on Kodachrome 64.

THE PERFECT LIGHT

Photographers are always in search of the "perfect light." But "perfect" is a very subjective word. What is inspirational illumination to me may seem disastrous to someone else. Some photographers love the rain, while others thrive in late-afternoon, low-angle light. I am partial to fog and mist; I like the romance and monochromatic qualities.

Luck plays a part in the search for your perfect light. You can plan all you want, but whether you get rainbows or simply rain to shoot ultimately has more to do with chance than skill. When you're traveling, you rarely have time to return to the same spot over and over in order to capture a rainbow or a full moon. So how you respond to an opportunity is often as important as the opportunity itself.

Be aware and anticipate; make your photograph happen. When something lucky happens, quickly assess the situation. Perhaps you can improve on the image by running 100 yards down the trail. Of course, although it doesn't always pay off, sometimes it is necessary to be an active participant when making your photograph rather than a passive one waiting for the world to create your photograph.

SIDELIGHTING

Light coming in at right angles to the subject provides wonderful texture, emphasizing the subject and creating an illusion of depth. Because of the resulting shadows, the sculpted surface of the earth or the individual hairs and other parts of a person's body stand out in bold relief. Sidelighting also produces a partial rim lighting, which accentuates human

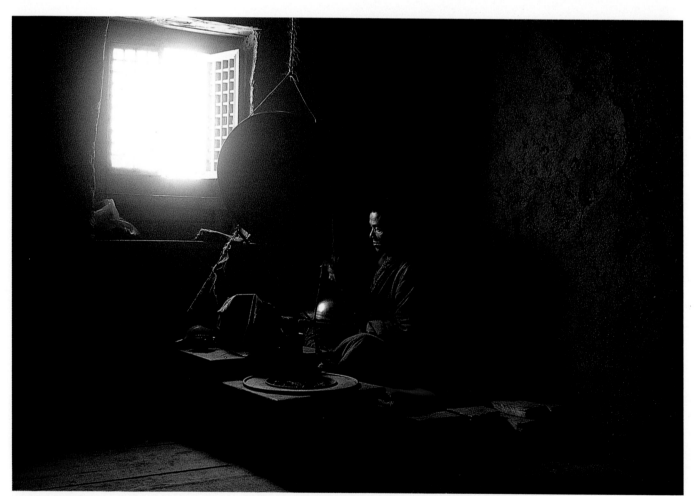

At the Gonga Shan monastery in Sichuan Province, China, I sat with a monk for a few hours everyday while he chanted his prayers. After a couple of days, he agreed to let me photograph him. The light coming in from the side window illuminated his profile. I used a 24mm wide-angle lens on my Nikon F3 to minimize his figure in the image and exposed for 1/8 sec. at f/5.6 on Kodachrome 64.

you can otherwise reduce your flash to $\frac{1}{8}$th or $\frac{1}{16}$th power if you want to keep some detail in the shadowed side.

BACKLIGHTING

Some of the most dramatic outdoor photographs feature backlit subjects, particularly people, animals, and small plants. When the sun is directly behind a subject, a halo of light separates it from the background, emphasizing the subject's form and texture. Subjects that the light can shine through look soft and translucent.

The correct exposure for a backlit photograph depends on the background and how tightly you frame the subject. A backlit head-and-shoulders shot should contain a background that is also backlit or in the shade; if it doesn't, it'll look overexposed. Take a reading by pointing your meter at the shaded side of a gray card, a neutral background, or your hand in the same light falling on the subject. The background will then be perfectly exposed in the photograph, and the closer side of your subject will be slightly darker than normal but still acceptable. A full-length backlit shot will be one stop less exposed, or darker, than the head-and-shoulders shot. Here you can see the sunlit ground the person is standing on, so it is obvious that you're looking at the shaded side of the subject. You expect to see the subject a little darker than usual. Sometimes to balance the photograph, you may need to add some fill flash (see page 95).

Always use a lens hood on your lens to prevent flare; this is caused by stray light hitting your lens. If the sun shines into your lens, you or a friend need to shade the lens with a hand or a piece of cardboard while you shoot or to tape a piece of cardboard or commercial black foil around your lens.

Extreme backlighting causes a silhouette. In these shooting situations detail is blanked out to give an unusual, often mysterious feel to the image. This is particularly effective for subjects that have graphic, recognizable forms, such as people, buildings, animals, and trees. To create a silhouette, simply meter the light area near the sun. The resulting exposure will be three to four stops overexposed, making your subject appear black and dramatic.

SUNRISES AND SUNSETS

An intense and rewarding time to photograph is just before and after sunrise and sunset. These are the times when the light is magical (the weather gods permitting, of course), when the world is full of brilliant, efflorescent colors. For an hour before dawn and following sunset, a cool-blue light casts an air of mystery across the landscape. During the 5 to 10 minutes

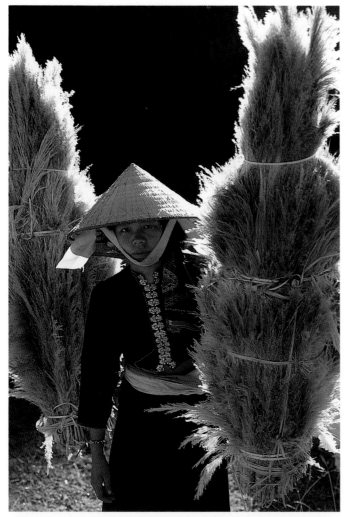

One day while I was photographing the ethnic hill tribes in Son La Province in northwestern Vietnam, a young Black Thai girl walked by carrying two bundles of Lau flowers used for stuffing mattresses. The sun was shining from behind, dramatically backlighting her and her load. I motioned to the girl to stop, metered off my hand, and shot a series of photographs. For this image, I used my Nikon F4 and a 24mm lens. The exposure was 1/60 sec. at f/5.6 on Kodachrome 64.

hair and animal ears, horns, or antlers. Because sidelighting effectively reduces the strength of the sun by at least 1 full stop, you'll have to open the aperture or reduce your shutter speed by 1 to 1 1/2 stops.

One of the most flattering types of indoor illumination is window light; it bestows on the subject an attractive sidelighting. But when light falls on the subject from the side, sometimes the contrast between the illuminated and shaded areas is very high. This causes the subject to appear to be cut in half. You might need to fill in the darker side of the face with a reflector;

right before sunrise and after sunset, the air is imbued with a golden glow emanating from the sun, and frontlit subjects are bathed in this spectacular illumination.

You have to work quickly and decisively to catch this mystical time. In the temperate latitudes in summer, the sun touches the horizon for less than two minutes after it first appears in the morning and before setting at night. In the northern latitudes the sun moves much more slowly, but as you get closer to the equator the sun drops like a lead ball at sunset.

I prize sunsets in dusty or humid places. These atmospheric conditions filter out the blue light, leaving only the red to produce splendid sunsets. Humidity and haze screen the sun so that it appears to be a crimson sphere when it drops below the horizon.

The most reliable way to determine exposure at sunset and sunrise when you want to include the sun in the picture is to meter an area of sky just to one side of the sun, excluding it from the frame. Then lock in the exposure indicated, and swing the camera back to compose the view as you want. I always bracket copiously in these situations, so that I have a range of color saturations to choose from later. Check your exposure often because light levels change by the minute. If you are a serious photographer, you might want to consider investing in an incident-light meter, which measures the light that falls on the subject. This will ultimately save you a lot of trial and error, especially when you photograph people at sunset.

If you want to correctly expose for the foreground subject without losing the color saturation of the sunset or sunrise sky, use a one- or two-stop split neutral-density (ND) filter. Don't use an aperture smaller than $f/8$ with a wide-angle or standard lens or $f/11$ with a telephoto lens because the filter's gray line of density will sharpen up on the film and cause a noticeable line in your composition.

The sun always seems bigger when it is low in the sky, but you need a surprisingly powerful telephoto lens to magnify it significantly on film. For a rough guide, dividing a lens' focal length by 100 gives the sun's size on the negative in millimeters. For example, with a 200mm lens, a setting sun fills just $1/12$th of the picture width. You'll find that using a teleconverter to increase the sun's size is worthwhile, and needle-sharpness isn't usually crucial in sunset and sunrise pictures.

On the other hand, knowing exactly when and where the sun rises and sets is obviously critical to help you anticipate and set up a shot. Local newspapers usually publish these times but often you are far away from such conveniences or they're printed in a language you don't understand. I always have a compass in my camera bag in order to orient myself to the sun. However, the positions of the rising and setting sun can vary as much as 60 degrees in the middle latitudes over the course of the year. The least-complicated method of

I set up my tripod on a stone outcropping above the Cay River in Nhatrang, Vietnam, and waited for the sunset. As the river began to turn golden, a small boat happened to paddle down it. I metered off my hand in the sun and bracketed while I shot. Here, I used my Nikon N8008 with a 35-70mm zoom lens and exposed for 1/60 sec. at f/8 on Kodachrome 64.

In Botswana, Africa, I was transfixed by the light and woke up every morning before dawn to photograph in the sweet light just before the sun rose. One afternoon in Savuti National Park, I noticed a group of magnificent dead trees; checking my compass, I realized that the sun rose directly behind them. So I returned the next morning with my Nikon F3 and a 20mm lens to capture this scene. The exposure was 1/15 sec. at f/5.6 on Kodachrome 64.

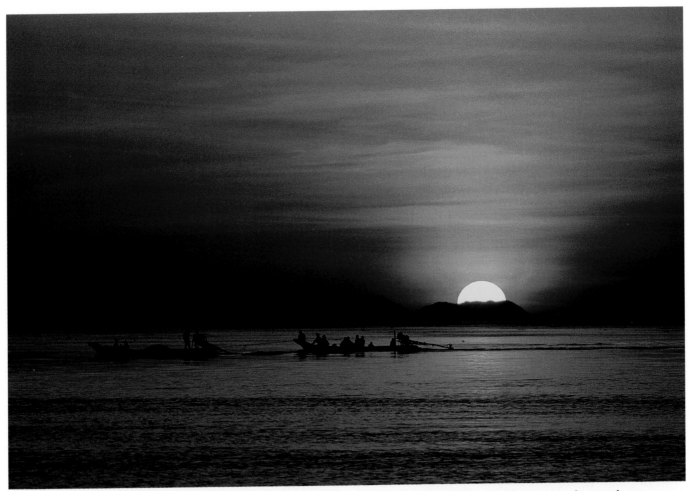

I was photographing the sunset off the coast of Cambodia in Kien Giang Province when, fortuitously, a long boat appeared just as the sun began to drop below the horizon. I metered to the left of the setting sun and quickly bracketed a series of photographs, using the motor drive on my Nikon N8008. Working with a 35-70mm zoom lens, I exposed for 1/125 sec. at f/8 on Kodachrome 64.

accurately forecasting sunrises and sunsets is being in the same place two days in a row and simply making observations.

You can also use the *Nautical Almanac*, which is published by the United States Naval Observatory and is available in any United States government bookstore. To use this almanac you need a map that depicts latitude and longitude and a good compass. Calculating the sun's rising and setting times is a little complicated, but it comes quickly and easily with practice.

Computer enthusiasts have another option: choosing from the dozens of software programs at a good computer-software store that tell you everything about what's going on in the sky. Visual Departures makes a software program for pocket computers called "Focal Ware." It determines the sun's angle at any time of day at any inputted longitude and latitude, and gives sunrise and sunset times.

TWILIGHT

At twilight the land is painted with the colors of sunset, but without the glare of the sun itself. So the colors are subtle across the whole frame, not just the sky. There is no direct sunlight illuminating the hard edges of the landscape, but there is still enough light in the sky to photograph.

Most photographers put their cameras away too soon. As it gets dark out you may lose the ability to detect color, but photographic film doesn't lose its sensitivity in the same manner; it can still record the fading colors. Twilight is an especially good time to shoot city lights and traffic. City lights give a cityscape a certain ambience, and if you shoot traffic at twilight with a long exposure, you'll get dramatic long trails of light from both the headlights and taillights of the vehicles. The longer the exposure, the longer the trails. At twilight the

lights of the city and the light of the sky are basically equal in their exposure values. Meter off the dusky twilight sky, not the city lights, and use the longest possible exposure to emphasize the flow of the traffic. For accurate exposures, use a handheld meter. I've also had excellent results with my in-camera meter, but I bracket extensively. Handholding your camera in this low light is impossible. Mounting your camera on a tripod is ideal, but you can also prop your camera on a wall or a chair.

Film speed drops in dim conditions. Allow 1/2 stop extra when the shutter is open for more than 1 sec., 1 stop for shutter speeds longer than 10 sec., and 2 stops for those longer than 60 sec. If your camera doesn't have these long shutter speeds, set the shutter-speed dial to "B," hold the shutter open with a cable release, and time the exposure with your watch or count the seconds. To compensate for reciprocity failure, which is a radical shift of color noticeable at shutter speeds longer than 1 sec., allow more exposure than the meter indicates, usually 1/2 to 1 stop. Personally I like the odd color shifts, but I always bracket long exposures since it is difficult to predict all the variables.

SHOOTING THE MOON

The moon adds drama and romance to a landscape photograph and is relatively easy to capture on film when you know a few of the basic rules. I try to shoot the "full" moonrise the day before it is actually full. At that time the moon rises in conjunction with sunset, casting a gentle glow onto the landscape and enabling you to photograph detail in both the foreground and middleground. If you wait until the next day for the true full moon, you'll find that the moon will rise approximately an hour later. By then the foreground will be too dark, and the moon will appear as a white hole in your photograph. If you do shoot on the eve of the full moon, be aware that there is a three- to four-stop exposure difference between the land and the sky. You can compensate for this with a split ND filter.

To get a good-size moon on film, use a 135mm or longer telephoto lens. Telephoto lenses that are 400mm and longer in length produce the most dramatic results. However, there are no rules. I've seen some stunning moonrise photographs that were made with wide-angle lenses. Whatever size lens you choose, mount the lens on a sturdy tripod, set it at wide open, and use the fastest shutter speed possible to minimize any image blur that can result from the shaking of the camera lens and tripod.

To retain detail, try to photograph the moon when it is just a little paler than the sky. The moon reflects direct sunlight at a reflectivity of only 7 percent, so it demands a near daylight exposure. The trick, therefore, is to have enough ambient light in the scene to hold detail in both the moon and the sky. A landscape with a moonrise should be metered no differently than a landscape without one. At sunset on the day

At the Makalu Basecamp, at an altitude of 16,000 feet, I mounted my Nikon F3 and a 180mm lens on a tripod and then made this image of the top of Makalu Peak, the fifth-highest mountain in the world. Shooting right before sunset, I exposed for 1/125 sec. at f/8 on Kodachrome 64.

I left my Nikon F3 and 180mm lens in place and returned half an hour later to capture the last scarlet remnants of light on Makalu Peak. For this shot, I exposed for 1/60 sec. at f/4 on Kodachrome 64.

before the actual full moon, the sky and landscape are equally bathed in the final remnants of light from the western sky; their exposures are as close to identical as you can get. Be sure to meter off the sky just above the horizon, not off dark shadows. If there is a one- or two-stop difference between the land and sky, you'll find it best to split the exposure with a bit of emphasis on the sky and to bracket.

The moon ascends in the sky roughly one diameter every two minutes. So to prevent blur and to keep the moon round, you need to expose for no longer than 10 sec. with a standard lens and a shorter duration with a telephoto lens. To photograph the moon one hour after dark and even later, set the fastest shutter speed possible with the lens wide open. For example, if you're using ISO 64 film, shoot at $f/5.6$ for 1/250 sec.

The time of the moonrise can vary greatly from day to day, a result of the angle of the moon's orbit around the earth. If possible scout the location beforehand, so you can see where the moon comes up in relation to the surrounding landscape. Plan your composition; you don't want to be running around at the moment you should be taking your photograph. Once again, you can use the *Nautical Almanac* or a computer program for times of the moonrise and moonset.

Just as you do with the full moon, you want to photograph the crescent moon immediately before or after the sunset in order to try balancing the brightness of the moon with the ambient light. The best time is just before the sky has lost its color or light. When shooting Kodachrome 64, you should photograph a half moon at $f/5.6$ for 1/60 sec. and a crescent moon at $f/5.6$ for 1/8 sec. Be sure to bracket your exposures $^{1}/_{2}$ to 1 full stop on either side of the indicated exposure; this will guarantee your getting a successful shot.

For unusual coloration and time effects, take a long time exposure solely by the light of the moon. Photographing by moonlight is a fairly straightforward but time-consuming process. Trial and error is essential here because so much depends on your lens and film. As a beginning point, Kodak recommends a 15-sec. exposure at $f/2.8$ with ISO 400 film. Add at least one stop for reciprocity failure, and two or even three stops for some films. With Fujichrome 400 I find that two-, four-, and six-minute exposures at $f/4$ gives me interesting results. Since you'll want to bracket exposures, it is clear that one successful image can take at least 30 minutes to produce.

Ideally your camera should feature manual exposure control, a tripod socket, a cable-release socket, and a mirror lockup button. Use a sturdy tripod, and bring a penlight to help you determine exposures in the dark. Since color film exposes moonlight quite vividly, be sure to include star trails or distant artificial lights, such as car lights or building lights, in your framing. Otherwise the photograph might appear as if it were taken during the day.

Later that night, after a virtually full moonrise, I ventured outside my tent to shoot Makalu Peak. Because I was at a high altitude, the light was especially brilliant and pure, almost like daylight. I used the automatic meter on my Nikon F3, which had a 50mm lens on it, for the basic reading and then bracketed. Here, I exposed at f/5.6 for 5 sec. on Kodachrome 64.

In Chukung Valley, Nepal, I steadied my camera on a wall to photograph the full moonrise over Island Peak. Since I was shooting the day before the actual full moon, I was able to take a light reading from the sky and still maintain detail in the mountain. Here, I used my Nikon F3 with an 80-200mm zoom lens and exposed for 1/125 sec. at f/5.6 on Kodachrome 64.

Including the moon as an integral part of a daytime photograph isn't always easy. Unless the sky is exceptionally clear, a moon of any kind during the day might simply be too faint to record well. One exception is a half moon at 90 degrees from the sun; it can often be made to "pop out" by using a polarizer.

RAINBOWS

Stormy weather and intermittent sunlight should alert you to be prepared for rainbow possibilities. To find a rainbow, stand with your back to the sun. If one is present, it'll be visible in the sky directly in front of you. Even faint rainbows are easy to spot in the sky because they move across a static background when you move.

The sun must be low on the horizon in order to form one of those enormous, spectacular rainbows that seem to form an arc from the ground to the zenith of the sky. This often conveniently occurs just before sunset as the sun bursts from the storm clouds before sinking into local cloud cover.

On film, rainbows often appear fainter than you remember because the colors aren't always bright enough to make a good picture. The key is the background: a rainbow photographs best against a dark backdrop. I usually meter and expose for the sky and the rainbow. If the sky is dark, I'll close down one or two stops to retain the drama and keep the rainbow colors saturated. Since the double-refracted light of a rainbow is polarized, you can brighten a faint rainbow or completely erase it by using a polarizer.

I am also always on the lookout for unconventional light reflections and refractions. Rainbow streamers are produced when sunlight is refracted through humidity or light mist and, as their name suggests, manifest themselves as streamers of light. They can be found when it is humid and misty out, but only if you use a polarizer.

IMPERFECT LIGHT

When you travel you have to accept whatever comes your way, opening yourself to the vagaries of the unknown. This applies not only to experiential encounters, but also to photographic endeavors. Often you'll end up somewhere during less-than-ideal light conditions. Your goal is to turn imperfection to perfection. Sometimes the "imperfect light" is an illusion or a curtain in front of a great photograph. If you walk away with a rigid preconception, thinking, "I can't shoot—it's the middle of the day, it's raining, and it's too dark," you might miss out on a photographic gem.

HIGH NOON

Sometimes it seems as if everything and everybody are conspiring against your photographic efforts. For instance, on one trip to Africa my companions and I always seemed to arrive at the game parks right in the middle of the day when the light was flat and the landscape was washed out. A scenario like this is frustrating, but there are ways to

At the Syambunath stupa in Kathmandu, Nepal, I was photographing with a polarizer on my 80-200mm zoom lens to darken the sky after a light rainfall. I noticed a series of rainbow streamers and framed them next to the famous Buddha eyes on top of the stupa. Shooting with my Nikon F3, I exposed for 1/250 sec. at f/4 on Kodachrome 64.

I was trekking in the Everest region through a thick fog. As I crested a ridge, the fog lifted slightly so I was able to get a brief glimpse of Namche Bazaar. It was dark, but I steadied my Nikon F3 and 85mm lens and shot this mystical image. The exposure was 1/15 sec. at f/2.8 on Kodachrome 64.

I usually avoid shooting at high noon, but one midday in Vietnam I was driving toward Nhatrang and passed some people winnowing rice. Struck by the deep shadows and the color of the rice, I got out of the car and talked to the locals while checking out the photographic possibilities. I used a 20mm wide-angle lens on my Nikon F3 to come in close on a couple of baskets that were resting on a pile of rice for a strong foreground and to include the activity in the background at the same time. I used a polarizer to help saturate the colors and exposed at f/8 for 1/60 sec. on Kodachrome 64.

salvage the situation. One option is to use a polarizer to cut the glare and squeeze some color out of a less-than-optimal shooting situation.

At midday people tend to linger in alleyways and doorways as well as inside buildings, mosques, and churches to escape the sun and heat. So these places are great opportunities for photography. Shadows saturate color. By waiting for the right person to complement a wall or a door, you can explode a dull scene with a vivid splash of color. Midday is also an excellent time to scout for potential photographic sites; this simple but often underutilized practice enables you to know exactly where the best photo opportunities are.

USING FILL FLASH

When you shoot at midday, another option is to use a bit of fill flash. This is a relatively easy procedure. Basically, you're adding light to the shadows to bring them closer in value to the highlights. In a sense, you're filling in the shadows—hence the term "fill flash"—although a more accurate term would be "balanced fill." If some fill light is impractical, you either have to live with the shadows or make them a graphic element of your photograph. Come in close to isolate an image, and make color or a detail, not light, the main event.

If you can use fill flash, the world of high-noon photography opens up to you. When the sun is at its zenith, it casts harsh, deep shadows (under the eyes or from hats) that normally ruin

portraits. A touch of fill flash opens the shadows and adds direction to the light. With the addition of as little as ¹/₁₆th to ¹/₂ the flash power of your strobe light, you can transform a contrasty setting into a stunning image.

Using fill flash has always been a common technique among professionals, but it has been incorporated only recently into the mechanisms of modern cameras, even point-and-shoot cameras, to make it easier for the amateur photographer. The older, direct full flash erased all shadows and texture of the subject, caused "red eye," or reflected light back into the camera from glasses or shiny surfaces. Now fill flash in combination with sunlight is becoming increasingly common

in outdoor photography. Balanced fill minimizes shadows across your portrait subject and blends your subject naturally with the background.

If your flash unit offers variable-power levels, you can experiment with fractional power to achieve just the right intensity of fill in the shadow areas of your shot. When I use a Nikon N8008 or F4 in conjunction with a Nikon SB-24 flash unit, all the fill-flash calculations are made for me. Combining TTL flash exposure with the camera's matrix-metering system produces accurate overall results. The strobe fills to the ratio of your choice between the main light and the fill flash (1:+1 EV, which stands for "exposure value," to 1:−3 EV) and continues to automatically maintain that ratio as you move from subject to subject.

If you set the strobe on the fully automatic mode, it'll fill somewhere between equal balance and −1 EV under the main light source. I feel that this is usually too much fill. In most situations I like to keep the SB-24 flash set on −2 EV to achieve a natural ratio between highlights and shadows; this is just enough to soften shadows or to add catchlights to the subjects' eyes to give portraits a professional look.

You don't have to be concerned about midday exposures because most of the newer cameras sync at 1/250 sec. In a bright sunlit situation requiring an exposure of $f/11$ for 1/125 sec., a sync speed of only 1/60 sec. calls for an $f/16$ aperture to maintain proper background exposure. Depending on the flash-to-subject distance, however, this aperture might be too small to produce adequate fill-flash exposure in the shadows. High sync speeds also help minimize the possibility of ghost images, which are additional existing-light images caused by subject movement.

Some professional photographers have made a career out of shooting strobe-filled photographs at sunset. With the recent advancements in modern cameras, amateurs can make the same type of shots without having to do elaborate calculations. Some photographers let the backgrounds and perimeters of their subjects blur with slow shutter speeds, and then freeze the subject with a blast from an on-camera strobe. The resulting images are called "fades."

If you can't adjust your strobe, you do have another choice. You can vary the ratio of the strobe to the main light by changing the film-speed rating or the exposure compensation of the camera. (Don't forget to reset your camera when you remove the strobe.) The critical element in your camera's exposure system is the aperture. You can also substitute a strobe with a reflector card or a Flexfill. This is a circular reflector made of silver, white, or gold cloth bound by a

After a long day trekking in Nepal I passed by some of the porters preparing their evening meal as I arrived at camp. I put an SB-24 flash on my Nikon N8008, set it to matrix fill flash with a -2 EV, and shot a couple of photographs. I used a 35-70mm zoom lens and Kodachrome 64.

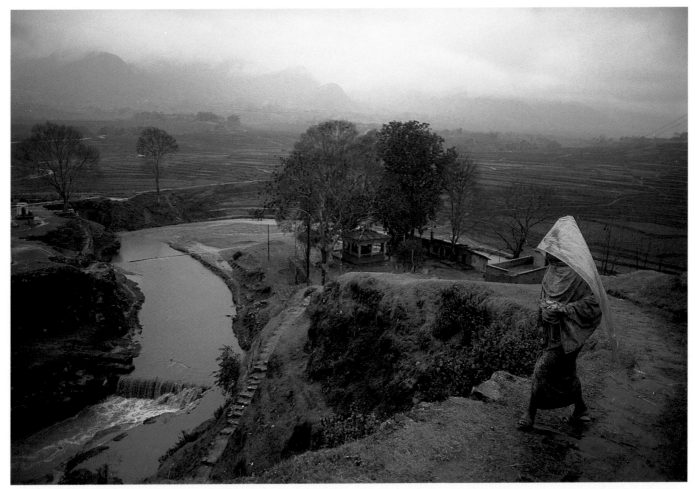

In the Kathmandu Valley in Nepal during a monsoon, it was raining heavily as I was heading to a friend's house to participate in a local festival. Behind me I saw a young girl coming up the trail with a religious offering. I moved to a spot above her, sheltered my Nikon F3 and 35mm lens with an umbrella, and shot unnoticed as she approached me. The exposure was 1/60 sec. at f/5.6 on Kodachrome 64.

flexible metal ring; it can be twisted to smaller than half its size, so it is portable. Both the reflector card and the Flexfill reflect sunlight back onto the subject from a different angle. One advantage to using a reflector is that you actually see the effect of the reflector on your subject: the light produced is much softer than the harsh, direct light of a flash. The disadvantage is that you need someone to hold the reflector.

If you're shooting a portrait with the background in the sun, you should calculate the exposure using the sun as the light source; otherwise the background will look overexposed. Since your subject is backlit, you need a fill light, one or two stops less than the full sun exposure (depending on your personal preference), from a reflector or a flash in order to avoid underexposing your subject. You usually want to keep the light soft, even, and natural looking, but not too flat.

OVERCAST SKIES AND RAIN

Many photographers head for the hotel or the tent when the clouds roll in and the sun disappears. This is unfortunate because gray, overcast skies are perfect for shooting portraits, markets, and subjects with intricate details or saturated colors, such as leaves, plants, and flowers. There are no harsh shadows; the light is diffused and evens out abrupt contrasts between sun and shade. The shadows have full detail, and there are soft, gradual transitions to the parts illuminated by the main light. You can shoot almost anything that doesn't require a blue sky or shadows to delineate land contours.

Sometimes inclement weather is as much a part of a place as sunshine is in the Sahara desert. The Brazilian rain forest, for example, looks terrible in the sun. If you get to the rain forest on a rainy day, be thankful—that is the way it's supposed to

be. Rain saturates and evens out colors, and evokes a special mood. Raindrops flash past so fast and their translucent quality makes them so indistinct that they often disappear in the picture. To prevent this, include an area of water, such as a puddle, in the foreground. You can also take advantage of strong backlighting from the sun to distinctly reveal the raindrops. You can even use a flash to capture the droplets of rain.

During a stormy afternoon in Botswana, Africa, the sun broke through the clouds for a few minutes to dramatically illuminate an acacia tree at the edge of the Moremi Reserve. I yelled for the driver to stop and reeled off a few exposures. Seconds later, the sun disappeared and the scene looked uninteresting again. With my Nikon N8008 and a 35-70mm zoom lens, I exposed for 1/60 sec. at f/5.6 on Kodachrome 64.

Storms often create unexpected and sensational lighting, with the foreground brilliantly illuminated against a navy sky. Catching these moments requires being instantly ready. Your camera meter usually responds to the extreme highlights of storm light and produces underexposed pictures. Bracket the exposure one stop over and one stop under.

HAZE, MIST, AND FOG

These conditions can spawn very romantic images. Haze creates a sense of distance and depth in a picture. It makes distant parts of the scene look bluer and lighter than the foreground, such as a series of ridges one after another that fade into the distance. If you want the clearest possible pictures, use a polarizer. This often darkens and improves the contrast of distant parts of the scene.

Light mist adds atmosphere to any scene, but you need to be out very early. Once the sun appears above the horizon, it is only a matter of minutes before thermal air currents lift the mist from the ground. Select subjects that have inherently strong outlines, such as buildings, boats on a lake, fences, and rock outcroppings. Subjects that rely on texture or form for their impact are weakened in such soft light. The prevailing white tones easily confuse the camera's exposure meter, so the resulting photographs tend to look too gray and dull. Open up 1 to 1½ stops.

Thick mist and fog isolate and soften the forms of buildings and intrusive objects, creating a dreamy scene that might

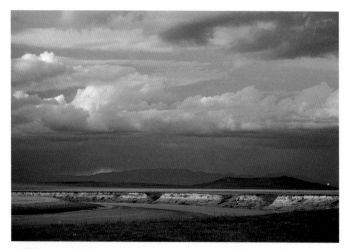

While I was riding across the Songpan Grasslands in the Tibetan Plateau in China, the sun unexpectedly broke through the clouds right before sunset to inject a thin line of yellow light across the landscape. Here, I used my Nikon F3 and a 35mm lens, and exposed for 1/125 sec. at f/4 on Kodachrome 64.

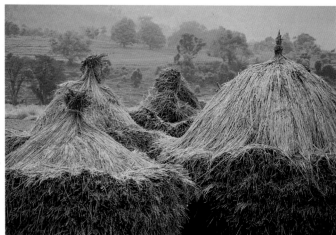

On an overcast, rainy day in the Modi Khola Valley in Nepal, I photographed a group of freshly stacked hay. I was attracted by the saturated colors and textures, which were emphasized by the diffused, misty light. Shooting with my Nikon F3 and a 35mm lens, I exposed at f/4 for 1/60 sec. on Kodachrome 64.

At the low elevations in Nepal, a fog often blankets the ground in the early morning. I photographed one of our porters carrying his wares to the weekly market in Khandbari Village through a light, hazy mist. With my Nikon F3 and an 85mm lens, I exposed at f/5.6 for 1/125 sec. on Kodachrome 64.

not be interesting in sunlight. If you want to retain the moody atmosphere of a dark-gray, misty morning, use the exposure indicated by your in-camera meter. The pastel tones of the fog will be amplified, and the objects in the image will loom mysteriously.

HIGH CONTRAST

Unlike the human eye, film has trouble coping with the broad contrast range between highlights and shadows that is prevalent in outdoor scenes. Most color-transparency films have a total exposure range of only four to five stops, and often the exposure range of a potential photograph is much

The light was extremely dim in this brocade factory in Chengdu in China's Sichuan Province. So I loaded my camera with a special push film, Fuji P1600, and rated it at ISO 800. Leaning against the wall to steady my Nikon F3 and 35mm lens, I made a number of shots using the motor drive.

greater. Your choice is either to expose for the highlights and let the shadows go dark, or to expose for detail in the shadow areas and wash out the highlights.

This is when a split-field ND filter, also called a graduated filter, becomes essential. It increases the latitude of your film, enabling it to record a much wider range of light values. It helps balance, for example, bright skies and glaring snowcaps with dark rocks and shaded foregrounds. This type of filter is dense at one edge, and the density tapers so the other edge is clear. There are many variations of these filters. They can be rectangular or round. Screw-on filters come in glass, plastic, and different tones and colors. Select a system that allows you to move the filter up and down in the frame and to rotate it 360 degrees.

Graduated filters work best when there is a sharp edge, or a horizon line, between the elements of differing brightness in a photograph. When you place the filter in front of the lens, the part covered by the neutral-density half of the filter is reduced in brightness, while the rest of the photograph remains unaffected.

I've begun to find more and more uses for graduated filters, such as sunsets with dark foregrounds, canyon shots in which one wall is in shade and the other is in bright sunlight, and backlit skies. I use a graduated filter whenever I feel there is a disparity of more than three or four stops between two essential elements of an image. These filters aren't the solution for all situations, but if used properly they allow you to make a successful image out of a potential loss.

I primarily use two Cokin Graduated Gray density filters: a G120, which results in a one-stop loss of light, and a G121, which results in a two-stop loss of light. I can also combine these filters for a three-stop change in light loss. It is important to note that Cokin filters aren't true graduated ND filters, but rather filters that range from clear to gray in color. They're made from an optical-resin compound and conform to the standards of neutral density.

Because Cokin filters are plastic, they hinder image sharpness more than glass filters do. They also tend to harbor static electricity, attract a lot of dust, scratch easily, and aren't always as neutral or evenly colored as I'd like. However, they are inexpensive enough to replace frequently if they become scratched, and light enough to carry in your pocket.

If your wallet allows, I recommend buying either the more expensive, sharper Tiffen glass-square filters that fit the Cokin P series holder, or the Heliopan optical-resin or optical-glass rectangular filters that come with their own rotating filter holder.

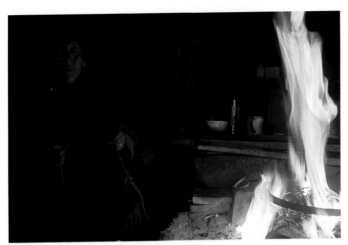

I photographed a Tibetan woman sitting by a fire spinning her prayer wheel. Because there was no natural light in the house, I set up my Nikon F3 and a 35mm lens on a tripod and took a light reading off her face and the fire. I used a slow shutter speed, 1/8 sec., to accentuate the flames and exposed Kodachrome 64 at f/5.6.

LOW-LIGHT SHOOTING

Modern photographic technology has effectively made it possible to photograph virtually anything that can be seen with the naked eye. This is important for photographers who travel to parts of the world with dark temples and small-windowed houses. Often some of the best photographic opportunities are in light that is too low for Kodachrome 64 or Fujichrome 50, and when your tripod is at home, fill flash isn't appropriate, or your lens is too slow. I love the grainy texture and ruddy color of Kodachrome 200, especially for indoor candlelight, firelight, and lamplight portraits. Films faster than ISO 200 are grainier and have slightly washed-out colors but work beautifully in low-light situations, especially in fog or by firelight.

When you photograph people in dark settings, such as inside a dim hut, using a slow shutter speed, wait for a relatively quiet moment or a pause in the action to avoid a blurred subject. Mount your camera on a tripod if possible, or brace your camera firmly so you can shoot with a very slow shutter speed. I can handhold my camera down to 1/4 sec. with a wide-angle lens and a motor drive. I press the camera against my forehead, pull my elbows into my body, and try to lean against a wall, a tree, or a friend to steady myself even more. Then I take a breath and exhale before pressing the motor drive, shooting between four and eight photographs. At least one image is always sharp; more usually are. The longer the focal length of the lens you use with this technique, the worse your odds at preventing camera shake are.

You can also consider pushing your film. For outdoor scenes, I've found that Fujichrome 100 can be pushed acceptably to ISO 200. I've talked to a number of photographers who actually prefer Fujichrome 100 pushed to ISO 200 over Kodachrome 200. When you push most slide or print film, you suffer increased grain, higher contrast, and an attendant loss of both shadow detail and color saturation. If you push film too far, usually more than about $2\frac{1}{2}$ stops, reciprocity failure will occur. Some slide films are specifically designed for push processing, such as Fujichrome P1600 and Ektachrome P800/1600 Pro films. Experiment with them to satisfy your own chromatic taste. I never push Fuji Velvia or Kodachrome 64; the color tones shift off scale. I've also found that Velvia is particularly bad for Caucasian complexions—they become very ruddy—and there is too much contrast.

Pushing film is a simple technique of resetting the film-speed dial to the desired film speed. Then when it comes time to process the roll, simply inform your E-6 lab that you shot it at a different ISO rating and want it push-processed accordingly. To ensure there are no mistakes, I write, for example, "push to ISO 200" with a marking pen directly on the canister or on a piece of masking tape on the canister. (Kodak sells ESP-1 prepaid mailers for one-stop push processing. Each mailer costs $2, and the price covers the additional expense for push-processing when used in conjunction with the standard PK36 mailer for Ektachrome and Kodachrome.)

In low-light situations selective focusing is extremely important. Since depth of field is probably limited, it is critical to focus directly on the person or object of interest. As long as the subject's eyes are in focus, it usually isn't disturbing if the rest of the photograph isn't. You can also use a bit of fill flash, $\frac{1}{2}$ to $\frac{1}{4}$ the power of the strobe. To match light given off by a fire, I tape an 85B acetate filter over my flash.

The problem with most automatic cameras with built-in automatic flash is that the camera often sets itself at 1/60 sec. or 1/250 sec., whatever is the camera's maximum sync speed. In low-ambient-light situations, this speed won't keep the shutter open long enough to give you a good background exposure. Backgrounds become black voids, and foreground subjects seem to be standing in a spotlight.

The Nikon SB-24 flash and other advanced strobes permit you to work with slow shutter speeds for low-light backgrounds by either setting the rear-curtain sync (when the strobe fires at the end of the shutter curtain opening), or setting the camera on shutter priority. The matrix meter reads the background perfectly while the SB-24 flash provides a balanced main light in the foreground.

ELUSIVE LANDSCAPES

A good landscape photograph is more than a mere record of where you were. It reflects your basic understanding of yourself in nature at that moment and is an important element of your traveling experience. There is no such thing as an objective landscape photograph. All photographers make subjective decisions at every stage of picture-taking, right from the moment they stop to view a scene and evaluate it. Often what they choose to leave out is more important than what they include. And packing in too much tends to confuse and ultimately weaken the image. Simplicity in design is the key.

CONTEMPLATING THE LANDSCAPE

Approach your landscapes with the same open mind with which you approach people, having no fixed ideas or preconceptions. I often try to steer a course between spontaneity and control. On one hand, I want to give the impression that I am in full control of technique; however, I don't want to rob a picture of its vitality. Sometimes I'll sit and look at a particular landscape for a long time before it becomes clear to me what I'm trying to express. At other times, what I want to say hits me right away. Great landscape photographs are usually the result of intuition, anticipation, thinking, and planning—and a bit of luck.

VARYING YOUR VIEWPOINT

Mobility is a more valuable photographic tool than owning a vast number of lenses is. By moving around your subject, you can totally change the composition of a picture, aligning different foreground and background elements or cropping out unwanted details close to the camera.

In New Zealand I was intrigued by the contrast of the gray, dead limbs of a Putukawa tree against the live green foliage. Shooting with my Nikon N8008 and a 180mm lens, I framed the image tightly. I exposed for 1/250 sec. at f/4 on Kodachrome 64.

In Nepal, I photographed the full moon and the Annapurna massif using a 24mm wide-angle lens on my Nikon F3. I wanted the sky to dominate the frame, and the mountains and the moon to anchor the image. The exposure was 1/60 sec. at f/5.6 on Kodachrome 64.

In the Central Pamir Mountains of Tajikistan, I watched the shadow patterns flit across the landscape. I framed the large boulder in the foreground to echo the large hill in the background. With my Nikon F3 and a 24mm lens, I exposed for 1/60 sec. at f/11 on Kodachrome 64.

I was photographing the glare of the setting sun in some rice paddies in Vietnam's Nghia Binh Province when I realized that the composition would be improved by a higher perspective. So I ran up a hill and took this shot just before the sun disappeared. The small figure in the fields adds needed perspective. With my Nikon F3 and a 180mm lens, I exposed at f/8 for 1/125 sec. on Kodachrome 64.

USING WIDE-ANGLE LENSES

It is easy to be seduced into collecting lenses by the expectation that they'll help you make better photographs. They won't, and they don't make you a better photographer either, although they do extend your range and give you a wider choice of viewpoints. Each photographer has a preferred lens for landscape photography. I tend to favor wide-angle lenses even though I've heard that 18mm to 28mm wide-angle lenses are the hardest to learn to use properly. This may be true, but once you master the techniques, you'll find wide-angle lenses to be perfect for landscape photography.

Wide-angle lenses enable you to provide an interesting foreground while including background information for viewers. They give a perspective to the entire image. These lenses simply increase the area that can be included in a photograph beyond what is possible with standard lenses.

Wide-angle lenses also help you in tight places, such as narrow canyons, creating a sensation of dynamic space that strongly involves viewers. Using a longer-focal-length lens in such places won't give you the feeling of the space you're trying to photograph.

Changing your viewpoint has the most dramatic effect when you use wide-angle lenses. Because they include more of the subject close to the camera, moving just a yard or two to the left or right brings a completely different foreground into view. A high camera position is very effective on flat terrain where the horizon is relatively distant. Extend the tripod fully, and point your camera down to show just a sliver of the sky; this emphasizes the immensity and vastness of the open space.

A low camera angle is one of my favorite shooting positions. It is most effective when an object or large subject is relatively close to the camera, and the terrain isn't the most

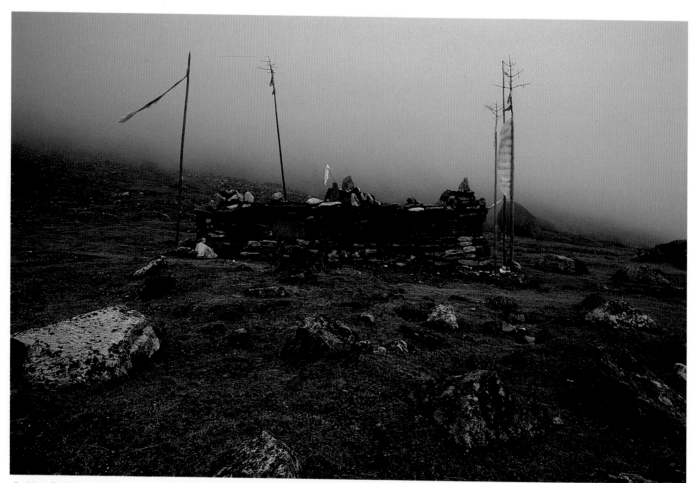

In Nepal's Barun Valley I accentuated the rocky field in front of a Buddhist mani wall, a bench stacked with stones carved with a prayer, to draw the viewer's eye toward the wall. Shooting with a Nikon F3 and a 24mm lens, I exposed for 1/30 sec. at f/8 on Kodachrome 64.

At sunrise along the Chobe River in Botswana, Africa, I set up my Nikon N8008 and a 20mm lens on a tripod low to the ground and shot up toward brightening sky from under the tree. The exposure was 1/15 sec. at f/8 on Kodachrome 64.

I was fascinated by the sinuous design and bright color of these rice fields in Nepal. I waited for the sun to illuminate the pattern. Then, for impact, I cropped the image close. With my Nikon F3 and a 180mm lens, I exposed for 1/250 sec. at f/5.6 on Kodachrome 64.

important element in the composition. It also works well for waterfalls and swiftly moving streams where the water appears to be flowing directly into your camera.

I often try to get close to my subject when I work with wide-angle lenses. Sometimes I'll be directly on top of a subject. For example, when I photograph flowers with a waterfall in the background, I am just inches from the flowers. As a result, the flowers dominate the larger scene.

I also try to use the smallest aperture I can to ensure all elements are sharp. And the best way to visually minimize

the effects of distortion is to compose so that there is no pronounced horizontal line. When you use a lens wider than 18mm, the distortion becomes harder to compensate for. In fact, it becomes so difficult to capture a true perspective of the scene that it is best to include the distortion as part of the image.

Trusting your camera's exposure meter is asking for trouble when you shoot with wide-angle lenses. An averaging meter opens up for the larger shadow areas, thereby overexposing the image. Aim a spot meter or center-weighted meter directly at whatever part of the scene is the most important to you.

When you use wide-angle lenses, your images are more susceptible to lens flare. If you use a lens shade or a polarizer, be careful that it fits the lens properly. Otherwise vignetting will occur. Pay attention to the edge of your frame. Unwanted objects somehow creep inside the frame if you aren't careful.

LENS SHARPNESS

Most lenses aren't at their sharpest at either end of their aperture scale. The best aperture for sharpness is two to three stops up or down from the limits of this scale. For example, if your 300mm telephoto lens has an f/5.6 minimum aperture, f/11 or f/16 will be the sharpest setting. Today's lenses are far better optically than those manufactured just a few years ago. The better telephoto lenses, such as the Nikon ED IF lenses made with low-dispersion glass, provide close-to-optimal sharpness even at the widest apertures. However, you pay significantly in cost and weight for this feature.

DETERMINING EXPOSURE

When shooting on a bright sunny day between midmorning and midafternoon, you can obtain correct exposure by using the sunny 16 rule. This calls for using an aperture of f/16 and the shutter speed that most closely approximates the film speed. For example, according to the sunny 16 rule, ISO 64 film calls for a shutter speed of 1/60 sec. at f/16, and ISO 100 film calls for a shutter speed of 1/125 sec. at f/16.

At most photography stores you can buy a Kodak Gray Card, which is invaluable when it comes to determining exposure. The card has an 18-percent reflectance, which is called middle gray. All light meters are calibrated to meter objects equal to a gray-card reflectance. I always keep one (or half of one) in my camera bag. In most low elevations at midday in the northern hemisphere, a cloudless sky is close to middle gray. At higher elevations, above 6,000 feet, the light reflected is darker than 18-percent gray. Pointing your camera

away from the sun, meter off the middle-blue of the sky. You can also meter off green grass during the summer because it is also close to middle gray in tonal value.

In order to accurately determine exposure, keep in mind that for most Caucasians, the skin tone on the back of the hand is approximately 1 to 1 ½ stops brighter than middle gray. If you are tan or have a red, yellow, brown, or black skin tone, experiment and adjust accordingly.

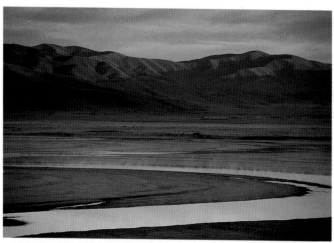

I took this photograph right before sunrise as the mist was lifting off the water. The curve of the river suggested motion as it wound its way across the landscape. Here, I used my Nikon F3 and a 50mm lens and exposed for 1/30 sec. at f/5.6 on Kodachrome 64.

From Panch Pokhari, a peak of 15,000 feet in the mountains of Nepal, the clouds stretched below me like a giant sea. At sunset I photographed the changing colors, keeping a portion of a ridge in the frame to anchor the image. I exposed for the clouds, continually checking the meter reading as the light faded. With my Nikon N8008 and an 80-200mm zoom lens, I exposed Kodachrome 64 for 1/15 sec. at f/4.

ON SAFARI

There is more to adventure travel than an adrenaline rush, and there is more to adventure-travel photography than people, action, and landscapes. I'm not a wildlife photographer, but I knew that I had to go to Africa to see and photograph the animals in a vast, unbridled environment.

I was late coming to Africa. I always assumed that it was ruined—wrecked by decades of tourism. But a good friend kept encouraging me to go to Botswana, saying, "You won't be disappointed." So I went, and he was right. There is a majesty and mystery to Africa. The country has piqued the fantasies of writers and explorers for centuries. For me, Botswana evoked a visceral feeling that exposed a new viewpoint of the world. It was all those huge animals. I've spent many years in the outdoors, hanging from cliffs and being roughed up by raging waters, but all of those experiences seemed very tame and insignificant when I heard a lion roar outside my tent.

I didn't have the time, money, or experience to travel solo in the African bush. So I joined an organized safari. I was with seven other people who weren't photographers and who had their own agendas. Not only did I have to adapt my journalistic style to wildlife photography, but also to group demands. I had to make compromises to the group while remaining resolute to my photographic goals. This balancing act required diplomacy, stubbornness, good humor, and the ability to let go of photographs that weren't critical.

The same phenomenon that I've witnessed in foreign countries involving people photography is true for wildlife photography, too. Photographers become so excited about seeing something new that they immediately begin clicking shots without really looking to see what is around them. It isn't enough to just see the right animal; you have to consider the light source, the angle, the composition, the background, and the animal's behavior. All of these elements rarely come together at the same time, and hardly ever when you are ready to shoot.

Wildlife photography is demanding and rightly deserves its own special place in photography. Wildlife photographers don't just cavalierly saunter off in a jeep for a few hours and return loaded with rolls of brilliant photographs. Recording special wildlife images on film requires infinite patience, an insatiable curiosity, and a reservoir of behavioral knowledge.

It is inevitable that you'll miss a lot of shots. Capturing the emotion and behavior of animals is excruciatingly difficult. Those are the elusive, great moments. It seems like every time you get a chance, the sun is in front of you or you have the

wrong lens on the camera. Sometimes you are lucky and get a great shot immediately. Usually, however, you have to sit, wait, and relax. The longer you linger near an animal, the more relaxed it'll become, and the better photographs you'll get. If you are serious about photographing wildlife, encourage your guide and safari group to stay awhile with a troupe of animals.

While on safari, I saw people driving their vehicles up to animals, taking a few shots, and then zooming on to the next attraction. Often people feel that after only a couple of pictures or even a couple of rolls of film, they've expended enough time, money, and energy on a particular animal and they just want to see something else.

No matter what you're shooting, you have to anticipate the best image and, if possible, move into position to get it. Often the most interesting picture isn't, for example, of an animal's head and horns, but of an environmental portrait. I approach many of my wildlife shots as if I'm photographing a landscape, incorporating the animals into the image.

Since I'm not an amateur zoologist, I didn't know what to anticipate in an animal's behavior. I often wasted film before I captured the relaxed or dynamic behavior. An animal's positions and expressions change continually, so you always have to be ready, with your camera to your eye. At the moment I intuitively know that I have a great shot, I don't hesitate to shoot a lot of film, sometimes even a whole roll or two. I bracket as I shoot, so that there are different exposures to choose from. I like heavily saturated images, but magazines often like ones that are less dense. Also, it is cheaper and easier to duplicate in the camera, and these bracketed exposures are insurance against loss or damage.

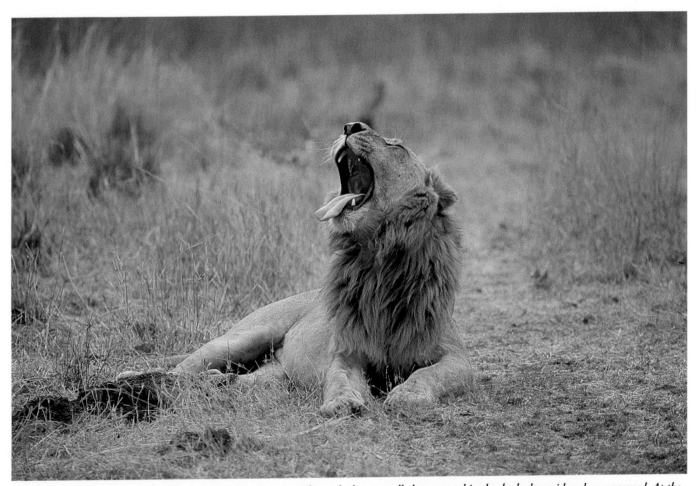

What safari would be complete without a lion? In Botswana, Africa, the lions usually laze around in the shade, languid and unconcerned. At the edge of the Moremi Reserve, my traveling companions and I parked our safari van next to a lion and lioness and watched them while they sunned themselves. Suddenly the lion raised its head and let out a loud roar. Since I had my Nikon N8008 and an 80-200mm zoom lens poised at my eye, I was able to catch this fleeting expression. The exposure was 1/250 sec. at f/4 on Kodachrome 64.

In Botswana, Africa, I spied some elephants lumbering over to the Chobe River. I minimized their presence in the sun-drenched landscape by including a lot of sky. Here, I used my Nikon N8008 and an 80-200mm zoom lens, and exposed for 1/250 sec. at f/5.6 on Kodachrome 64.

I find bird photography especially demanding. One day, however, I was fortunate enough to see a yellow hornbill perched on the limb of a dead tree. Its curved bill mimicked the curved branches so well that he seemed to become part of the tree. Shooting with my Nikon N8008 and a 300mm lens, I exposed for 1/500 sec. at f/4 on Kodachrome 64.

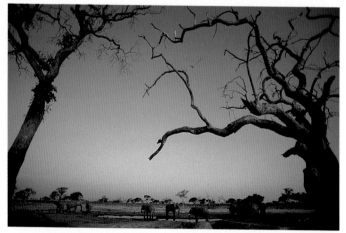

After photographing the elephants drinking water from every conceivable conventional angle at the famous watering hole at the Savuti swamp in Botswana, Africa, I decided to use a 20mm wide-angle lens on my Nikon N8008; I wanted to incorporate the limbs for an unusual image. The exposure was 1/60 sec. at f/8 on Kodachrome 64.

LOOKING BEYOND THE ANIMALS

The light in Botswana is fabulous. I had a very accommodating guide who uncomplainingly woke up at 4:30 A.M. and drove with me at dawn to the spot I'd selected the day before. Sometimes animals were present, but often they weren't. I focused on dead trees, termite mounds, branches, and the vast, interminable landscape.

It is easy to become myopic in a traveling situation, especially when there is a definite focus of attention, such as the wildlife in Africa. Occasionally it is important to take your attention off the parading wart hogs and shoot some of the other peripheral events around you, such as your safari mates and guides and

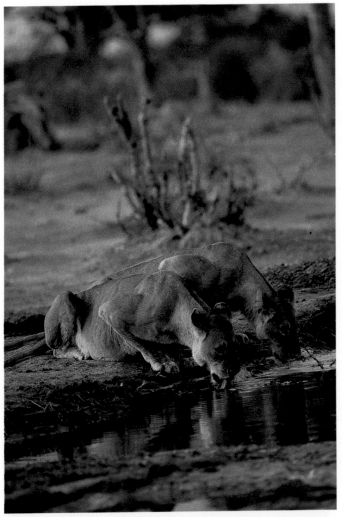

Just as my companions and I were leaving the waterhole at the Savuti swamp in Botswana, Africa, a pride of lionesses ambled over. The light was very low, but I placed my Nikon N8008 and a 300mm lens securely on a sandbag and shot a series of photographs using the motor drive. For this image, I exposed for 1/15 sec. at f/4 on Kodachrome 200.

camp scenes, particularly if you plan on putting together a slide presentation or album when you get home. Be alert to any details and lifestyle images that convey an element of the trip, such as coffee mugs on the table, the inside of your tent, or the campfire. Make a still life with found objects, baskets, feathers, and bones. Not only will this enhance your presentation, but also lead you toward an awareness of the entire journey.

WHAT TO BRING

While on safari in Africa I used two Nikon F3s with motor drives and a Nikon F4 with an array of lenses. These ranged from a 300mm $f/2.8$ lens with a 1.4X tele-extender to a 20mm wide-angle lens. I'd mounted different lenses on the three camera bodies and loaded two with Kodachrome 64 and one with Kodachrome 200. I shot a lot of Kodachrome 200 on this trip; I needed the speed for handholding long lenses and shooting in low light. I had one camera around my neck, and I kept the other two in my camera bag at my feet or beside me wrapped in a towel on the seat of the jeep, ready to be used in an instant. If you do wear more than one camera, adjust the camera straps so that they are at different lengths to prevent them banging into each other.

I carried this large arsenal of photographic gear in a Tamrac Super Pro camera bag that measured 18 inches wide, 10 inches deep, and 9 inches high. It was a formidable bag, big and heavy. Actually I brought too much equipment with me; there were a number of lenses I never even used.

The next time I go on safari, I plan to bring: two or three camera bodies, a 400mm lens (with 2X and 1.4X tele-extenders), a 300mm $f/2.8$ or $f/4.5$ lens, an 80-200mm $f/2.8$ lens, a 35-70mm $f/2.8$ lens, a 24mm $f/2.8$ lens, and a 20mm $f/2.8$ lens. If I want to travel really light, I'll bring only: two camera bodies, a 400mm lens (with 2X and 1.4X tele-extenders), a 100-300mm $f/4.5-5.6$ lens, a 35-70mm $f/2.8$ lens, and a 20mm $f/2.8$ lens.

A 400mm lens is a great choice, but it is expensive and requires a tripod. A 300mm $f/2.8$ lens is also expensive, heavy, and difficult to hold steady without a monopod or tripod. Using a 300mm $f/4.5$ lens means losing $1\frac{1}{3}$ stops of light, but it can be handheld. One stop can often mean the difference between being able to shoot a fine-grain film, such as Fujichrome 50 or Kodachrome 64, rather than a grainier ISO 200 film. Bear in mind that depth of field at 25 feet with a wide-open 300mm $f/2.8$ lens is a mere 2 inches. An autofocus lens can be indispensable for a range that small.

You can also use a 300mm lens with two tele-extenders (2X and 1.4X) to achieve the equivalent of three large lenses—a 300mm, 420mm, and 600mm—but with the weight

of only the 300mm lens and two small tele-extenders. You lose some quality when you attach a tele-extender to a lens. If, however, you use a lens of good optical quality, the loss won't be significant. But if you use a marginal-quality lens, the loss will be perceivable. You lose one stop of light with a 1.4X tele-extender and two stops with a 2X tele-extender.

Bring a camera bag that is large enough so that all of your equipment is readily accessible and your lenses don't pound against each other as the jeep bounces along on the rough dirt roads. Be sure to bring a flash, too. You can use it for fill at any time of the day, and it adds a sense of mystery to and enhances the mood of dusk shots. Keep your camera on the quietest mode possible.

Tripods can be an awkward item to have in a safari jeep. Monopods are better, and you can find tripod clamps specially made for attaching to windows or jeep bars. I brought an empty pillowcase with me, filled it with Kalahari sand the first day of the trip, and kept it on the roof of the jeep for the remainder of the safari. It supported both the camera body and lens, and I was confident that my photographs were free of camera motion at the lower f-stops. However, I did have a tripod with me for shooting outside the jeep.

To protect your cameras and lenses from the all-pervasive dust, wrap them in cotton scarves or a small towel. You can also use Domke Protective Wraps, which are padded cloths with Velcro corners. Keep skylight filters on all your lenses.

A pocket minicassette recorder makes it easy to quickly make a log of photo notes, animal and bird names, and your guide's anecdotes. A tan lightweight vest is indispensable for holding your small lenses, binoculars, tape recorder, and

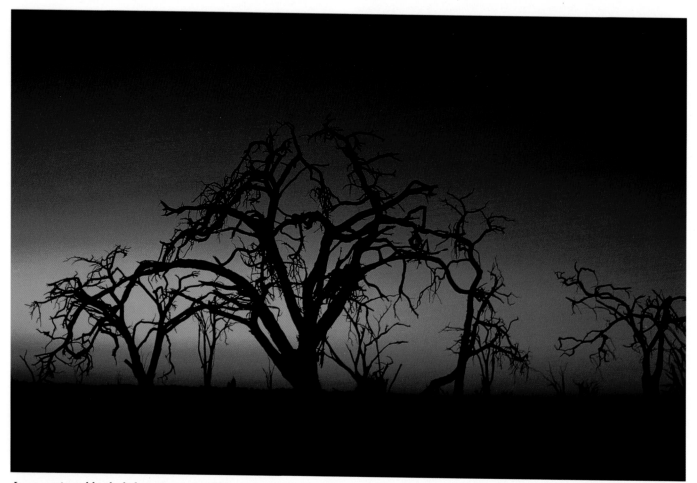

I was captivated by the light in Botswana, Africa, as well as by the whimsical shapes of the dead trees. One evening I pleaded with my guide to drive me to a particular spot at 4:30 A. M. the next morning so that I could photograph the trees silhouetted against the red sky at dawn. Luckily he agreed, and I was able to get this dramatic shot. Working with my Nikon N8008 and a 20mm wide-angle lens, I exposed at f/8 for 1/15 sec. on Kodachrome 64.

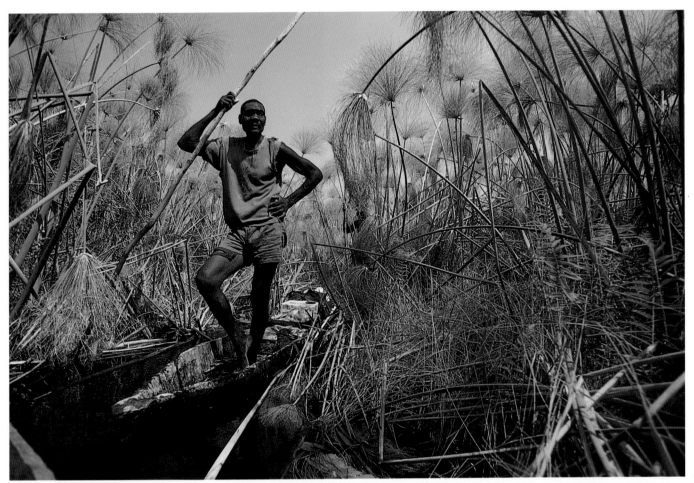

I traveled through the Okavango Delta on a wooden makoro boat for a few days. As my companions and I passed through papyrus reeds on channels created by hippopotamuses, I turned around and photographed the guide as he paused for a rest. I used a 20mm wide-angle lens on my Nikon N8008 in order to include him and the encroaching reeds. The opposing triangles formed by the guide's arms and right leg draw the viewer's eye. The exposure was 1/125 sec. at f/8 on Kodachrome 64.

sundry items when you take short walks outside the jeep. Always wear cool, lightweight-cotton clothes to combat the heat. Khaki is the best color for not showing dust or disturbing the animals. Don't forget a travel alarm clock for early-morning wake-up calls, sunscreen, and a hat or visor.

TRAVELING ON A SAFARI TOUR

On a photo tour you have the advantage of being among like-minded people who wake up before dawn and are out until dark photographing. You're also jockeying for space and position, with elbows, tripods, and long lenses perpetually in your way. I enjoyed being with people with diverse interests. The avid game- and birdwatchers sat up on the roof of the jeep keeping an eye for movement and any breach in their prey's camouflage, while I stalked the light and promising compositions.

There is a fine line between being courteous to your jeep-mates and getting the shot you want. Be intent on taking the photographs you want, when you want, for as long as you want. Simply be as patient with your colleagues when they want to stop and gaze at a yellow hornbill.

I was on a "luxury-tented safari." The luxury was certainly nice, but the invaluable part was not having to sacrifice any of my photography time worrying about logistics. A less-expensive alternative is a participatory safari, where you set up the tents and help with the meals. These trips are great fun, but not always appropriate for photographers who want to be in the field at first light, rather than cooking breakfast. A small group is best, certainly no bigger than eight. Finally, traveling with guides who are knowledgeable, patient, and sympathetic to, or at least tolerant of, your photographic needs is critical.

PREPARING FOR YOUR TRIP

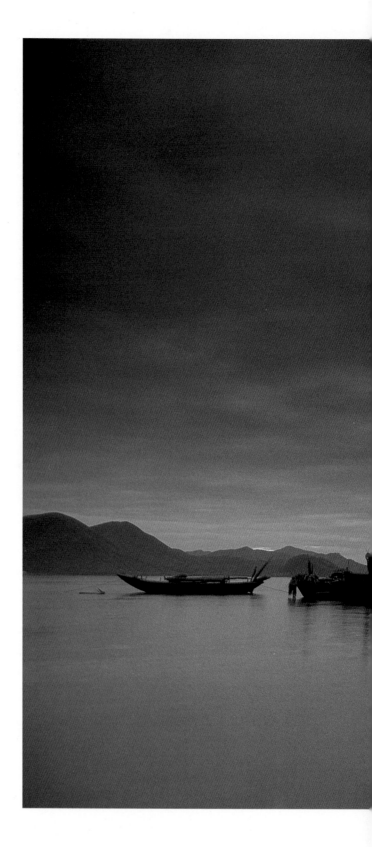

When planning your adventure, you must first decide what kind of adventure suits you. If you are an experienced traveler and have outdoor skills, you can penetrate deep into remote regions on your own or with a harmonious group of friends. If you've never been on a wilderness trip or traveled outside the United States, you should join an organized adventure-travel trip with a reputable company. There are many varieties of adventures, from jeep safaris in Africa to rugged mountaineering trips in the Himalayas. Pick one that suits your skills, fitness level, and dreams. And while you travel, remain flexible and maintain a sense of humor because everything that can go wrong probably will.

Don't expect that you can suddenly go from a sedentary lifestyle into a wild "Indiana Jones" adventure. Whatever type of journey you decide to take, you should be in excellent physical health. I recommend getting a thorough physical examination before you set off on any rugged journey. In fact, most adventure-travel companies require one.

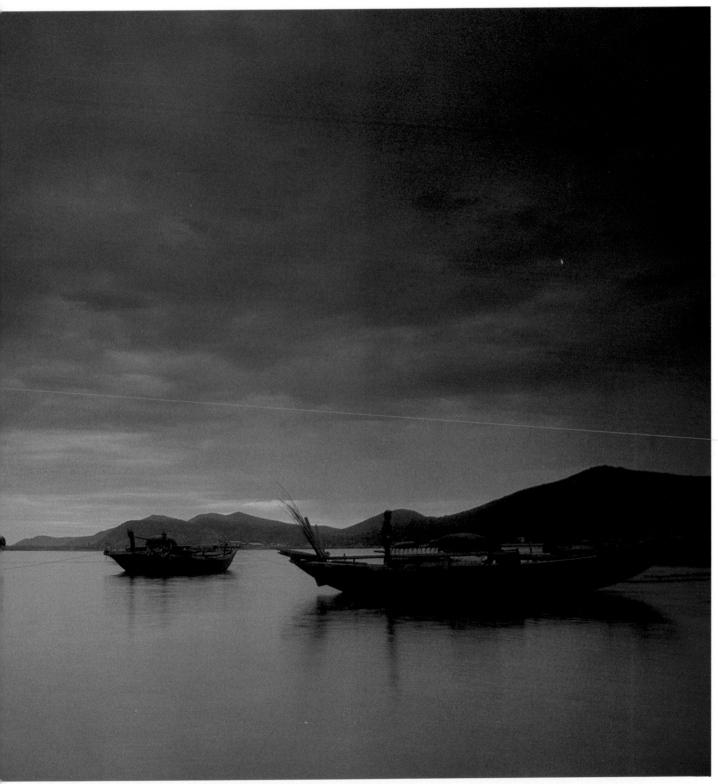

One morning in Vietnam's Nghe Tinh Province, I drove down to the beach at Cua Lo to shoot the fishing boats against the red sunrise. But when the darkness began to lift, I saw a deep blue sky; a storm was approaching. I mounted my Nikon F4 on a tripod and put a split ND filter on my 85mm lens to darken the sky. The overall cold blue tone enhances the mystery of this scene. I exposed for 1/8 sec. at f/5.6 on Kodachrome 64.

Just as important as your physical stamina is your mental stamina. Cultural shock is considerable in the so-called "undeveloped" countries. Customs, religions, and government regulations differ, and laws can be confusing and convoluted. Other problems are matters of comfort and convenience. Tap water isn't always suitable for drinking. And inclement weather, fouled-up air schedules, and other unforeseeable and uncontrollable events may cause delays or other situations that are impossible to resolve quickly. If you can't accept these kinds of problems graciously or if rude surprises cause you to blow your stack, you should think twice before undertaking a journey that is too far off the beaten track.

HOW TO GET THERE

In the modern world of transportation buying an airline ticket and finding yourself on the other side of the globe the next day are relatively effortless processes. Since the deregulation of the airlines, there are numerous ticket options and prices available. Finding the best offer just takes a little research. If you can travel Monday through Thursday and are willing to buy a "nontransferable, nonrefundable, restrictions-apply" ticket at least three weeks ahead of time, you can save a substantial amount of money. Consider an "around-the-world" excursion fare if you'll be traveling to different continents. To find these bargains, look in the Sunday travel sections of the *New York Times* or the *Los Angeles Times* for advertisements for inexpensive ticket fares. If you need a ticket that is open-ended, refundable, and changeable, you'll have to pay a higher price.

There are also more exotic modes of overseas transportation, such as traveling on steamer ships or hitching rides on sailing cruises. Although more romantic in concept, they are also more expensive and require a greater time commitment. Some tramp steamers, which are cargo-carrying freighter ships, are licensed to carry passengers in conjunction with their standard freight. Tramp steamers can take you virtually anywhere in the world, from Sri Lanka to Melbourne, or from Rotterdam to Mombasa; they embark from a number of East Coast, West Coast, Gulf, and Canadian ports. Depending on the freighter company and the itinerary, you can travel anywhere from two weeks to six months. The accommodations can be quite plush and the atmosphere convivial. The cost is less than that of a luxury cruise, but still more expensive than that of an airplane ticket. Also, you sometimes have to make your plans a year or more in advance. It is essential to remember that the major function of freighters is transporting cargo, so schedules and

ports of call are solely determined by the shipping needs of the companies whose products the freighters are carrying. As a result, the ports of call may change at any time. Consult a local travel agent for names of freighter lines.

Hitching a ride on a small yacht is a good idea if you are a seasoned sailor, but captains often look for cooks or inexperienced deckhands. This kind of travel requires time and a commitment to hanging around yacht clubs and marinas in order to find out about potential openings on cruise ships.

Once you arrive at a foreign destination your options multiply: you can ride trains, buses, and trucks (in some places truck travel replaces local-bus travel). You can also hitch, but this isn't one of your safer options in most parts of the world. It is best to consult with other travelers about the various local-transportation options. Always hedge on the side of safety; pay attention to your instincts. The naive often end up with their luggage being stolen, or worse, by trusting the wrong people.

TRAVELING ALONE

Sometimes I have a yen to travel somewhere at a particular time, and no one is able to join me. So I go alone. This isn't as impressive as it sounds, but it is rewarding. The truth is that when you are by yourself, you meet more people than when you travel with a companion. You also experience a country and its people in a way that is impossible when you are with another person or a group. Being solely responsible for transporting your gear and arranging all the logistics is tiring and time-consuming, but you're compensated by a very real freedom to come and go exactly as you please.

It is easier for me to travel alone when my primary purpose is photography. I can go at my own pace and not feel guilty for holding anyone up. I can stand on a street corner or on the top of a Himalayan ridge for hours and wait patiently for my perfect moment without having to account to anyone. Traveling alone isn't for everyone, but if you are an avid traveler, I definitely recommend going on a solo trip once in your life.

Some places off the main traveling arteries aren't suitable for women alone; other areas can even be dangerous, such as some Moslem countries, southern Pakistan, and the hills of Morocco. Although I've never had any trouble traveling alone, I am aware that as a woman I need to be more cautious and alert in places where a man wouldn't think twice. This is unfortunate, but it is a reality. When I feel uncomfortable in places or situations, I'll often team up with a group of people that I met along the way.

TRAVELING IN A GROUP

Traveling in a remote area with friends over an extended period of time can mean experiencing camaraderie at its finest. However, it takes a good deal of cooperation to plan the details and the route and to coordinate all the different aspects of a long trip. Mountaineering and other expedition leaders very carefully consider not only the skill level of their potential members, but also the compatibility. The dynamics of the group often can make or break the success of an expedition's outcome.

Some of my best trips have been with friends. Nevertheless, I'd be very wary about going to a remote, rugged mountain range with people who had very limited experience traveling outdoors. Choose an expedition that matches the experience and expertise of the group, and vice versa. On all the remote-travel trips I've gone on, I've been with companions who have extensive experience in the outdoors and traveling experience in foreign countries.

Unless your companions are photographers as well, chances are that they won't be too enthusiastic about stopping every two minutes for you to shoot pictures, or about your dashing out in the middle of dinner to chase the sunset. The key in situations like this is to make deals, such as "If I don't have to cook dinner, I'll clean the dishes," and stick to them. This will not only mollify your companions, but will also help you to relax and enjoy your trip.

There are often many bewildering and perplexing moments when you travel, especially in places like China and India. It is helpful to be with someone in order to support each other through the difficult moments, such as missing a train or finding a good place to eat. Traveling with a friend also means having someone to share the high and low points of the trip with, and you can rotate responsibilities and logistical chores.

An organized tour is another option. If the convenience and security of having prearranged hotel, transportation, and logistical plans sound appealing, a group tour is definitely for

Protecting my Nikon F3 and 24mm lens with an umbrella, I photographed my companions breaking camp in a sudden snowstorm in China's Sichuan Province.

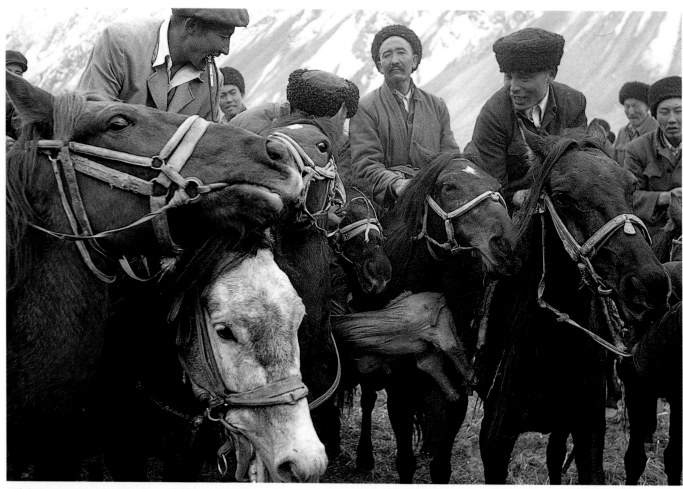

While I was staying in a Kirghiz village in China's Pamir Mountains, I was beckoned to join a group of villagers who were heading off on horseback in their best clothes. Even though we didn't speak the same language, it was clear that they wanted me to bring my cameras and that we were going someplace special. I was thrilled when we arrived at a game of bozkashi, a Turkish variation of polo played on horseback with the skinned body of a goat. At the end of the game, I walked up to the players and captured this moment with my Nikon F3 and a 24mm wide-angle lens. The exposure was 1/125 sec. at f/8 on Kodachrome 200.

you. Group tours enable you to meet new friends with shared interests and to benefit from the savings that come with traveling in numbers. There is a plethora of adventure-travel companies that run every trip imaginable in practically every crevasse and corner of the world. As a photographer, you have the choice of going on an organized adventure tour for laypersons or experienced travelers, or on a tour designed specifically for photographers.

If you're traveling on an organized tour, you may not have much control over your time, so be sure to select one with a relaxed pace, not one that tries to cover as much ground as possible. Talk to the tour leaders ahead of time and explain why you are there and that you need a certain amount of time on your own; doing this will help them understand when you

rush off from the group to photograph. Go out of your way to be polite and considerate. Try to do most of your work on your own. You aren't, of course, obliged to join the group for events that don't interest you. Be prepared to have your breakfasts and dinners late in order to free yourself up during the perfect light. Inevitably anytime you combine traveling with a group and photography, you'll have to make compromises. The challenge is to minimize them.

Unlike most conventional tours, the numerous photography tours are designed around photographic opportunities rather than around mealtimes. Planned with photography in mind, the tour schedules usually include special events or colorful festivals. In addition, you have the advantage of being with a group of people with a similar aim and focus.

It is important for you to check the qualifications of your tour guide. Ideally the guide will be a photographer who knows how to impart his or her knowledge to others. Many photographers are brilliant in the darkroom, but not in the classroom. Does the guide have a column in a photography magazine or regularly teach workshops? If that is true, get references from former workshop participants.

HOW TO SELECT AN ADVENTURE-TRAVEL COMPANY

Before you send your money to a tour operator you need to ask a number of questions. First, is the company reliable, with a proven record of successful tour operations? How long has

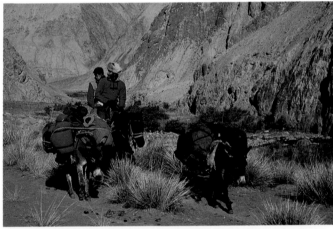

Here, a friend and I are on the final leg of a journey in the Pamir Mountains in Xinjiang Province in China.

I photographed my bicycle-tour members and Tibetans doing the "Bunny Hop" outside Maerkam Town in Sichuan Province in China.

the company been in business? Does the company actually run the trip itself, or does it subcontract local outfitters? (With so many destinations, most companies subcontract some of their trips to other outfitters abroad that they've established a reliable working relationship with.) Quality control is a key factor, so it is always a good idea to get references from people who've already gone on a trip.

Next, you should carefully explore the package. What's included in the cost of the trip? Are there hidden costs, such as meals or local air fares? What equipment is provided? What is the level of physical activity? What is the guide-to-client ratio? What class of accommodations are offered? (In many remote areas, standard tourist facilities don't exist.) Is there a guaranteed departure? (Some companies cancel trips at the last minute if there is insufficient sign-on.) Is there tiered pricing? (Some companies vary the cost of a trip according to the number of participants.)

Finally, be aware that the tour leader or guide can make or break a trip. It is essential that the guide has been to the destination before and, preferably, is an expert in the area. In remote areas, it is helpful to have a Western guide, or at least one who understands Western predilections, as well as a local guide.

BEFORE YOU GO

Read everything you can put your hands on about the area where you'll be traveling, and pore through picture books and travel guides. For example, find out what is unique about the place, which tribes live there, and what their customs are. Do your homework before you go; know, as best you can, what is permissible legally and culturally. If you're planning an international trip, obtaining a passport should be one of your first steps. There is an additional fee if you need to apply in person in order to have the passport rush-processed. Your passport is valid for 10 years. Always keep it in a secure place, such as in a pouch under your shirt or a hotel or tour operator's safe. If you are unfortunate enough to lose your passport, contact the nearest United States Consulate or Embassy as soon as possible. Either one will have you fill out a "lost passport" report and issue you a replacement. For emergency assistance, call the Overseas Citizens' Emergency Center.

A visa is official permission from a foreign government to travel in that particular country. The visa is usually stamped into your passport, although some countries issue you a separate document. Each country has different visa requirements. Some countries require that you obtain a visa before your arrival, while

others issue visas at an official border station. Requirements for obtaining a visa continually change. It is best to get them from the consulate of the nation you want to visit. (You can find the addresses and telephone numbers of these agencies through any knowledgeable travel agent or from a guidebook.)

Carry most of your money in the form of United States traveler's checks. Internationally recognized brands are accepted more readily than lesser-known traveler's checks. A combination of small and large denominations is best. When I fly into a new city or country, I usually exchange a small amount of money at the airport. In town I ask or look around to see where the best place is to change money. Sometimes it makes a big difference. For example, in Hong Kong you can lose a great deal of money at the street exchangers. For the intrepid, sometimes there is a black market. In some countries you can get a much better rate for your dollar, but, remember, the black market is illegal and can be dangerous.

You can also get money from an American Express office by writing a personal check on your home bank account. For a long trip this is a safer way to obtain funds instead of carrying a large wad of bills. But this works only when you travel through major cities. I always bring some United States dollars in small denominations. Some countries, such as Vietnam, prefer cash. Make sure that you do some research on how to bring your money for each country before you leave.

Major credit cards are accepted in most places around the world. The exchange rate that applies to a credit-card purchase is the one prevailing on the date of the bank notification. This can work for or against you since the charge often takes up to three months to show up on your bill.

Depending on your foreign destination, you might need proof of vaccination before crossing a border. Consult your County Public Health Service, your personal physician, or the Center for Disease Control (CDC). CDC has a very useful

I shot these prayer wheels in a small shrine in Patal, Nepal. Handholding my Nikon N8008 and 50mm macro lens, I exposed Kodachrome 64 for 1/30 sec. at f/5.6.

automated hotline that gives travelers current information on disease prevention anywhere in the world. So does the State Department's Citizens Emergency Center.

HOW TO TRAVEL LIGHT

I have a large repertoire of cameras to fit a variety of occasions. I rarely take all of my equipment with me on my travels. I tailor my photo gear to each situation, and I ask myself the crucial question, "Who's going to carry this stuff?" Sometimes I have porters, vehicles, horses, or camels with me, but more often than not the answer is, "Me." Lamentably, I've never been accused of traveling light. I certainly don't recommend that you emulate the amount of equipment I use. I envy travelers who carry only a small, lightweight backpack. If I weren't making my living from photography, I'd bring one or maybe two camera bodies, a 24-50mm lens, an 80-200mm ƒ/2.8 lens, a 20mm lens, and a strobe. This equipment would cover almost every shooting situation.

The actual weight of the equipment I carry varies between 15 and 50 pounds, depending on the lenses and film I take along for a particular trip. For day hikes or excursions I rarely carry more than 15 pounds of gear, including my daypack or duffel bag. On an overnight trip I try to keep the weight under 25 pounds. If I'm going on a long trip, I carry quite a bit of equipment, weighing between 25 and 50 pounds. However, I don't carry all that on my person every day; this amount includes film, backup equipment, accessories, and more lens options than are usually necessary. I keep most of the equipment in my duffel, suitcase, or pack during the day and switch gear to my daypack as needed. During a long trek, I have access to everything at camp in the morning and evening when the light is best. While on the trail I keep various lenses in my photo vest and carry one camera. I don't carry extensive lighting equipment or large-format cameras. The photographers who do, usually bring assistants with them.

CAMERAS

There have been some outstanding advances in cameras in the last decade, particularly in the field of autofocus. I used to be a true purist and worked with only manual cameras, feeling smug that I was a real photographer. But during the last few years I've altered my thinking. For certain subjects and shooting situations, such as horseback riding, kayaking, mercuric sports, and low light levels, there are definite advantages to using an autofocus camera.

On one of my trips through China's Sichuan Province, I dropped my bike at the foot of a road sign and took this photograph. I liked the combination of colors and casualness. Shooting with my Nikon F3 and a 35mm lens, I exposed for 1/60 sec. at f/8 on Kodachrome 64.

I have one Nikon F4 camera, two Nikon F3 cameras with motor drives, and one Nikon N8008 camera. The N8008 is becoming a favorite because of its lightweight construction and superb metering capabilities. I'm not abandoning my F3s; they are workhorses, and I like being able to remove the motor drive.

I'm convinced that complex professional cameras, such as the Nikon F4, require more expertise to operate than manual ones do. The marketing premise that automatic cameras are easier to use than manual cameras holds true only for simple cameras and artless expectations. After mastering the complex controls of the F4, I discovered that the camera's features enabled me to explore a new level of photography. But there is one drawback: I find the camera too large for most women's hand grips.

LENSES

Always buy the best lenses you can afford. Obscure "bargain" lenses are no bargain when it comes to shooting sharp pictures. In most cases, you are better off purchasing the same brand of lens as your camera. However, many lenses that are made by independent lens manufacturers do produce very sharp photographs if used properly, such as Tokina and Tamron. But you do get what you pay for.

I use a wide range of Nikon lenses, from 16mm to 400mm. I favor wide-angle lenses over telephoto lenses. Telephoto lenses are great but they are heavy, bulky, and expensive, so they are usually the first to be left behind. My armory of lenses includes: a 16mm $f/2.8$ lens, a 20mm $f/2.8$ lens, a 24mm $f/2.8$ lens, a 28mm $f/2.8$ perspective-control (PC) lens for correcting parallax in buildings or trees, a 35mm $f/1.4$ lens, a 35-70mm $f/2.8$ AF lens for autofocus and autoflash capability, a 55mm $f/2.8$ Micro-Nikkor closeup lens that works well as a standard lens, an 85mm $f/1.8$ lens (my favorite low-light portrait lens), a 180mm $f/2.8$ ED IF lens (Nikon's "ED IF" designation indicates that the lens is made with extra-low-dispersion glass that allows better registration and greater sharpness of primary and secondary colors on the film plane), an 80-200mm $f/2.8$ AF lens, a 300mm $f/4$ ED IF AF lens, and a 400mm $f/5.6$ ED IF lens. I also have a TC-14A teleconverter, which is a 1.4X teleconverter for lenses up to 300mm long, and a TC-14B teleconverter, which is a 1.4X teleconverter for lenses 300mm or more in length.

Until recently I shied away from zoom lenses, complaining that they weren't fast enough and that the optics were mediocre. However, they've improved dramatically in the past decade, thanks to the advancement of computer-assisted optical development and optical-glass manufacture. The ranges of both available speeds and focal lengths have expanded considerably. I now include zoom lenses in my camera bag, and I find them on my cameras more often than my old favorite single-focal-length lenses. Zoom lenses are perfect for travel photography; you can't beat the size and convenience. You can bring fewer lenses and have more flexibility because they let you use odd millimeters for cropping your compositions when you can't change your shooting position. The ability to frame precisely and quickly without changing lenses allows you to concentrate more fully on the subject.

FILTERS

Some photographers never use a filter on their lenses because it can degrade image sharpness. This is fine for studio work, but when I'm on the Mongolian Plateau with the wind hurling

sand at my lenses or I'm working fast and changing lenses throwing them in my camera bag without their lens caps, I want a filter on my lenses. Filters are much cheaper to replace than lenses are. Use filters only as needed, one at a time, and only those of superb optical quality. At low altitudes, I keep a Nikon skylight filter on each of my lenses; at high altitudes, I use ultraviolet (UV) filters. These filters remove some of the blue haze and ultraviolet haze, respectively, that are found in most outdoor scenics.

Polarizers cut through high-altitude glare to strengthen the subtle color of rock and to improve the separation between the white of clouds or snowcaps and the blue of the sky. These

Photographing elephants while on safari in Botswana, Africa, I often focused on a detail of an animal. For this closeup, I used a 300mm telephoto lens on my Nikon F3 to frame the thick, tough folds of skin around the elephant's eye. The exposure was 1/250 sec. at f/4 on Kodachrome 64.

filters also reduce glare on water, increase visibility by cutting through haze, and cut down on reflections caused by moisture in and on plants (especially in humid countries). A polarizer won't have much of an effect on an image unless the camera's pointed approximately 90 degrees away from the sun. You lose 1 to 1 1/2 stops with a polarizer in place. Use a circular polarizer (as opposed to a linear polarizer) with an autofocus camera. With a wide-angle lens 20mm and lower, you tend to see the gradation shifts of the polarizer, going from dark blue in the center of the sky to a lighter blue at the edges.

To subtly enhance a warm feeling in an image I'm shooting in the late-afternoon sun or at sunset, I use an 81A, 81B, or 81C warming filter; these filters warm the tone of the reflected light in degrees of increasing intensity. I also keep an assortment of Cokin and Tiffen graduated and ungraduated color filters, including gray, sepia, yellow, sunset, mauve, and blue filters. No one likes to admit to using colored filters. I use them once in awhile to enhance a subtle color, to give a kick to a scene, or to try and salvage a seemingly hopeless situation.

LIGHTING EQUIPMENT

Unless you're doing a large commercial shot and you need to lug large, expensive studio strobes with you, you should avoid bringing any flash other than the one built into your camera or a shoe-mount unit. I use a Nikon SB-24 flash. Frankly, this flash is a miracle worker, offering a variety of settings, particularly for fill flash. The biggest disadvantage of an electronic flash is the inability to previsualize its effect. Even though the latest cameras do a remarkable job of automating fill flash, for optimal results your exposures need to be thought out carefully. Run tests of your flash before you set out on any trip.

Reflectors can be made of anything that reflects light. Usually they are made out of fabric or some sort of hard board. While traveling you can use bedsheets or aluminum foil, or you can bring a collapsible lightweight reflector. I sometimes bring a Flexfill 38-inch gold/white reflector for bouncing sunlight into shadows. Using a reflector usually requires an assistant. During my travels I find it easy to enlist the services of a bystander or a friend to help me.

Attach a bouncer to your flash to help diffuse and soften harsh shadows. I use both the LumiQuest Ultrasoft and the LumiQuest 80/20, which has holes to send 80 percent of the light to the ceiling and a flat area to direct the rest of the light forward, filling in shadows under people's eyes. The reflectors attach to your flash with Velcro and fold up compactly for storage in your camera bag.

TRIPODS

Although bringing a tripod with me means carrying extra weight, I always do. When it comes to choosing a tripod, the goal is to bring the lightest but sturdiest one possible for your purposes. A tripod that is too heavy to carry with you is useless. A tripod that weighs between 1 and 2 pounds is fine for small, lightweight cameras, but I find that this weight is too light for either a Nikon F3 or F4. I have a 4-pound Gitzo 226 Reporter Mode Performance tripod, which I keep in a custom-made zippered Cordura case with a shoulder strap. When I need to travel lighter, I bring a 3-pound Gitzo 106 Total Luxe tripod with me.

Of course, for the sharpest photographs you'll need your sturdiest tripod. Don't use the center post to increase the height of the camera; extend the legs fully instead. Elevating the center post turns the tripod into a unipod, which destabilizes the whole system. To help stabilize a tripod you can hang your camera bag, a heavy "stuff" sack, or a plastic bag filled with rocks, sand, or water from the center of the tripod. Hang a heavy towel over the barrel of a long lens for extra stability. Remember to recheck your image for possible focus shift. A cable release separates the camera from your body motion, preventing the transfer motion during the exposure. Whenever I use a tripod, I ordinarily use a cable release on my camera; the only exceptions are when I'm following motion or shooting with a flash.

Always lock up the mirror before each exposure, and use a cable release. Many SLR cameras have vibration problems from 1/30 sec. to 1/2 sec., particularly with lenses that are 200mm or longer. Unfortunately, many of the new cameras, such as the Nikon N8008, lack a mirror-lockup button. I'm forced to use one of my Nikon F3 or F4 bodies instead of my N8008 when I use a tripod; furthermore, the N8008 doesn't have a cable-release outlet. If your camera doesn't have a mirror-lockup button, you can use the self-timer button and put a motor drive on the camera body to absorb vibrations. Another option is to avoid shutter speeds between 1/15 sec. and 1/4 sec. by using either a faster shutter speed and a larger f-stop, or a slower shutter speed and a smaller f-stop. I've found that 1/15 sec. is especially bad on most cameras. When you use either wide-angle or standard lenses, you don't have to be overly concerned about mirror vibration. But you should still use a tripod whenever possible.

If you're working without a tripod, roll up a garment—the bulkier the better—into a ball, or jam it inside a stuff sack. Then prop it up on a window, a rock, or against a tree or building and push the camera deep into the garment. You can

also brace yourself and, if possible, the camera firmly against a tree, building, or some other solid object. Take a breath, and then exhale before pressing the shutter-release button. Since most shutter-release buttons depress two-thirds of the way before they click, remember to depress the button slowly and gently to avoid camera movement.

I prefer a ball head over a two-axis tilt head. A good ball head facilitates panning on a moving person or animal, and you can quickly position the camera to focus on a stationary subject. Landscape photography benefits from the ease of correcting horizons and changing from a vertical to a horizontal format. For closeup work the ball head allows quicker and easier positioning of the camera, especially in awkward positions low to the ground. Choosing the best ball head differs from photographer to photographer. I use both the Gitzo Ball 2 Head and the Arca Swiss Monoball B1. Slick and Bogen also make a range of excellent ball heads.

The Kenyon Gyro Stabilizer KS 4 is a portable stabilizing system that you can use for shooting from boats, cars, kayaks, and helicopters, and even for handholding cameras with long lenses at very slow shutter speeds. The KS 4 is a small pod that fits beneath a camera or lens and resists any quick movements transmitted to the assembly. The pod weighs 2 pounds, 2 ounces and is attached to a battery pack that weighs 5 1/2 pounds. This advanced technology isn't cheap—it sells for close to $2,000—but it solves problems that aren't easy to resolve any other way.

ACCESSORIES

Lens shades and caps are the items usually left behind when you pack for a trip, so you should double-check to make sure that you have yours before you leave. Lens shades block glare on the front elements of your lens and are the often overlooked cause of flat colors in a final photograph. You can also use your hand to shade the lens, but this is awkward. It isn't always effective either because the photographer's hand often ends up in the corner of the picture.
I'm continually ferreting lens caps out of my pockets and camera bag after a frenetic spat of shooting. One solution is the CapKeeper. This disc-on-the-end-of-a-cord adheres to the lens cap, and the other end of the cord, both of which are elastic, hooks to the camera or around the lens.

Batteries fit into two broad categories, rechargeable and nonchargeable. You can reuse rechargeable batteries many times, which is convenient for travel photography, but only if you'll be near an electrical socket and you have an electrical 110/220 converter. I prefer bringing extra AA batteries with me

since I am usually far from electrical outlets for long periods of time, even though the practice is more expensive and translates into more weight in my bag.

When carrying a light bag is a primary factor, I depend solely on the light meter in my camera. At other times, I bring an incident meter. These meters are very helpful in difficult shooting situations when the light's rapidly changing. Handheld incident meters have a white diffusion dome and measure the brightness of the light falling on them. When using an incident meter, stand next to your subject and point the white sphere toward the main light source. This will be more or less in the direction you'll be photographing. You want to know the brightness of the light source, such as whether it is from the sun or the sky (as in backlit situations).

Split-image focusing devices and microprisms, which are usually found on most standard focusing screens, are intended to help you focus sharply. However, they always seem to obscure my view of the subject and hinder focusing. So I replace them with a grid screen that's commonly used for shooting architecture. The vertical and horizontal lines help me keep horizons level and compose. However, you should experiment with one before you invest in it. Some people find them more difficult to focus than split-image screens, especially in low-light conditions. You can also replace your standard screen with a Beattie Intenscreen. This is at least one stop brighter than most camera screens, and is also available in a grid.

Years ago cameras had thin, nylon straps that dug grooves into your shoulder. Today you can buy thick straps that help absorb the weight of the camera. I have Optech Straps on all my cameras. As a result of the shock-absorbing qualities of the thick-neoprene strap, I can easily carry two or three Nikon F3 or F4 cameras without serious stress. Domke also makes a good strap, the Gripper Strap; it has rubber tracks woven into its entire length, so it grips your shoulder and the swiveling hooks keep the camera flat against your body.

I always carry the camera and flash manuals in my accessory bag. No matter how well I know my cameras, the manuals save me from a lot of aggravation and fiddling when I try a technique I haven't used in a long time.

CAMERA BAGS

Most travel and outdoor photographers know that the proper transportation, protection, and maintenance of equipment are critical. Photographic equipment is fragile and expensive, and if you want it to remain in good working condition, you'll need to find a suitable means of protecting it during transportation or storage. I have two systems for choosing and packing my

camera bag. One is designed for efficient traveling, and the other for responsive shooting. The first, which stresses protection and compactness, I use while en route to somewhere. I use the second when I arrive at my destination and convert my bag to shooting mode.

When I'm carrying a full array of photographic gear, I use the enormous Tamrac 614 Super Pro bag, which measures 18 inches wide, 10 inches deep, and 9 inches high. I also pack one or two smaller camera bags in my checked luggage for later use. The Super Pro holds my two motor-driven Nikon F3 or F4 bodies and one Nikon N8008, as well as eight lenses. The bag also has voluminous pockets for meters, filters, and film. A giant pocket underneath the bag holds my 3-pound Gitzo tripod or a 300mm or 400mm telephoto lens. As you can imagine the bag is monstrous, and I usually transport it around airports on a wheeled cart. As an alternative, I use an Eagle Creek Overland Carry-On bag. I pack it full with a Tamrac 610 bag, which is 15 inches wide, 6 inches deep, and 9 inches high, or a 709 Pro Convertible, which is 13 1/2 inches wide, 6 inches deep, and 9 inches high, as well as with my other carry-on items. The Tamrac 709 bag satisfies Federal Aviation Agency (AAA) carry-on regulations and has a backpack harness that I can zip inside a custom pocket for storage. I either keep any big lenses that don't fit into my camera bag in separate cases or wrap them in Domke Protective Wraps.

If necessary you can check your gear as luggage in a hard camera case, such as a Haliburton, but make sure that it's locked and isn't obviously a camera case. Then put the case inside a scruffy duffel bag for extra security. Hard cases work best for shooting in places where you need to protect your gear from water and dust, such as on river trips and safaris. Remember, though, they are much more awkward and harder to carry for long periods of time.

Packing your carry-on camera bag means getting the most equipment in the least amount of space, while paying special attention to protecting your equipment. Figuring out how to pack everything you need into a 9 × 14 × 22-inch space beneath your airline seat is a puzzle. Sometimes you can get away with an extra bag on a flight, but most international airlines are becoming very strict about having more than one or two carry-on bags. You don't want to get stuck arguing with the airline attendant and risk having your cameras put through as checked baggage.

You must pack carefully as you decide on the type and amount of equipment you'll bring, and how much film and which accessories you'll need. Place fragile items deep inside the bag, far away from its vulnerable periphery. Put hard

On Africa's Zambezi River I carried my non-waterproof Nikon gear in a Tundra SeaKing waterproof case and an REI waterproof bag. During the trip I kept my Nikonos V strapped around my neck and clipped to my life jacket.

objects against soft ones or against the padding of the camera bag itself to cushion them. Don't pack heavy items on top of lighter, more fragile ones. You'll probably find that you can get more in your bag if you pack the camera without a lens attached. When transporting your camera without a lens, make sure that you use a body cap.

When I reach my destination, I rearrange my gear to make it readily accessible when I'm actually shooting. For most situations, a good medium-size shoulder bag is my favorite choice. These bags have been improved remarkably during the last decade, and there is now one for all photographic needs. The hallmarks of a good shoulder bag are a well-padded shoulder strap, adjustable interiors, a dustproof lid closure

system, a large film pocket, and a rigid, padded interior with a low-fashion Cordura exterior with Fastex buckles (Cordura is a rough-textured nylon material). Using the camera cradle or bridge is an intelligent way to keep a long lens in place for ready use and the camera well protected.

Avoid all stylish designer bags that scream, "Expensive cameras here!"; the uglier and older the bag, the better. Tan and gray are probably the best colors because light colors reflect heat, and bags have an unfortunate habit of standing out in bright sun more often than they should. Ballistic nylon on the backside of the camera bag helps protect your clothing from the abrasive rubbing of Cordura.

Lowe, Tamrac, Domke, and Tenba are all good brands. However, Tamrac has the best lid system, with an amply sized, Velcro-edged rain flap on its fully zippered and Fastex-buckled lid. I ordinarily use the Tamrac 709 Pro Convertible. It holds two cameras and six or seven lenses, and has a hip belt that I can tuck away in a rear pocket. I like built-in waist straps and shoulder harnesses because they make carrying equipment for long periods of time much easier—and less stressful for your body. I hope manufacturers continue to incorporate these two features into future bag designs, particularly in the larger bags that require extra carrying support.

The backpack convertible is a hybrid design that offers some of the best features of both hard cases and soft shoulder bags. The LowePro Photo Trekker is the largest of these cases and is a true backpack, offering a superb harness system for long hours of comfortable carrying. It just fits under an airplane seat and looks more like a backpack than a valuable-camera bag, especially if you take the labels off. This is a great case for backpacking and landscape photography, when you have time to set up shots and can safely put your gear on the ground while you work. However, the best backpack for outdoor photography often is a regular backpack with one or two fannypacks inside.

When I'm photographing I don't like to have my cameras on my back; I like them within easy reach without having to undo straps. Tamrac's PhotoPack has a unique design that successfully combines the qualities of a shoulder bag and a small backpack, complete with removable side pockets and a greater degree of flexibility. I like the concept but my Nikon F3 cameras with motor drives don't fit comfortably in the bag, and I get lost going through all the different pockets trying to find a particular lens. (I hope that Tamrac will continue to experiment with this design.)

When I take minimal gear with me, I like to use the Tamrac 636 Photo Traveler One. It is slim and unobtrusive and holds a surprisingly large amount of gear. The bag can also double as a briefcase or a purse. For short outdoor trips a fanny pack is a handy camera bag. It rides out of the way on your back, and then swings to the front for lens, filter, and film changes. I use one when I'm skiing, bicycling, or hiking.

Once you've arrived at your shoot, repack only the items you'll need for the specific subject you're shooting that day. Decide on your priorities in advance. Your shooting bag should be full, but not overflowing, and lighter. Try to have just a single layer of equipment. If that isn't possible, place your most-used items on top and keep your most-used lens mounted on the camera body. Support the lens with a lens cradle or similar device, especially if it is large. Distribute the weight evenly in order to balance the bag, and have it sit flat on the ground.

Be consistent and pack predictably, so you'll always know where everything is. Compartmentalize your bag; you want to be able to work by touch, whether you're removing or replacing equipment. Theoretically, you should be able to locate any item within your camera bag instantly without removing your eyes from your subject.

There are numerous other bags and excellent brands that might work better for you. Every photographer has his or her favorite system. Spend a couple of hours at your local camera store exploring the possibilities before you buy one.

FILM

Ten years ago deciding which transparency film to shoot was easy: the only real choice was Kodachrome. Now that Fuji has challenged the photographic giant, the choice is less clear and more controversial. But this has led to a dramatic rise in both the quality and the variety of film. I still primarily use Kodachrome 64 because it gives me the best balance I've found in terms of sharpness, speed, and archival properties. I usually rate it at ISO 80 for more saturated colors.

But I'm also beginning to use more Fuji Velvia. It has picked up huge accolades since its recent introduction. Some photographers consider it to be the finest landscape film available on the market. Its granularity equals that of Kodachrome 25, and its color saturation and separation of tones exceed those of Kodachrome 64 (although some people prefer Kodachrome's relatively muted colors). Fuji Velvia yields some of the most vivid colors I've seen while not picking up heightened contrast. It is, however, excellent at picking up details in shadows. Kodachrome 64's rendition of greens in shadow under a blue sky is poor, and the film turns most shadow detail to black in high-contrast situations.

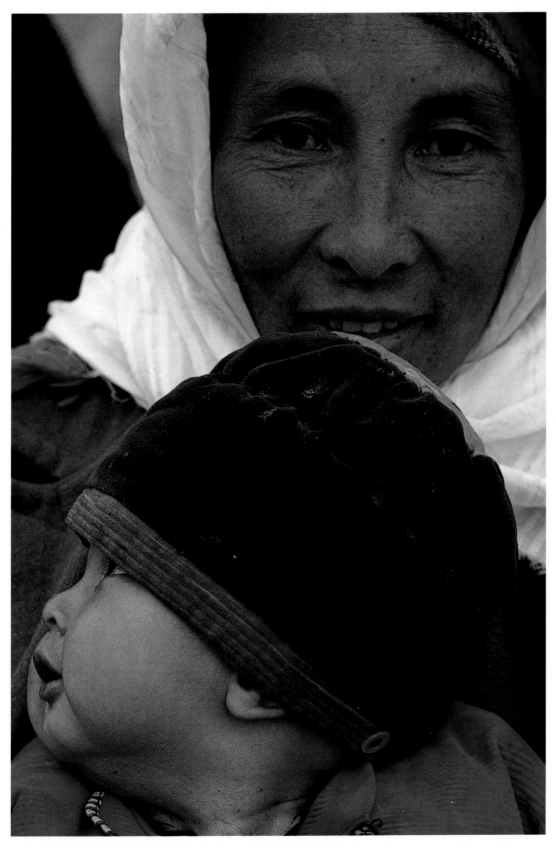

Traveling with friends through the Pamir Mountains in China's Xinjiang Province, I saw a group of people on horseback approaching me. When they stopped to make our acquaintance, I noticed this Kirghiz woman and her son. After she dismounted, I walked up to her and quickly photographed a series of shots while maintaining eye contact with her; the baby stared at his father. I like the combination of a full face and a profile, as well as the red and green framing the subjects in this image. Working with my Nikon F3 and an 85mm lens, I exposed for 1/60 sec. at f/8 on Kodachrome 64.

Velvia isn't recommended for people photography because the skin tones shift to red; Kodachrome and Ektachrome 64X (EPX) are better choices here.

Ektachrome 64X has a warmer tone and improved color saturation than regular Ektachrome 64 (EPR). EPX has both a color palette and saturation similar to those of Fuji 100, but EPX has a larger contrast range and warmer shadows. It is an excellent choice for people photography. Fuji 50 and 100 aren't as sharp as Kodachrome, and since they require E-6 processing they aren't as archivally stable. All E-6 films start to degrade after six years under realistic storage conditions. Fuji Velvia claims a 25-year life span, like Kodachrome, but there isn't any evidence to back this up. When tested, however, Fuji 50 and 100 were found to be more stable than Kodachrome for extended use with a projector or a lightbox. In rain and dim light, I like the romantic grain and muted colors of Kodachrome 200; this film can also be pushed to 400 with good results.

As to the question of whether professional film is better than amateur film, the answer varies from one photographer to the next. It depends on your preferences, the eventual use of your images, and the various circumstances you'll be working under. Professional film, which includes Fuji Velvia, isn't shipped until its optimal point: when its color rendition meets standards considered ideal by its manufacturer. It's delivered in refrigerated vans to the retailer, who keeps it in cold storage to prevent heat from accelerating the aging process. Since Kodachrome is notorious for its color shifts, I always use color-tested professional film from the same batch number (which I order from Fishkin Bros. in New York).

Professional film is perfect for people who work in studio conditions where they can keep the film refrigerated at temperatures below 55°F before and after use. But it isn't quite so perfect if you're traveling to the farthest reaches of the world. In that case, nonprofessional film is a better option because it

I rose very early to photograph two small fishing boats at sunrise over the Xuan Huong Lake in Dalat, Vietnam. I used my Nikon F4, a 180mm lens, and a tripod.

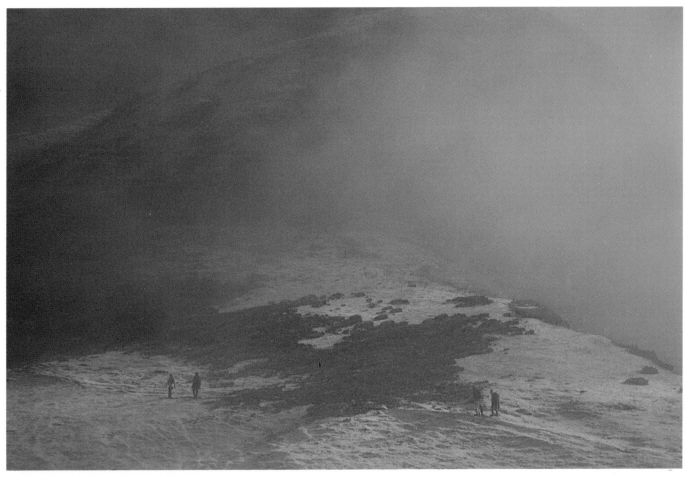

Returning to Chengdu, China, as the sun rose, I noticed these Tibetan sheepherders in the morning mist. With my Nikon F3 and a 35mm lens, I exposed for 1/60 sec. at f/4 on Kodachrome 64.

was actually designed to continue maturing to its peak performance level. The point when this film reaches its optimal color balance is typically one year before its expiration date.

Experiment with Fuji and Kodachrome, and choose the film that suits your specific needs and personal taste. Each has its own strength and weakness. There is an advantage to getting familiar with one film and using it as much as you can. The best exposures often result from long familiarity with the characteristics of a film.

I have yet to use print film for my work. For publication most magazine and book publishers prefer color-transparency film. However, if I were shooting only for myself, my family, and my friends, I'd readily make the switch. Unless you're dedicated to slide shows, transparency film usually ends up on the top shelf of your closet in cobwebs. With color-print film you can make photo albums that can be enjoyed over and over again. The past year has seen quantum leaps in the

technology and improvement of color-negative film. Kodacolor Gold, Kodak Ektar, and Fuji Reala are the films of choice in this category.

The pro-series Extapress Gold 100, 400, and 1600, excellent color-negative films for traveling photographers, are designed for storage at room temperature. Extapress Gold 1600 is specifically intended for push-processing. Even pushed to its limit of ISO 6400, it still performs remarkably well. For available-light photography in remote locations where flash isn't feasible or permitted, a few rolls of Ektapress Gold 1600 are indispensable.

A rule of thumb is to bring between 5 and 10 rolls of film per day for serious shooting. (You can certainly shoot less or more, especially if you're shooting for an assignment or stock.) I continually remind myself that film and processing are relatively inexpensive compared to my investment of time and effort.

WHILE YOU TRAVEL

There is more to photographing and traveling than being in an exotic location. You have to deal with the tedium of travel: finding a hotel, waiting for planes, and dealing with officials and permits. You have to meticulously take care of your gear from the moment you leave home. Inclement weather and unexpected dilemmas can foul up your travel plans and photographic equipment. Camera-repair technicians usually aren't available in remote locations. To avert disasters you have to anticipate possible problems before they occur. But if they do, you need the know-how and the tools to solve them.

AT THE AIRPORT

Following a few simple guidelines will make getting through the airport easier. For international flights arrive at the airport at least two hours before your flight's departure time. Never check your luggage at the curb; take it to the inside counter, and make sure that the luggage is tagged with the proper destination code. After I check in at the ticket counter, I immediately go to the security and X-ray inspection area. Although I rarely have bad experiences, I always give myself ample time in case the security guards insist on examining all my photographic equipment.

I prepare for this encounter before I arrive at the airport. At home I take all my film out of the boxes and out of the canisters. I put 50 to 60 rolls in one zip-lock, heavy-duty, gallon-size freezer bag, squeeze the air out, and seal it. Then I put it inside two or three more bags in the same manner, so it is well protected, minimizing the chance of puncturing the inner bag. I keep the film in my carry-on bag and put the film canisters inside my checked luggage. If I'm taking a large quantity of film, I take only about half of the canisters and recycle them.

When I get to the X-ray security check, I take the zip-lock bags of film out of my carry-on bag and put the cameras (I remove all film beforehand), lenses, and other items through the scanner. Without comment I hand the film to the security staff member for inspection. I try not to argue because I've found that it is more effective to use strong body language, looking firm and single-minded. If the inspector says the expected, "The X-ray is film-safe," I don't say a word. I just shake my head and hand over my film bags. I find this is usually enough encouragement, and the inspector then hand-checks my film readily.

I've never had any trouble with this method in the United States (inspectors are required to hand-check bags if asked to) and Asia, but at some foreign checkpoints, particularly in Europe, inspectors resolutely insist on X-raying your film if it isn't high-speed film. When this happens, I reluctantly let my film go through. Actually, despite all the dialogue on this issue, I know of very few situations where film has been damaged by an airport X-ray machine.

Evaluations show that after 150 cumulative exposures through a HI-CAT machine, no perceptible damage occurs to films up to ISO 400, color-slide films have less damage potential than color-negative films, and higher-speed films are more susceptible but still don't incur any visible damage after minimal exposure to HI-CAT scanners. I used to put my film in lead bags, such as a FilmShield bag, but they are heavy and bulky. I prefer the zip-lock-bag method. Also, since the machines can't see through the lead bags, in some countries inspectors crank up the power to see inside the bag, which nullifies the effectiveness of the FilmShield bag. Currently there are no foolproof measures that you can use to protect your film from being X-rayed, but never let your film go through as checked baggage. The dosage level of X-rays used on checked baggage might be 5 to 20 times higher than the carry-on-baggage screening level.

When I get to my destination I put the film back into the canisters for everyday use. Then when I've used a substantial amount of film, I remove the exposed film from the canisters and package them again in zip-lock bags so I am ready for my return flight. I then reuse the canisters for my next batch of film or discard them; of course, I recycle them if possible. Although this might sound like a lot of work—which it is—it is worth it.

CUSTOMS REGULATIONS AND PAPERWORK

Before leaving the United States you should register the camera gear you're taking with the United States Customs Service at a major international airport. This provides proof of your ownership, so you won't have to pay import duty upon your return. (For more information write for the free pamphlet entitled, "Know Before You Go," from United States Customs, P.O. Box 7407, Washington, DC 20044.)

Entering foreign countries is usually very simple and trouble-free. Most of the time I'm waved quickly through customs. You're allowed to bring in, without duty, all of your personal effects. This includes clothing, sports and travel equipment, personal appliances, camera gear, and film.

However, in some countries if you have a computer, video camera, or some other electronic item, it's recorded in your passport and you have to show the item upon departure to ensure that it wasn't left in the country duty-free.

When you return to the United States, you'll need to declare all items bought by or given to you. The first $400 of value is duty-free, and on the next $1,000 you must pay a 10-percent duty. Beyond this limit, the excess value of your goods is charged at full duty rate, which can range from 1 to 2 percent depending upon the merchandise.

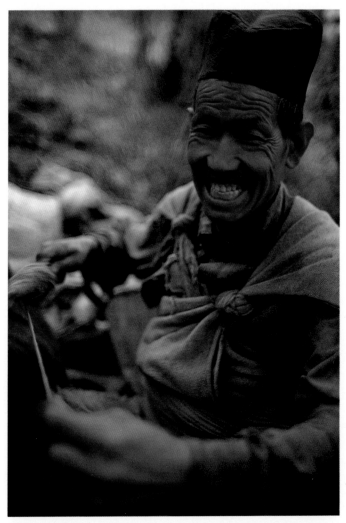

At camp I often spend time with the porters. This Tamang man is spinning hemp to make a new head strap for his doko, a basket used to carry loads. Since we were sitting under thick foliage, I shot at a low shutter speed, 1/15 sec., to ensure a workable exposure and to suggest the motion of his hands. With my Nikon F3 and a 35mm lens, I exposed for 1/15 sec. at f/2.8 on Kodachrome 64.

KEEPING JOURNALS AND CAPTION NOTES

Since I often take hundreds of rolls of film with two or three different cameras on a trip, I have to take meticulous field notes each day. I have a system that works well for me: I keep a daily chronological list of names, places, and other important caption information in a notebook. After I finish a roll of film, I label it with the date and the number of roll. For example, on July 18th when I finish my fifth roll of the day, I mark the film canister with a permanent marking pen, "7/18 #5."

Sometimes I use a microcassette tape recorder tucked in a photo-vest pocket or my camera bag, especially when I need to keep involved notes and I don't have time to write them down. I identify the roll and exposure number and speak into the recorder. You can record a lot more information more quickly onto tape than you can in a journal; usually two tapes are more than sufficient for one trip. Sometimes I transcribe the information from the tape at night into my notebook, or I wait until I get my processed film back at home. Then I play the tape back as I study the images on my light table, and transfer the information to the caption on the slide mount or on a separate piece of paper kept in my trip film journal.

OBTAINING MODEL RELEASES

In America many lawsuits against photographers arise because of a failure to have a model release when one is necessary. A model release is a document that basically says the person being photographed has given his or her consent not only to the taking of the photograph, but also to its use. The American Society of Magazine Photographers (ASMP) has sample release forms in its publication, *Professional Business Practices in Photography*. I use the forms included in that book as guidelines, and bring copies of my adult release and property release when I travel.

Whenever you include Westerners, particularly Americans, in a photograph that might be published, always get signed model releases at the time you take their picture. I usually show them the release and explain its need before I take the picture, but wait until after I've taken the photograph before I give it to them to sign. This way they know basically how they'll be portrayed in the photograph. If they refuse to sign the release, then I don't have much choice except to disregard that photograph.

If you plan to use your photograph for publication or stock, I think it is wise to have signed model releases from any people you photograph in a foreign city, no matter what their nationality or what the shooting situation is. (Even though

lawsuits aren't currently common in the rest of the world, this might change.) Translate your release forms into the language of the country you'll be traveling and photographing in. In more remote regions it is a bit trickier to get signed model releases, and not always appropriate. People may be suspicious, confused, or frightened if they're asked to sign a piece of paper. Use your common sense.

PROTECTING YOUR EQUIPMENT FROM THE ELEMENTS

It is important to keep your film out of the sun and heat. When I travel to hot climates, I bring a cooler that holds all my film. I either carry the cooler on the airplane as one of my carry-ons or put it in my checked luggage inside a large duffel. Bring two ice packs, and keep a frozen one in the cooler at all times. If bringing a cooler is impossible, keep your film in the coolest place available, such as inside your sleeping bag, the hotel refrigerator, or a shady closet.

You must be constantly vigilant about keeping very fine sand and dust away from lenses and camera mechanisms. This is a particular concern in desert regions and high-altitude plateaus, such as Tibet, Ladakh, and the Middle East. Make sure all your film and lenses are protected from sand and grit. If necessary, keep your lenses in individual zip-lock bags. Pay special attention to preventing dust and sand from entering the back of your camera, or you'll find long scratches across your developed film. Getting dust into tripod works is almost unavoidable. Try to chose a tripod whose legs and locks tend not to trap sand, or that work in spite of this. I've had excellent luck with Gitzo tripods because they can be easily taken apart and cleaned.

In climates with inclement weather, I always carry a large assortment of plastic bags, trash bags, and zip-lock bags. They are the best and cheapest insurance against everyday encounters with water. You can drape one bag over your

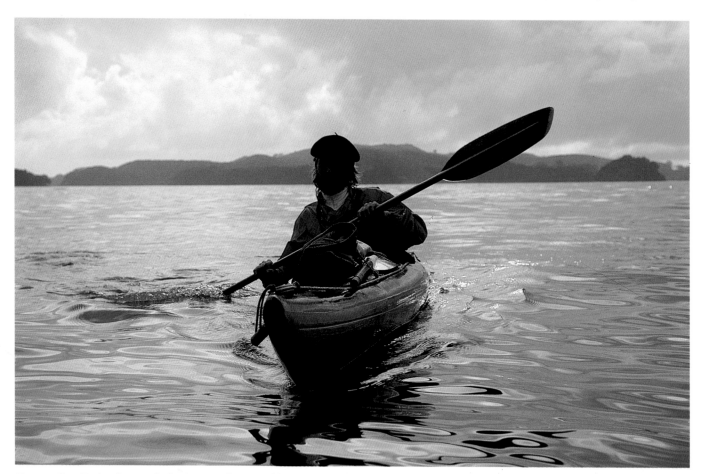

Because New Zealand's Bay of Islands was still, I was able to remove my Nikon N8008 and 80-200mm zoom lens from the case strapped on the front deck to get this shot.

camera bag for rain protection, and punch some armholes in a large trash bag for yourself. To make a temporary snow- and rain-resistant housing, slip your camera into a bag, make a small hole where you want the lens, stretch the plastic around the front of the lens protector, screw on a lens hood, and use a little duct tape to seal the edges. If you don't like sticking your head inside the plastic bag while shooting, remove the eyecup on the eyepiece, and repeat the procedure.

If too many raindrops get on the lens, tape an extension made out of cardboard or some other available material on the lens hood. Duct tape is always useful for customizing and repairing plastic bags, as well as making impromptu inventions. I usually find all sorts of situations where plastic bags and duct tape are indispensable.

Hard cases with shiny white or light-colored exteriors tend to reflect heat, which keeps the equipment (and film) inside cooler than black or dark ones do. Shoulder bags made out of Cordura or canvas should also be tan or gray. No matter what kind of bag you have, keep it and your camera out of the sun so that they don't become too hot and cook your film. Intense sun heats cameras quickly. I've touched black camera bodies that are too hot to pick up after just an hour in the sun. If there isn't any shade, place something reflective over the camera to minimize the heat.

Beware of leaving your cameras and film in a closed car. Temperatures inside will quickly soar past the safety point even in winter. I carry a small cooler complete with silicone desiccant and ice packs in my car to safeguard film. I also put my film inside zip-lock bags to protect it from moisture inside the cooler. Damp conditions also require paying special attention to film and equipment. Humidity softens the emulsion so that film becomes sticky, and condensation on a camera can seep into delicate mechanisms.

Adhering to some guidelines can also protect your equipment and film. First, keep rolls of film in their airtight containers until loading, and then try not to leave film in the camera for too long. To prevent mold and fungus from forming on your cameras or lenses, store your film and cameras in plastic bags (after you squeeze as much air from the bag as you can) with silica-gel packets. Silica gel is a crystalline compound that soaks up moisture, and changes color when fully saturated. It is usually available at a chemist's shop. Make sure you dry out the gel regularly, in the sun or in an oven. To avoid condensation when leaving air-conditioned areas, keep equipment wrapped in plastic bags until it warms to the ambient temperature. Finally, process film promptly.

Despite all of the precautions I take, I always carry an extensive repair kit with me. It is an indispensable part of my photography gear and contains: a set of jeweler's screwdrivers, needlenose pliers, a small wrench, a small pocketknife or a razor blade, lens-cleaning fluid and tissue, soft lint-free cloth, a pencil eraser for cleaning electrical contacts, a tool for extracting film leaders (this can be found in camera stores), cotton swabs for cleaning hard-to-reach places, super glue, garbage bags, tape, safety pins, rubber bands, twist ties, wire, string, and duct tape. Duct tape is the most well-used item in my repair kit. I keep some on my tripod legs, extra pens, and cable release.

CLEANING YOUR GEAR

When I am in the field I regularly clean my equipment, particularly in very dusty environments. I carry plenty of lens tissue, lens cleaner, compressed air (use the environmentally kind ones without Freon), and cotton swabs. Hold the camera and lens upside down while dusting, so dust falls away from them, not back on them. Use separate brushes for cleaning your lenses and camera bodies.

Most modern amateur cameras can go two to four years between professional servicing for normal use, but I usually end up abusing my cameras as much as I use them. As soon as I return from an extended trip or if I've been in an exceptionally harsh climate, I take my camera to a reputable camera-repair professional for a thorough internal cleaning and have its diaphragm, shutter, and exposure system checked. Older, all-mechanical cameras need professional cleaning, lubrication, and adjustment more often than modern, electronically controlled ones do. At home, I check each lens to make sure the screws are tight and the filters aren't scratched. Then I clean the lenses thoroughly.

If you aren't going to use your camera for a few weeks, remove the batteries and store them separately. This prevents the slight battery drainage that can occur if batteries are left in place, as well as removes the danger of battery-terminal corrosion.

SAFEGUARDING YOUR EQUIPMENT

From the moment you leave home until you return, you must be alert to the possibility of theft and take the necessary precautions to avoid making yourself an easy target. Not all areas of the world have the same risk factors. The highest-risk areas are in Latin America and India, and the lowest-risk countries are China, Japan, and the Muslim countries of Asia. However, don't let down your guard in so-called low-risk areas. Trouble always strikes when you least expect it to.

Your packing goals are to minimize your equipment and keep a low profile. A well-worn, somewhat-scuffed camera bag (remove the logos) isn't as noticeable as a pristine, polished leather case with an embossed "Hasselblad" or "Nikon" logo on the front.

If possible, don't put any of your valuable gear through as checked baggage at the airport. Unscrupulous airline employees have learned to recognize bright metal camera cases, such as Haliburton cases, as high-ticket items that bring a good price on the stolen-goods market. I know photographers who've shipped their large telephoto lenses in these cases without any trouble, but I wouldn't take the risk. If you must put some gear through as checked baggage, put the case inside a cardboard box or an old duffel. Most airlines won't cover the loss of camera equipment, even though anything else lost will be covered up to $1,000 or $1,200. Most airlines won't even sell you additional insurance coverage for cameras. However, some credit-card companies provide insurance if the airline ticket was purchased with the card.

Never reveal the contents of your bag to anyone (except when you go through customs or an airline security inspection). Keep your film in a separate compartment, so you won't have to show your cameras when you ask to have your film hand-checked. While you're waiting for the plane, don't leave your equipment unattended even for a moment. Keep it close to you, and wrap the bag strap around your wrist or ankle. Never ask a stranger to watch your bag while you go buy a cup of coffee.

An alternative is to send your equipment by air freight. In case of loss or damage, your gear is then insured. To collect, you must be able to show proof of the original purchase and have receipts for replacement equipment. Federal Express and Next Day Air service by the United Parcel Service (UPS) are also possibilities for shipping, but are expensive.

As you enter a hotel lobby don't advertise that you have expensive cameras with you. Keep your equipment in its bag. Leaving film and equipment in your hotel room can be as risky as taking it with you everywhere you go. This is a personal choice. So if you feel more comfortable having your equipment within sight and it is a manageable amount to carry, it is probably better to carry it with you. You can also put your camera in the hotel safe; just make sure that you get a receipt.

If you're traveling on a small budget and staying at the least-expensive hotels, then you have to be perpetually on your guard. Often the locals aren't a threat, but other travelers are. Don't advertise the fact that you have expensive cameras

by indiscriminately telling locals or fellow travelers that you are a photographer. When you leave your hotel room in dubious-security situations, lock your cameras in your suitcase or duffel. Then, for added protection, hide the bag in the closet under your dirty clothes or in the shower with the curtain drawn. If you are in an extremely high-risk area, chain your suitcase or hard camera case to a pipe or a secure post with a bicycle lock and chain. If you're staying in a higher-priced hotel, you should have more security. Still I make a habit of keeping my photographic equipment out of sight.

On the street or trail, I wear the shoulder strap of my camera bag diagonally over one shoulder and walk away from the curb so that no one can grab the bag off my body. I find the waist strap of the Tamrac Pro Convertible shoulder bag invaluable, not only for weight distribution, but also for security. I carefully fasten the belt around my waist and drape an arm around the case, holding the bottom. This helps to keep the weight off my shoulder and ensures that no thief can possibly yank the bag away from me. Wear inconspicuous, inexpensive clothing, and be aware of the people around you.

Most of the time I try to keep the zippers closed and buckles fastened on my shoulder bag. However, when I'm working at a fast pace and changing lenses often, I leave the top unzipped—but I always keep the Fastex buckles closed. When I put the camera bag down, I try to keep it close to me with a hand on the strap or around my shoulder or foot. Even when you feel confident, your gear might not be safe. Loose equipment on a table top or chair is an open invitation to theft.

Probably the most important precaution you can take is to insure your equipment adequately. While a standard homeowner's policy covers most of your possessions while traveling, there are often strict limitations when it comes to photographic equipment. Study your policy carefully to see how well you're covered. Many insurance companies sell floater policies for more expensive equipment. But keep in mind that these policies usually apply only to amateur photographers. If you use your photo equipment to earn money, you might need to take out a separate commercial policy, and these premiums can be quite high. Often photographic trade organizations offer lower group-rate insurance to their members.

PROTECTING YOURSELF

A trip can be delayed, curtailed, or terminated if you lose your money and passport. It is absolutely essential to keep them secure. I split my money into two or three different Eagle

My companions and I traversed the foothills of at the Qaratash Gorge in the Pamir Mountains in China's Xinjiang Province to reach a few isolated villages. Because I was ahead of the pack horses and mules, I turned around to photograph this scene. I used a 50mm standard lens on my Nikon F3 in order to minimize the caravan in proportion to the landscape. The exposure was 1/250 sec. at f/8 on Kodachrome 64.

Creek "undercover" pouches: a waist pouch, a neck pouch, and for truly crime-ridden areas, a leg pouch. Nevertheless I've been pickpocketed a couple of times in China and South America. But since I never have more than small bills in my most accessible wallet, I've never experienced a true disaster. I have one friend who sews inside pockets into all her traveling clothes. She has never lost a dime; thieves would have to rip her apart to find any money. Keep a separate record of all your credit-card numbers and other important information. Bring photocopies of the first two pages of your passport and of any important visas. And I always have a few extra passport-size photographs with me.

I also bring a few of my favorite teas, soups, granola bars, and chocolates for those moments when sea slugs and chicken feet are the only items on the menu. Patience is a virtue, but being comfortable while being patient is even

better. In my daypack I carry a collapsible chair called "The Chair." It triples as the internal frame for my daypack, a pad for my camera gear, or best of all, a chair for me to sit on during those long hours outside waiting for the alpenglow. If you're limited in terms of weight and space, you might want to bring a 1/2-inch-thick ensolite pad that fits inside your camera bag instead.

Dress warmly. The weather changes quickly in the mountains; you can be pelted by hail one minute and overheated by intense radiation the next. The right clothes let you stay out in the elements in comfort. Make liberal use of modern fabrics and fills, such as Gore-Tex, Capilene, Thinsulate, and Bunting. Dressing in layers provides the warmest protection. Fingertip-less gloves or extra-thin liner gloves are helpful when you're working with cold metals and you still need to manipulate intricate camera features.

WHEN YOU RETURN

There is a bittersweetness to coming home after a long trip. I am always anxious to see my friends and a good movie, and to develop my film. But it isn't always easy to make the abrupt transition from walking in the Himalayas or riding across the plains of Mongolia to living my comparatively mundane existence in the United States. Suddenly the cinemascopic events are reduced to memories and pieces of celluloid. This change can be unnerving.

To me, coming home means hard work at my desk, indoors; it certainly isn't romantic. Being out on the road meeting people and coming across unusual situations and events is fun, but the real work associated with adventure-travel photography takes place in your office. It isn't simply a matter of selling travel photographs. The business of photography is 20 percent taking pictures and 80 percent marketing them. Magazines and publishers rarely come to you; you have to court them.

Whether you're interested in selling your photographs or just plan on producing a photo album or slide show, you'll find that both require thought, careful editing, and a pinch of tenacity.

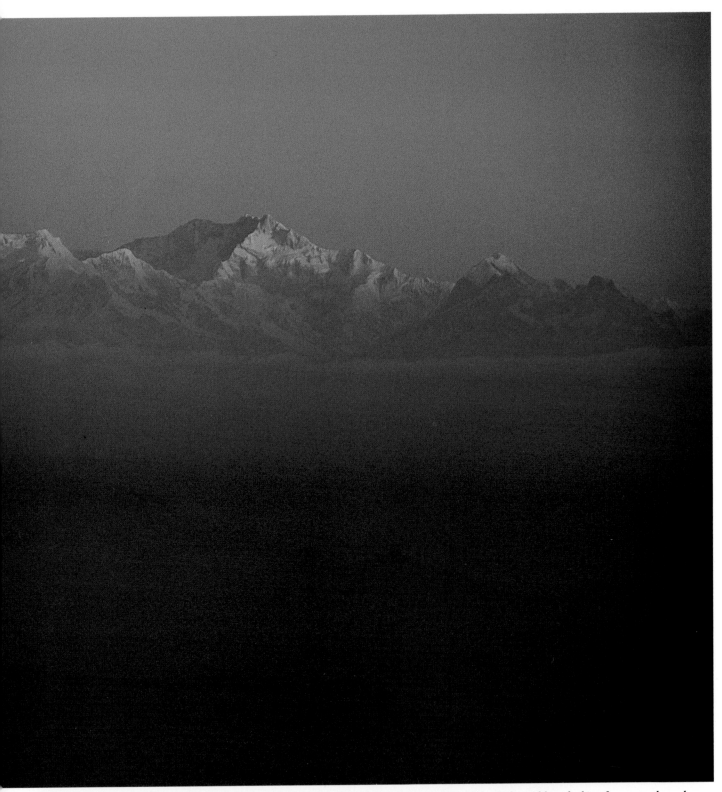

I shot this spectacular view of Kangchenjunga Peak at sunset from a high viewpoint in Darjeeling, India. I'd been looking for a spot above the telephone wires and finally, at last light, I found a hill above town that provided this perspective. Shooting with my Nikon F3 and a 180mm lens steadied on a tree, I exposed for 1/125 sec. at f/4 on Kodachrome 64.

I made this portrait of a Tibetan woman at the Gonga Shan monastery in China's Sichuan Province. She'd just finished making some bread, and I coaxed her outside to take her portrait. I shot with my Nikon F3 and an 85mm lens, and exposed for 1/60 sec. at f/5.6 on Kodachrome 64.

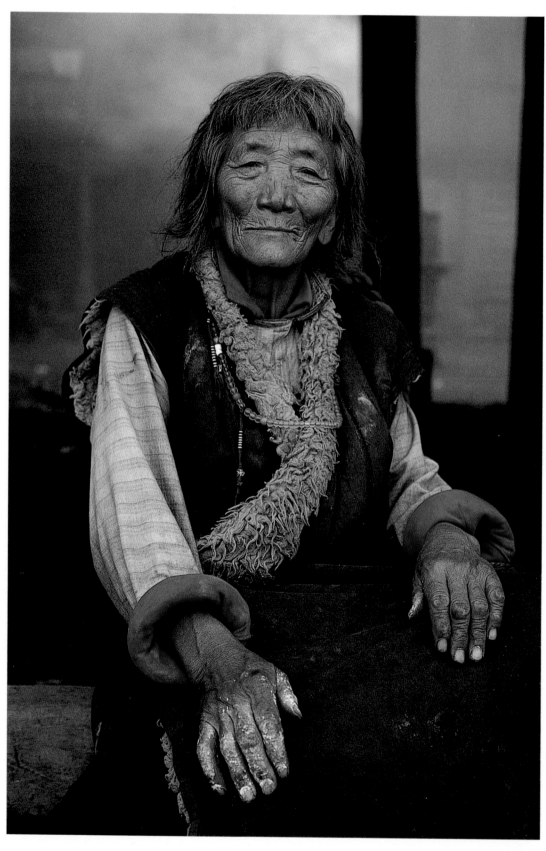

EDITING YOUR PHOTOGRAPHS

Editing and captioning slides are my least favorite aspects of photography. However, I've disciplined myself to begin the task as soon as the slides come back from the processing lab. Although I keep daily notes about my slides during my trip (sometimes written, sometimes taped), there is always some information that isn't recorded. The longer you wait to caption your slides, the greater the chance of valuable caption information being lost in your fading memory.

When the boxes of processed film arrive, first I count them to make sure I've received them all. If not, I locate the missing film-receipt stub from the mailer and contact Kodalux or the lab. Then I arrange the boxes chronologically according to the dates written on the name label. Next, I begin my preliminary edit. I spread the contents of each box on a 2 × 6-foot color-corrected Acculite lightbox, and examine each slide with a

4X Schneider loupe. (A loupe is a magnifying eyepiece used to examine slides on a lightbox.) I quickly sort through each box and toss out the obvious "no-goods." Since I sometimes use two or three camera bodies as well as different films in one day, I also have to rearrange the similar slides so that they're all grouped together.

After this first cursory edit, I start over and begin the process of fine-editing, captioning, and sorting my slides. I use a computer and caption-writing software to label my slides as I edit them. I separate them into various piles: one for assigned magazine articles, one for my stock agency, one for my personal files, and one for my portfolio. I also keep a slide projector set up so if I'm having trouble deciding on certain slides, I can run them through the slide projector and get a bigger and better viewpoint.

Throwing out slides is very cathartic. I used to hold on to every exposure and angle, afraid that I'd misjudge a slide and

Shooting with my Nikon F3 and a 24mm lens in Tajikistan, I focused on the top section of an ancient mud tomb. I wanted both to emphasize the design and to punctuate the vast expanse of the sky. The exposure was 1/125 sec. at f/11 on Kodachrome 64.

throw out an undiscovered masterpiece. I've since learned to trust my judgement. Now I enjoy throwing the rejects into the trash basket. But before I toss them away, I study each slide to know why it is a reject. I ask myself if I could've prevented its failure, and how. I'm not completely ruthless about discarding slides. Some slides might not be aesthetic award winners, but they might have important historical, personal, or behavioral value.

I keep only slides that are tack-sharp. Spare your friends and editors fuzzy slide presentations. For wildlife and people shots, check the eyes first; if they are sharp, the slide is still a contender for the files. If only part of a slide is in focus, it means the shutter speed was adequate but that the focus or depth of field was off. If nothing is sharp, generally there was camera or subject motion because of, for example, a too-slow shutter speed. A slide doesn't have to be sharp from edge to edge; sometimes the most interesting image is partially blurred. But this is an aesthetic choice, not a technical one. Keep only your best slides. Although it is tempting to keep less-than-perfect pictures, eventually they become liabilities by cluttering your files. Your final selections should be sharp, exposed properly, and interesting.

EDITING EQUIPMENT

There are two types of light sources for editing slides: light tables and slide sorters. Light tables are usually flat, with some capability for an upward tilt, and contain one or more fluorescent lamps depending on their size. The better light tables are color-corrected but expensive. Slide sorters are ribbed to hold rows of between 40 and 80 slides at about a 45-degree angle. They're illuminated by household light bulbs, so they aren't color-corrected.

The main consideration for sorting slides is the intensity of illumination, whether it is from a light table or a slide sorter. Check the intensity of your light source with a light meter. It should read 1/125 sec. at f/5.6-8 at ISO 100. The optimal color temperature should be 5000K and have a color rating index (CRI) of 90 or more. Besides a quality light table, you need a good-quality loupe that covers the entire image, such as the Schneider 4X loupe. It is essential for editing slides. Hoya recently introduced an excellent, and considerably cheaper, 4X loupe.

After I finish editing my slides, I caption them. A computer slide-labeling program is indispensable. I use the Cradoc CaptionWriter. Essentially it works like this: you type the information you want on each slide into the computer and give the print command. The information is then transferred to the slide labels in your printer. This is neater, quicker, and more professional than writing information on the slide by hand. There are many different slide-labeling programs on the market.

Some are very basic and only create labels for slides. Others are sophisticated systems for pros who need to catalog and retrieve slides, as well as keep track of billing and accounting.

STORING YOUR PHOTOGRAPHS

When color films are processed, exposed silver is exchanged for the color dyes that make up the image. Some of these dyes are less stable than others. When a dye fades or bleaches away, the remaining colors dominate. Some color films are more archivally stable than others. Although Kodachrome has the best long-term archival-storage properties, Ektachrome and Fujichrome have better light-storage longevity than Kodachrome. If I'm going to frequently project an image in slide shows, I make E-6 dupes. And, naturally, a print hung on the wall in the light has a considerably shorter life span than one stored in the dark.

The conditions under which you store your photographs are very important. Heat and humidity have a profound effect on photographic stability. Store your prints and slides at room temperature, 68°F at about 40-percent relative humidity. If you live in a humid climate, storing your photographs in an air-conditioned room is best. If this isn't possible, do the best you can by investing in a dehumidifier for the hotter months and avoiding storage in areas subject to severe temperature swings.

The dyes in color materials are also adversely affected by storage in certain albums, sheets, boxes, and cabinets. I avoid storing my slides in polyvinyl-chloride (PVC) slide sheets. Instead I use ones made of polypropylene or Mylar, usually labeled as "archival." If you've stored your slides or negatives in the older PVC or glassine storage pages, replace them now.

I store my slides in metal file cabinets, using secretarial hanging folders and archival file folders. I make sure that I don't stuff each drawer too full; I don't want my slides pressed tightly against each other. Be sure to avoid certain wooden cabinets whose varnishes and formaldehyde can ruin emulsions, print albums with sticky adhesives, and cardboard storage boxes that aren't archival. There is a vast number of archival-storage products on the market. It is worth spending a few more dollars today to protect your photographs for future enjoyment.

PRODUCING A SLIDE SHOW

A slide show can be a great ending to any trip, but creating an interesting presentation requires thought and a lot of editing. Narrow your choices to the most informative, best-exposed,

in-focus, and stunning slides. A short production, one or two trays, is enough for the average attention span of an audience. Some people make a complete audiovisual production, with music and sounds accompanying the slides.

PRODUCING AN ALBUM

Even though you might shoot transparency film, you can still have prints made from slides at a local photography store or by a less-expensive mail-order company. This process costs a bit more than making prints from negatives, but the advantage is that you can pre-select your images. Another possibility is to bring along a pocket-size point-and-shoot camera in addition to your better cameras for "album possibilities." Just be sure to edit, edit, edit. Keep your selection minimal, informative, humorous, and dazzling. Many of my friends keep an album for each trip in a bookcase. These albums are well thumbed and appreciated by all curious arm-chair travelers.

However, you can also venture beyond the standard photo album into an uncharted creative domain. I have one friend who makes an extraordinary picture album/scrapbook/journal for each journey; they are masterpieces of travel reportage. She uses a small, unruled bound book with high-quality paper. She writes as she travels, jotting down conversation and observations, pasting in mementos (ticket stubs, menus, newspaper articles, napkins, and business cards), and reserves space for the photographs she inserts after she gets home. Journals and photographs can be combined in countless creative ways.

SELLING YOUR PHOTOGRAPHY

Making photography your primary source of income calls for good business sense, marketing skills, tenacity, and, finally, photographic skills. Take a serious, critical look at the quality of your photographs, and count the number of excellent images you see. Then scrutinize your commitment to devote time to pursuing more of the same. If you honestly feel that you'd like to pursue photography professionally, be aware that you have an exciting but long road ahead of you.

Begin pursuing your dream in your spare time. Get a copy of the latest edition of *The Photographer's Market*, and look up magazines and stock houses that specialize in the type of photography you actually produce—not what you want to produce. Contact these firms by mail, and ask for submission guidelines. You'll probably receive an impersonal form letter. If the intended marketplace is receptive to new work, it might ask you to submit a number of images for consideration. These should be examples of your very best work that you think fit the needs of the specific magazine or stock house. If asked to send your portfolio, select only the highest-quality originals; they should be sharp, perfectly exposed, and thoughtfully composed. Send your portfolio by certified mail or an express-mail service. Some clients might request duplicate slides instead of originals; make sure that they, too, are top quality.

All of this takes time. Art directors and picture editors have very full days and must interrupt their schedules to look at your portfolio. Don't start telephoning before a reasonable length of time has elapsed. And don't be depressed if your work's rejected. That is the nature of the business. Your "tenacity quotient" counts. If being a travel photographer is what you really want and you can cope with an erratic life and income, welcome to the world of adventure, exploration, and travel.

My photograph of participants at the Yi Torch Festival in China appeared on the cover of the April 1990 issue of Popular Photography magazine.

The opening spread for an article I wrote for the July 1988 issue of Discovery magazine is shown on the left. The other three spreads reprinted here show images that capture the lives of the Tibetan cowboys.

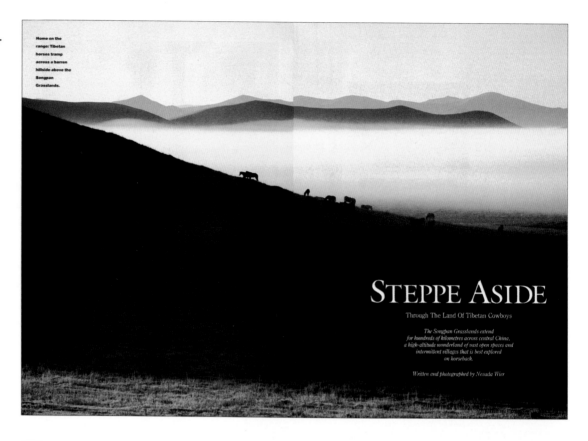

Home on the range: Tibetan horses tramp across a barren hillside above the Songpan Grasslands.

STEPPE ASIDE

Through The Land Of Tibetan Cowboys

*The Songpan Grasslands extend
for hundreds of kilometres across central China,
a high-altitude wonderland of vast open spaces and
intermittent villages that is best explored
on horseback.*

Written and photographed by Nevada Wier

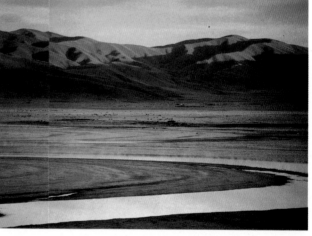

WE ARRIVED IN ZOIGE IN OCTOBER. IT WAS an odd Chinese town. People gathered around pool tables on the main street instead of lounging in the usual tea shops. Swarthy Tibetans in thick yak coats rimmed with fake leopard fur, sent pool balls slamming wildly across the old warped tables. Their horses stood placidly beside them, reins tucked securely into the players' leather belts. An intense, high-altitude sun pierced the cool air and the streets smelled of horses, yak butter and incense. Characterless and rather ugly concrete houses flanked the streets, in stark contrast to the colourful excitement of bargaining, gossiping, pool playing and eating that was taking place around them. Outside the town the grasslands stretched off in the distance, a golden undulating sea.

Politically speaking, we were in the Sichuan province, but geographically we were on the eastern edge of the immense Tibetan Plateau, home for several Chinese cultural groups, but mainly populated by Tibetans. At 3,660 metres, Zoige is the gateway to the Songpan Grasslands, a carpet of short grass that extends for hundreds of kilometres. Only a few foreigners have visited this dusty town. It's difficult to find on a map, and even if you found it you'd need special permission to stay there.

Michael and I had been travelling companions on several expeditions in China. While in Chengdu we became intrigued by the possibility of exploring the northwest frontier of Sichuan on horseback, a region not visited by Westerners for over 30 years. Spurred on by fantasies of riding with Tibetan cowboys, we pitted ourselves against the Kafkaesque Chinese bureaucracy.

"Nothing is easy in China," a valuable motto I've come to swear by. Using every gram of *guanxi* — otherwise known as "connections" — we had acquired in our four years of travelling and guiding in China, we were able to procure this precious travel permit. Immediately we stuffed a van with tents, camping equipment, food and Double Happiness beer, then drove two days from Chengdu to Zoige in the company of a Chinese driver and two liaison officers, Mr Li and Mr Lin. Now all we needed was a guide and a few horses, and Mr Lin assured us they would be easy to find.

Unfortunately, horses and guides were not available; we had arrived a week too late. All the Tibetans were cutting hay and fattening their horses for the long winter that was beginning to sweep down from the north. As I said, nothing is easy in China. By the same token, I had also learned that nothing is impossible either. After a friendly dinner with Zoige's minis-

Above: A youthful Yellow River twists and turns through Songpan. Above left: Pattern of faded Buddhist prayer clothes in Hongyuan. Left: The Tibetans routinely utilize their yaks for transportation.

ter of foreign affairs, many toasts to co-operation and exclamations of infinite friendship, we heard that the Chinese army might be persuaded to lend us horses. And, as Michael could speak passable Chinese, it was decided that a local guide would suffice.

Next morning we were introduced to Lau Ma, a sullen-looking fellow, our guide. The day before he'd been a truck driver for the People's Liberation Army; today he was a horsepacker stuck with two foreigners for a week. And he was dazed with disbelief.

We were on our way at last — almost. We had permission, we had a guide and horses, now we needed a route. Our plan was to spend a week riding north to Lamusur on the Gansu border and then

back. Lamusur was the epicentre of tantalizing rumours about traditional Tibetan culture and huge Buddhist monasteries, but it wasn't on either of our maps. One was a photocopy of an army map, in Chinese characters. The second was a copy of a copy of a Sichuan map from an unremembered source. Our Chinese friends sketched a circle on one of our maps in a blank spot that seemed to represent the grasslands, wrote in "Zoige" and "Lamusur," then proudly announced our route. As things transpired, Lamusur was Lau Ma's hometown; he'd know how to get there.

A few hours later the horses arrived in the courtyard of our green cement guesthouse. They seemed high spirited and nervous, at least to my concerned

eyes. The truth of the matter was that neither Michael nor I were good riders. Actually, the real truth was that Michael had been on a horse once and I only a few more times than that. The Chinese didn't know this, and we certainly weren't going to tell them at this point. We both subscribe to the "learn-by-doing" philosophy.

We mounted our wary horses, assuming an outward countenance of confidence and skill. The entire population of Zoige — lamas, merchants, pool players, yaks, bundled babies and dogs — gaped at our undignified departure. Michael's knees were up to his ears, as there had been no time to adjust the stirrups. My reins were too short. Our baggage horse looked increasingly unhappy. Suddenly the awkward load shifted and slid side-

ways, strewing our belongings along the road. The amused onlookers covered their white teeth with weathered hands and laughed. Lau Ma soothed the frightened horse and bound up the load a little tighter. We waved and rode out of town.

※

Our route followed a meandering stream across a broad valley with swamps and uneven mounds of grass, sabotaging our attempts to take a direct track. We wove to the right, away from the swamps, then left, away from the yak herders' camps guarded by fierce mastiff dogs. Michael and I grinned at each other. We had done it: we were riding in the Sichuan grasslands.

We ambled through a Tibetan village festooned with long white prayer flags and encountered the wildest looking Tibetans we'd ever seen. Matted black hair was twisted in braids around their heads, fastened with turquoise rings, and silver-cased knives swung easily from their waists. They bore themselves with a bold insouciance and flashed wide smiles at us. They were real horsemen. They knew how to ride — horses or yaks, saddle or no saddle, it didn't matter.

The following day it took a long time to make that indispensable cup of morning tea. The wind, wild and energetic, blew out our camp stove every five minutes. You soon get the impression that this wind feels the plateau is its personal playground and anything that dares to cross it is fair game. Relentless, it can drive men mad, and also horses I suppose, considering our current predicament: three of our four horses had run away. They had bolted from their stakes and were desperately heading for the running. He had merely trotted in the opposite direction in pursuit of fresher grass. Lau Ma frantically snatched the horse's reins and flew off, bareback, into the grasslands. There was nothing we could do, so we decided to have some more tea.

A few minutes later two Tibetans rode nonchalantly into our dismantled camp. Word was already passing from village to village that we were here. Having never seen a foreigner before they were compelled to visit. After initial greetings, the two sunbaked Tibetans sat down among our partially packed gear and accepted some tea. Their yak coats enveloped them like big warm houses. First their eyes and then their hands began to roam over our possessions with eager interest — plastic buckles, bright yellow nylon, cameras . . . zippers! They reminded me of children playing with treasured toys.

One of the Tibetans picked up a novel lying on Michael's pack and stared at the back cover photo of a white-bearded man with an amused smile. He pointed at the portrait and looked quizzically at Michael. "Hemingway," said Michael. "Hem-ming-way," the Tibetan repeated perfectly, staring at the photo. The two Tibetans glanced at each other and laughed, nodded and grunted their approval. One of the Tibetans held the book and stared at the photograph gravely. He continued to stare at the book, muttering "Hem-ming-way," then solemnly raised the book to his forehead in a reverent salute.

Before Michael could explain the true nature of the photograph he was interrupted. In the distance, a horseman with three riderless horses approached us at an easy lope. Lau Ma was back and he looked tired. The horses had gone most of the way back to Zoige; he had been chasing the renegades for three hours. It was

already afternoon, but with the help of our Tibetan friends we packed the sweaty horses and rode off towards a distant row of dim blue mountains.

The two Tibetans stayed with us until their camp of yak-hide tents came into view. With sweeping gestures they insisted it was late and we should spend the night in their camp. It was tempting: we would probably sit around a warm fire and drink Tibetan yak-butter tea and laugh. But we decided that it was imperative to make up for lost time. The sun was sinking low between dark clouds, spreading honey-yellow light across the valley. We glanced back at the two Tibetans trotting towards their camp — each held a picture of their god-king outstretched before them.

By morning our world was an opaque white. Peering out from our dome tent, we could just see four shadowy figures in white felt coats, on shadowy horses. The riders, all of them women, bent low, belly to belly with their wet horses, to peer into our tent. Seeing two blond, blue-eyed Westerners wrapped in red-and-purple nylon, they immediately began to laugh — Tibetans always laugh. Actually, Tibetans are the most amiable souls on this planet (with the meanest, snarliest dogs as balance). They live over three kilometres above sea level in a windy, barren, bitterly cold environment and I suspect that laughing keeps them warm and sane.

After pacing around our camp for a few minutes inspecting our gear and breakfast of leftover rice, the Tibetan women disappeared as silently and mysteriously as they had come.

※

For four days we rode — six to eight hours a day, often at a slow walk as the terrain was uneven and marshy. Our recalcitrant horses resigned themselves to the journey. My knees ached from being constantly bent and Michael resorted to sitting on a foam pad to relieve the hardness and deformity of the Chinese cavalry saddle. Aside from these minor unpleasantries, we were content and grateful that we were on tolerant horses. And we felt extremely cavalier in this aloof, romantic country.

The grasslands rolled out around us in a series of shallow yellow valleys and low green hills. We rode over trackless ground, occasionally crossing a narrow dirt road. The air was crisp and crystalline; winter was coming. We passed a few small villages, yak camps and families moving their belongings to winter pasture. There's a lot of space on the Tibetan Plateau, which is about the size of Western Europe but populated by only six million people and countless yaks.

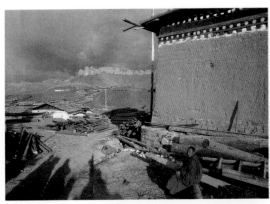

Far left: Traditional Muslim-style hats on the wall of a Lamusur mosque. *Left:* Tibetan monk wrapped in the robes of his order. *Above:* Inner sanctum of a monastery in Lamusur, once the fulcrum of Tibetan Buddhism in the Songpan region.

20 DISCOVERY JULY 1988

21 DISCOVERY JULY 1988

Lau Ma had resigned himself to the journey. He was a Muslim from the Hui minority group in China, but his true allegiance was to trucks. "I drive big trucks," he often told us. He thought it was ridiculous to be riding to Lamusur when one could drive much faster.

Besides wondering why we wanted to travel to what we considered as the far side of the planet, riding between poor forgotten villages, he was concerned about our choice of food. According to Lau Ma, our mode of travel demanded two kinds of food in voluminous quantities: rice and *tsampa*, the Tibetan mainstay, a paste made from ground barley. Tibetans thrive on it, shovelling it into their mouths with great gusto. Our dinners of Chinese noodles with tomato sauce convinced him that all the stories about disgusting Western eating habits were true.

On the fourth morning we met a composed Tibetan boy on a black horse. We were almost to Lamusur. Once over a pass in the jagged hills confronting us, the northernmost point of the blank spot on our map was only an hour away. The boy conferred at length with Lau Ma, describing the route in detail, and escorted us up the narrow valley. As we began to ascend the hills, the boy stopped to water his horse in a small creek. We kept moving and as the distance between us lengthened, he suddenly sang out in a loud and sonorous voice. His thin arm was raised high, wishing us luck and a good journey. The sweet, melancholy song reverberated through the canyon, gradually fading as we moved up the gravel slope.

"We'll be in Lamusur soon," said Lau Ma offering a cigarette to Michael. Practically all the men smoke, and it's considered very polite to offer a cigarette to someone you've just met and to keep proffering them throughout the conversation. Michael doesn't normally smoke, but he took one and lit it.

Lau Ma smiled and pointed straight ahead, "Lamusur."

"What's Lamusur like?" Michael asked.

Lau Ma shrugged, "Dusty."

From a distance Lamusur looked unremarkable. It appeared to consist of post-Cultural Revolution architecture, sombre and boxy, typically clashing with the local minority culture. At closer inspection, however, it gave the impression of a place immensely intriguing.

We trotted into town, aware of the silent scrutiny cast in our direction from windows and doors. One wizened old man squinted his eyes at us, broke into a toothless grin and waved. As we moved through the narrow, muddy streets, we passed stones carved with the Tibetan Buddhist symbols for *Om Mani Padme Hum* (a mantra meaning "Hail to the jewel in the heart of the lotus"), and strewn with prayer flags, tattered and grey from years of blowing prayers to the unyielding wind. Row after row of shiny new golden prayer wheels lined the sides of the streets. On the hillsides all around the town, mammoth Tibetan monasteries were being constructed. In their various stages of development they looked like giant cocoons about to hatch. A tall green minaret loomed over the centre of town. This was Lau Ma's hometown. Half Hui, half Tibetan; half Muslim, half Buddhist; half in Sichuan province, half in Gansu province.

※

Lamusur was once the centre of Tibetan Buddhism for Sichuan, Qinghai and Gansu provinces. Then, in 1966, Mao Zedong launched the Cultural Revolution. For ten years the country plunged into madness attempting to purge itself of "bourgeois" elements. The minority areas were particularly hard hit. In Lamusur, all the monasteries were plundered and destroyed. Some relics were hidden and saved, but most went up in flames.

The rebuilding of Lamusur began in 1978 when the Chinese Government eased their policy of cultural hegemony and began allowing more religious freedom throughout China. Over ten monasteries are now in the process of being reconstructed. Everything is being built by hand. Even the lumber is being painstakingly shaped with hand tools from crude logs. We were impressed by the scope of the project and the complete devotion it required.

A coterie of lamas in long red robes accompanied us onto the construction site of one of the larger monasteries. We estimated that over a thousand people would fit comfortably in the main room. The smell of freshly sawed timber mingled with incense burning from small black pots. An enormous Buddha sat in a hieratic attitude on a wooden altar, a huge gilded figure looming out of the dimness. The oldest and most treasured relics rested at its base, some encased in glass, and photos of previous reincarnates hung on the front wall. I especially enjoyed the largeness and ornateness that impressed me — there are much bigger, more opulent monasteries in other Tibetan towns — it was the overwhelming effect of seeing so many of them being diligently built at the same time so close together.

Later that day we followed the lamas to a forested canyon on the west end of town. Through it flows the White Dragon River, the head waters of one of the nine major tributaries to the Chinese mother river, the Yangtze. "The mouth of the canyon is holy," said the eldest lama. "A dragon once lived in one of the caves, a lion in another. Centuries ago the lion rode the dragon across the canyon. Here, where the lion landed, you can see the marks made by his claws." The lamas gently pressed a palm or a forehead to the series of gouges in the limestone cliff, expressing a silent devotion.

Inside the cave, squatting in the darkness, was a large bulbous stalagmite, declared to be the only female Buddha in Tibet. The lamas walked deftly up to the base and rubbed the slippery rock. Outside the cave we were shown other important markings, such as a boulder that bore the signs of Buddha's feet. "This is where he hitched his horse," said a lama pointing to a natural rock handle in the canyon wall. "If you throw a rock in this hole you will have good luck," said the youngest lama, gesturing at a baseball-sized hole in the wall above us.

A day later, we ambled through the streets of Lamusur, buying turquoise-hued plastic hats, black felt boots and Himalayan snuff in the small shops that lined the main street. A black-veiled woman in sturdy shoes strolled past us, dragging her child which was mesmerized by our presence. A bent, grey-haired Tibetan woman waddled in the opposite direction, gumming devotions as she methodically rubbed her prayer beads. Around the corner were the ubiquitous ratty pool tables and Tibetan pool sharks.

That afternoon we rejoined Lau Ma, who had taken the horses to the outskirts of town to graze. We drank jasmine tea and ate preserved vegetables while plotting the route back to Zoige. I was looking forward to getting back on my horse, eager to feel again the slow rhythm of riding, back to meeting people in a leisurely manner, on their own terms. Lamusur had become another stop along the trail, another moment and place to be savoured. Every day had been perfect in its own way, and I knew the journey back to Zoige wouldn't be any different.

An American adventure holiday firm offers horseback tours of the Songpan Grasslands for those who have neither the time nor inclination to make their own arrangements. For more information contact Boojum Expeditions, 2625 Garnet Avenue, San Diego, California, USA 92109; tel: (619) 581-3301.

Cathay Pacific has seven flights a week between Hong Kong and the cities of Shanghai and Beijing, from where there are connections to Sichuan province.

Nevada Wier is a freelance writer and photographer based in Santa Fe, New Mexico, who has spent much of the last four years exploring little-known parts of China.

Above: At least ten Buddhist monasteries are being refurbished in Lamusur. *Right:* Lau Ma leads the horse-trekking party across the grasslands.

RESOURCES

ADVENTURE-TRAVEL COMPANIES *

Afro Ventures
P. O. Box 2239
Randburg 2125
Republic of South Africa
011-27-11-789-1078
011-27-11-866-1524
Fax: 011-27-11-886-2349
Canoeing on the lower Zambezi River, Zambia, and other African safaris

Boojum Expeditions
14543 Kelly Canyon Rd.
Bozeman, MT 59715
406-587-0125
Horseback-riding expeditions to the Tibetan Grasslands, Mongolia, and Central Asia

Innerasia Expeditions
2627 Lombard St.
San Francisco, CA 94123
800-777-8183
415-922-0448
Travel to Central Asia, Mongolia, Patagonia, and other exotic destinations

Intertreck
P. O. Box 126205
San Diego, CA 92112
800-346-4567
619-259-1552
Fax: 619-259-1552
Trekking in the Pamir Mountains in Tajikistan

Mountain Travel/Sobek
6420 Fairmount Ave.
El Cerrito, CA 94530
800-227-2384
415-527-8100
Fax: 415-525-7710
Rafting the Zambezi River, going on safari in Africa, trekking in Nepal or Vietnam, and traveling almost anyplace else on the globe

New Zealand Adventures
11701 Meridian Ave. N.
Seattle, WA 98133
(206) 364-0160
Sea kayaking in New Zealand

Sourdough Outfitters
P. O. Box 90
Bettles, AL 99726
907-692-5252
Dog-sledding trips in the Brooks Range in Alaska

* *For a more complete listing of adventure-travel outfitters, consult the "The Active Traveler" directory in the back of* Outside *magazine. For a listing of adventure-travel-photography workshops consult the "Travel and Workshops" directory in the back of* Outdoor Photographer *magazine.*

OUTDOOR GEAR

Eagle Creek
1665 S. Rancho Santa Fe Rd.
San Marcos, CA 92069
619-471-7600
800-874-9925

Lowe Alpine Systems
P. O. Box 1449
620 Comptorn
Broomfield, CO 80020
303-465-3706

Marmot Mountain Works
827 Bellevue N.E.
Bellevue, WA 98004
206-453-1515

Roy McClenahan
P. O. Box 313
Eldorado Springs, CO 80025
303-494-1408
(Custom-made frontal packs for hiking and skiing photographers)

The North Face
999 Harrison St.
Berkeley, CA 94710
510-548-1371

Patagonia
1609 W. Babcock St.
P. O. Box 8900
Bozeman, MT 59715
800-638-6464

REI
P. O. Box 88126
Seattle, WA 98138
800-828-5533

INDEX